HOMAGE TO

LEON AMIEL PUBLISHER

NEW YORK

HOMAGE TO CHAGALL

Special issue of the XXe Siecle Review

© 1982 by Leon Amiel Publisher, New York

ISBN 0-8148-0725-9

PRINTED AND MANUFACTURED IN THE UNITED STATES OF AMERICA

LEON AMIEL PUBLISHER

NEW YORK

preface

by leon amiel

The twinkle in his eyes tells everything. The music, the poetry, the action, the colors, it's all there in his eyes. He could have been equally a great actor, or a successful musician, and even a renowned poet. But he chose to put his immense and creative talents on canvas. To look at the paintings of this great master is to observe the wonders of all these attributes. One can readily envision the influences of the early Russian Chassidic environment in the joyous scenes of the Old Testament, the French influence in the music and poetry of his Paris paintings, his bouquets, his circus and theatrical decorations. Form and color, music and poetry — that is the essence of this incredible master whose works will live on through the centuries.

On this wonderful occasion of the Master's 95th birthday, I would not only like to wish him a continued joyous and productive life, but I would also like to thank him for the many personal memories he has given me, beginning with the time I first met him walking along 57th Street with Vertes and his daughter Ida, and until now, working with him all these years in publishing his works in America.

This volume has been inspired by all these memories, and it is only fitting that upon this momentous occasion, I dedicate it to one of the great masters not only of the 20th century, but of all time.

LEON AMIEL

the admirable chagall

by louis aragon

Painting! A man has spent his life painting. And when I say his life, you must understand what I mean. Everything else is gesticulation. Painting is his life. What does he paint? Fruits, flowers, a king entering a city? Everything that is explainable is something other than life, that is, from what he understands by life. His life is painting. Inexplicable. Painting or talking perhaps: he sees like the rest of us hear. Subjects are painted onto the canvas like simulated sentences. Connected words. After all, the words make a sentence, there is nothing to understand; is it this way with music? Then why is it not so with painting? Let us start from the beginning. How does one begin to write about this unfinished world, this strange, unfamiliar country, this weightless land where there is nothing to differentiate a man from a bird, where the donkey lives in the sky and everything is a circus, and where we walk so well on our heads. No explanation is needed if color is used to emphasize a rooster on a flutist's arm and a naked woman is drawn in the shadow of his neck while in the distance the sun and moon bathe the village in gold. We are constantly before the clock. The second hand shows the path. The spectacle is *given*: men and women surrounded by visions of brutal beasts, characters from a travelling theatre company, a meaningless sabbath in Brocken, childhood obsessions, wandering souls, gymnasts from a topsy turvy world, jugglers accompanied by an invisible violin. People's fantasies in a world so full of lovers that it is hard to choose one. Without doubt, no painter has ever flooded my eyes with so much light, with nights that are so divine.

There is a Chagallian dialectic for which *The Midsummer's Night Dream* is the only precedent I know. No need to have rags adorn the actors who wear anything from sequins to feathers, and bouquets are somehow thickets that are compared to dancers. The older the painter became, the more he took a pagan pleasure in shavings of colors. The mirage is not at the end of a desert but in a shimmering vision mingling human beings and animals; nor do we know in which daydream the hand lovingly cuts up shadow and light and feels through the fingers a scattering of green and orange. The painter sometimes appears, palette in hand, at the bottom of the canvas, with an animal-like expression on his face reminiscent of Bottom. The

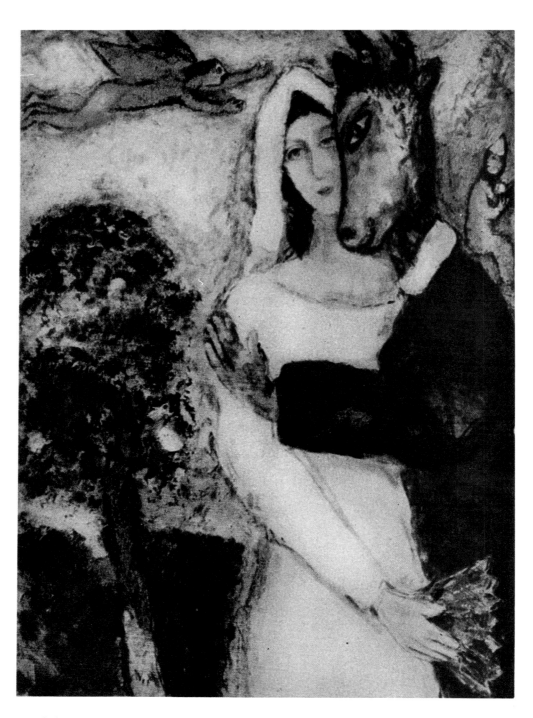

6

whole world seems to be in front of him like the model of an imaginary parade where far-away visions and dreams become reality and the unconscious becomes the conscious. And everywhere, almost everywhere, it is the kingdom of touch, the caressing world of hands, mostly opened — who else has ever painted like this?

An ox walks by in the distance so slowly that the violin dies out and every embrace depends on the silence of love constantly being reinvented, as if it is always the first time, the same wonder felt at adolescence.

Wonder here hardly depends on understanding because everything I recognize increases rather than diminishes the sense of mystery. Peasants, clowns or lovers for one night. And the villages off in the distance that can also be Notre-Dame, the Eiffel Tower, or the Opera. Even Paris is the countryside, with its lights that could be lilacs. In the

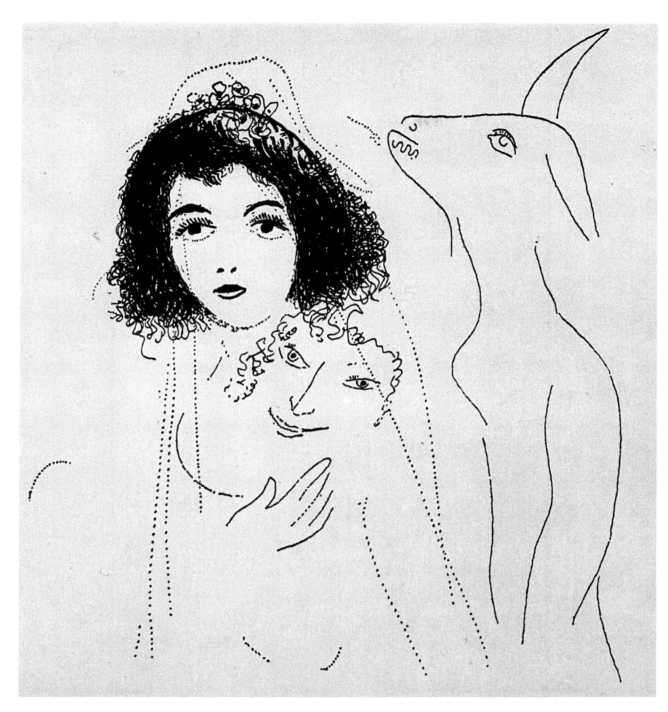

First Meeting.
1945.
Pen drawing for
Burning Lights
by Bella Chagall.

old days painters used to leave students and artisans free to add details to the secondary characters, thereby changing the perspective of their major works; these were all *postiches*. Chagall always rejects any hasty interpretation of his paintings that may make them non provocative.

One character starts running through the streets on his hands, another takes off through the sky, head cast downwards, face turned away; try to get a sensible and coherent story, at least so that a mythology can be defined. The painter tends to contradict the general composition through the detail and even upsets the balance of what the painting seems to say — for example, when animals are coupled with human beings, to which I dare you to attach any symbolic meaning or value. Time does not change this work that covers more than 80 years. On the contrary, nowadays, the logic of ar-

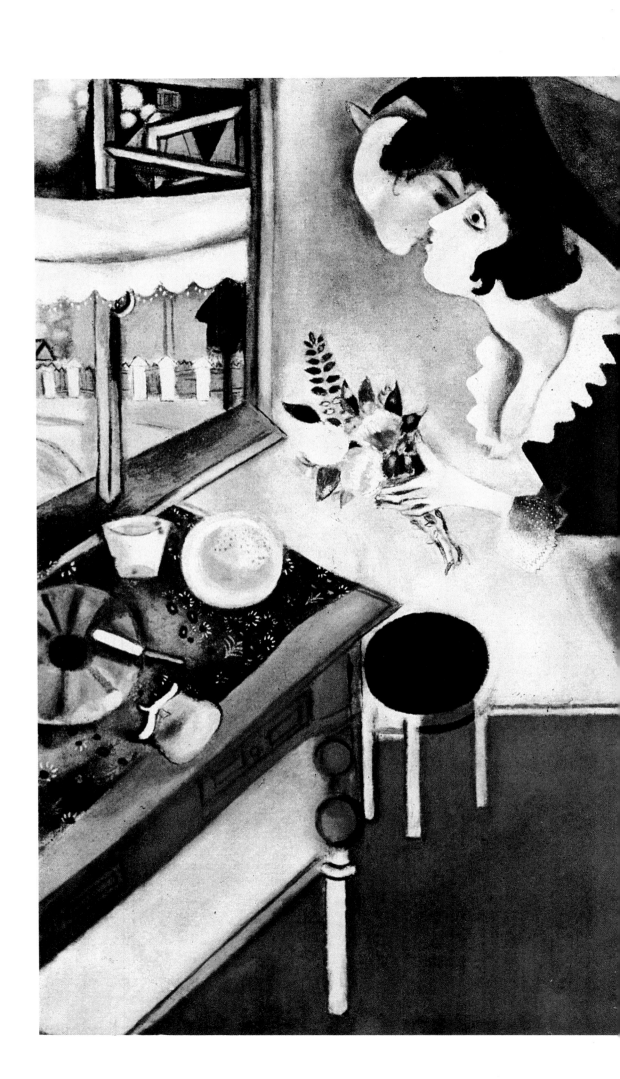

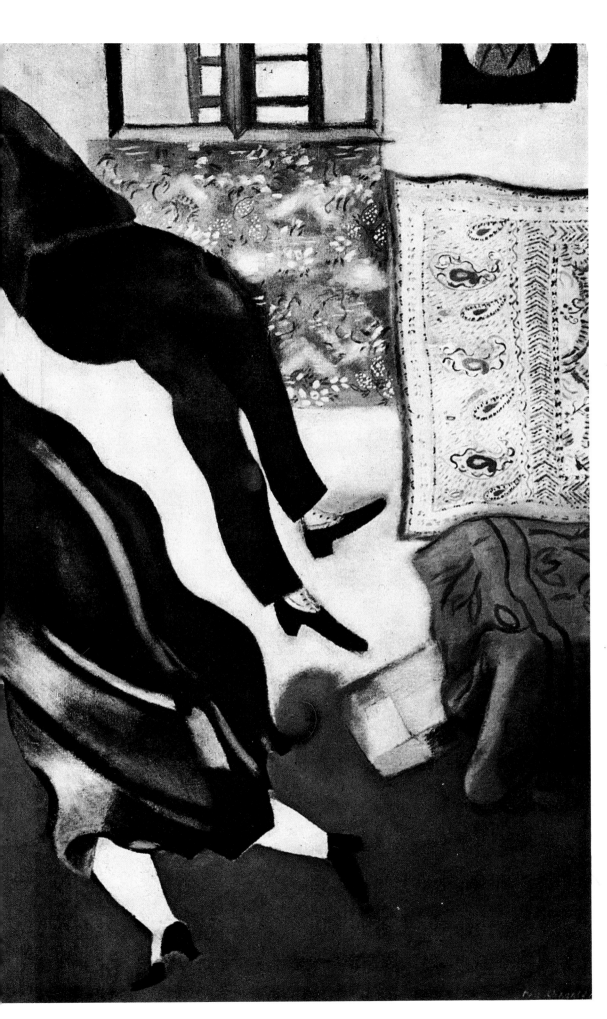

The Birthday.
1923.
Oil on canvas. 31⅞x39½".
The Solomon R. Guggenheim
Museum, New York

9

Time Is A River Without Banks.
1930-39.
40½x32⅝".
The Museum of Modern Art,
New York.

bitrariness predominates, a challenge hurled at age, a mockery of time and of its power. Some will certainly say that some of Chagall's paintings contradict my observations and will insist on the coherence of the subject matter, particularly because in the great biblical works the painter seems to comply with the "story" as it is told, to respect and even illustrate it. But what does this prove, except that the painter is extremely versatile. Besides one mythology does not preclude another.

Certain paintings, having looked at them for so many years in a particular way, no longer strike us as either strange or irrational. Their *irreducible* quality eludes us. But this is precisely wherein lies their greatness, their poetry. Since a Chagall scene is hardly reminiscent of everyday life, it is impossible to give a common meaning to the individual elements. For this painter, the rigor of composition resides in his freedom. It is my belief that Chagall is dominated by the pleasure he gets from his painting, from the hegemony of colors, rather than by what he is trying to represent. I like him most of all when he seems to get lost or unraveled in apparent disparity. Also, he seems to play in a strange kind of kaleidoscopic way that always destroys the geometric balance just as the work of art is about to be finished.

With Chagall there is a bestiary to assemble, and if at times parents, horses and birds are all there, variations in their morphology are to be expected. I would like to take the example of a recent painting in which on a deep blue night the moon is black and the ground once again bears a Bielorussian village; someone is sitting under a raging sky and like a thunderbolt, lightning falls like a scarf on his shoulder...try and describe this! When it is really the indescribable, two birds, a naked child, a female figure laterally traced in white against a dark background, a pony, and this face lighting up the top of the canvas — does it belong to the body striped in brown, black, green and fresh blood? And below on the left, cast in light, is the pinkish head of a horse with a green body whose blue foot rests on the paleness of a moon-like face (or is it a stone?) while the other foot and its fine ankle seems to belong to the mysterious pregnant woman in the sky. Look at it! You will probably not see what I am observing,

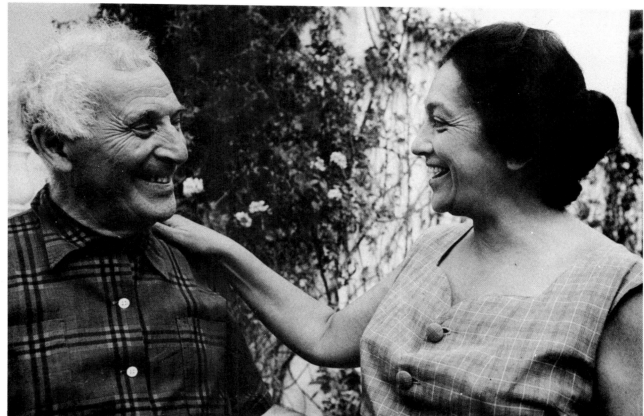

12

and bless your eyes if they see something else. I only wish to warn you against any tendency to impose on these nocturnal paintings or even on those bathed in sunlight an arbitrary mythology. Do not wake the painter up. He is dreaming, and dreams are sacred. Secret things. He will have dreamt his painting and his life. The world is his night just as he has made his day.

We think we have a certain vocabulary, but, in fact, words are enigmatically *dictated*, as is our choice of words; it all resembles a painter's palette. I read my works over and over, and I connect myself to what has been written in those pages. I try to penetrate the work as if I were getting dressed very slowly. So too with painting. It becomes my mirror the depth of my vision, my eye. Suddenly, some strange pollen appears and injects itself into my fixed vocabulary, like the breath of strange beings coming from somewhere other than myself. As Chagall would say, I suddenly invoke the words of a different glass factory, words that maybe I had in the back of a cupboard but that I was not using. It is as if without noticing, accidentally, they appear among the painter's bouquets, in a glass of water, or in an outstretched hand, carried by who knows? But no, they must not be compared to

The Blue Violin Player.
1937. 32⅛x24¾".

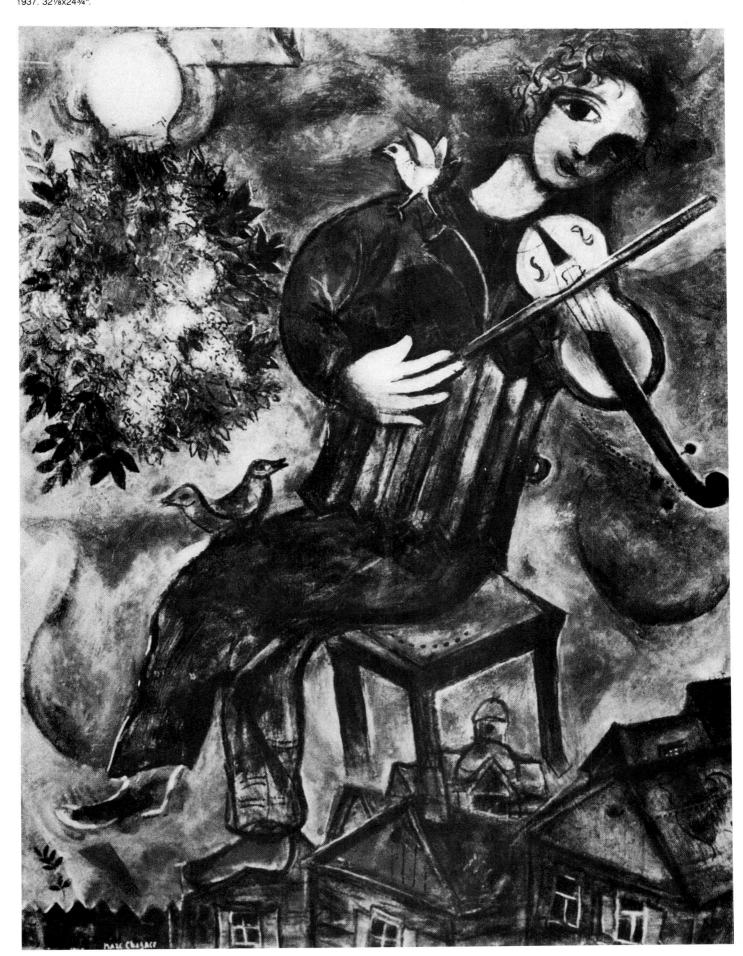

13

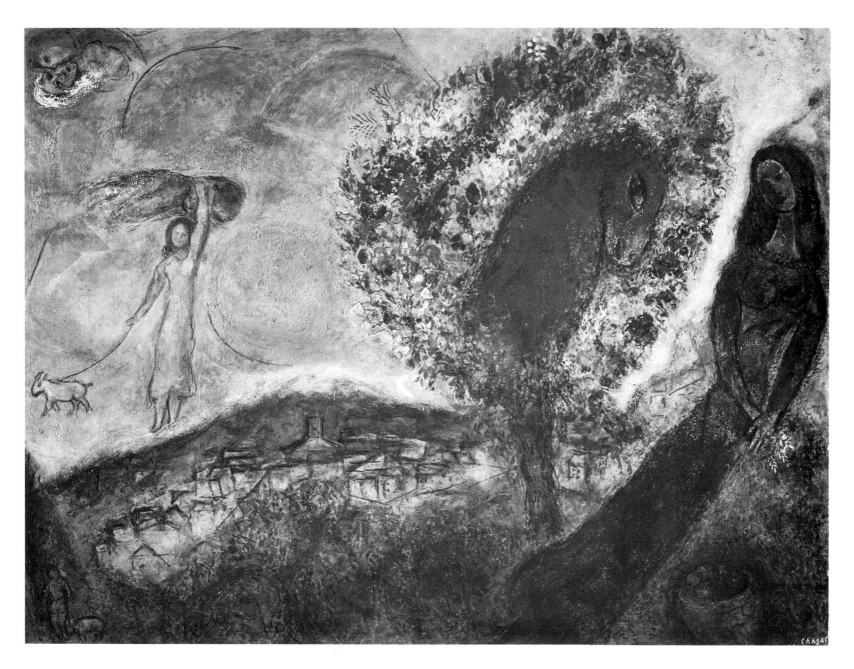

14

thickets, bushes of large shrimp perhaps, since they are also called *bouquets*. But I saw them as thickets, and that word does not come from my palette. Now getting back to that banal proposition: *...and the bouquets are thickets to be compared to dancers ...or maybe to sleepers*, I hear a voice in all this that is not mine, an exterior accent, since, to my knowledge, the word "thicket" is not one of mine — not my color. Why did I think of it for Chagall? A sound comparison, a variation used as a rhyme would be too easy an explanation. I am thinking of a different relationship for these words, like the uneven flow of water. When I look at a Chagall I have this feeling of the unconscious, of coming before another painter and another era, like before Manet and Velasquez. The word "thicket" seems to come out of a gala evening in the 18th century, so unlike a painting of Chagall's, a contradiction of dreams, an incompatibility in reading it...yet, this word imposed itself on me, like a proposition drawn on a wall leading me

where I would not go by myself, the confidence of a vagabond, of a thief who knows, a strange kind of complicity. What did they want me to think? Where is that strange hand guiding me, with chalk or charcoal, this unfamiliar hand that is unveiling a secret to me? Suddenly light streams in: why didn't I think of it? The bouquet does not resemble the thicket, or vice versa. We are talking about another relationship, another parallel...another underground river. Now I remember a painter whose name is like his country, one who is haunted by the unreal, one whose country is full of thickets — Hieronymus Bosch. Everyone drags around his childhood like dead wood, and the thickets of Holland are hanging by the patronymic of this hell clearer, like the other one charts his way through the paths of exile from Vitebsk where he was born. And if rhyme is not for the ear, I certainly do not think it is for a play of words, or a geographical reference; but because nothing is closer to this unexplainable painter than the one I am talking about, and that Chagall resembles him as

Above Vitebsk.
1914. 27½x35½".
A. and S. Zacks Collection, Toronto.

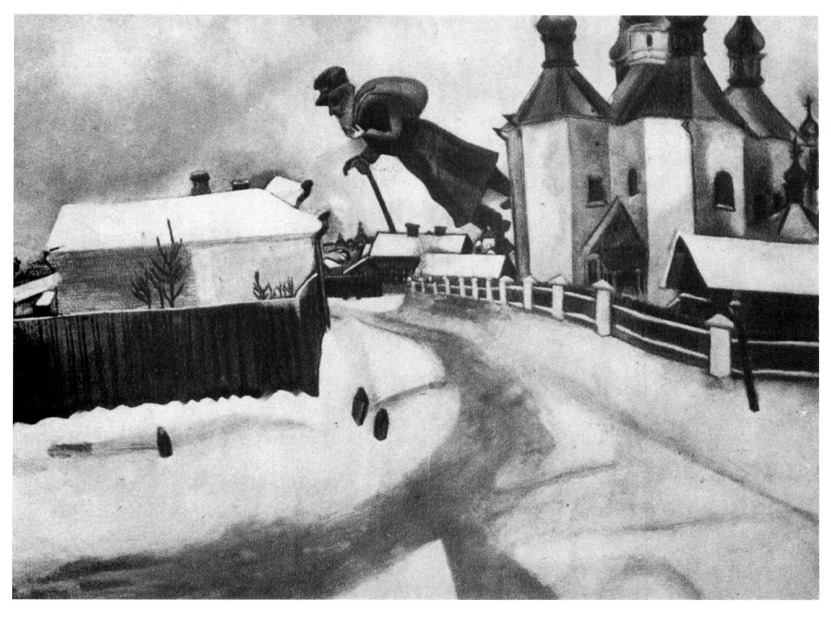

Feast of Purim.
Sketch for a mural. 1916.
Watercolor and India ink on paper.
18¾x25½". Private Collection.

well as Poussin, Corot...not that I believe I can in any way *justify* (in the typographical sense of the word) my painter by a precedent of centuries, but simply that this crystal echo traversing time and countries is making it difficult for me to resist tapping this blue glass, or this orange glass with my nail...All of this may seem arbitrary and purely gratuitous; I only wanted to point out, to underscore through a related perspective, the unique place that the painter Chagall occupies today, as Hieronymus Bosch, the painter of the impossible whose glory has erupted in our century, occupied in his own time. The time has come to break our eyeglasses and let the birds sing on the shoulders of blind people.

In the same way that a stone is set down at the threshold of a house about to be built, when the walls are still only plans, and the roofs are pure hypotheses, I chose to call this *Chagall, the Admirable*, a name which was given to a certain Ruysbroek formerly from Brabant. *Admirable,* as I write it here is meant to be pliable. I use it as an adjectival future, if, on behalf of the epithet, the verb can no longer enjoy the privilege of imagining the future. Not to cast this painter opposite another of his contemporaries, or of some future artist. But with all due respect, to the new iconoclasts...I want to place him at the beginning of a day that will never end.

The Dead Man.
1908. 27⅜x34¼".
Private collection.

Homme mort.
1908. 70x87 cm.
Collection privée.

My Fiancée in Black Gloves.
1909. Oil on canvas.
34⅝x25⅝".
Kunstmuseum, Basel.

Ma fiancée aux gants noirs.
1909. Huile sur toile. 88x65 cm.
Kunstmuseum, Bâle.

Self-Portrait with Brushes.
1909. Oil on canvas. 22½x18⅞".
Kunstsammlung Nordrhein-Westfalen, Düsseldorf.

Autoportrait.
1909. Huile sur toile.
57x48 cm. Collection privée.

18

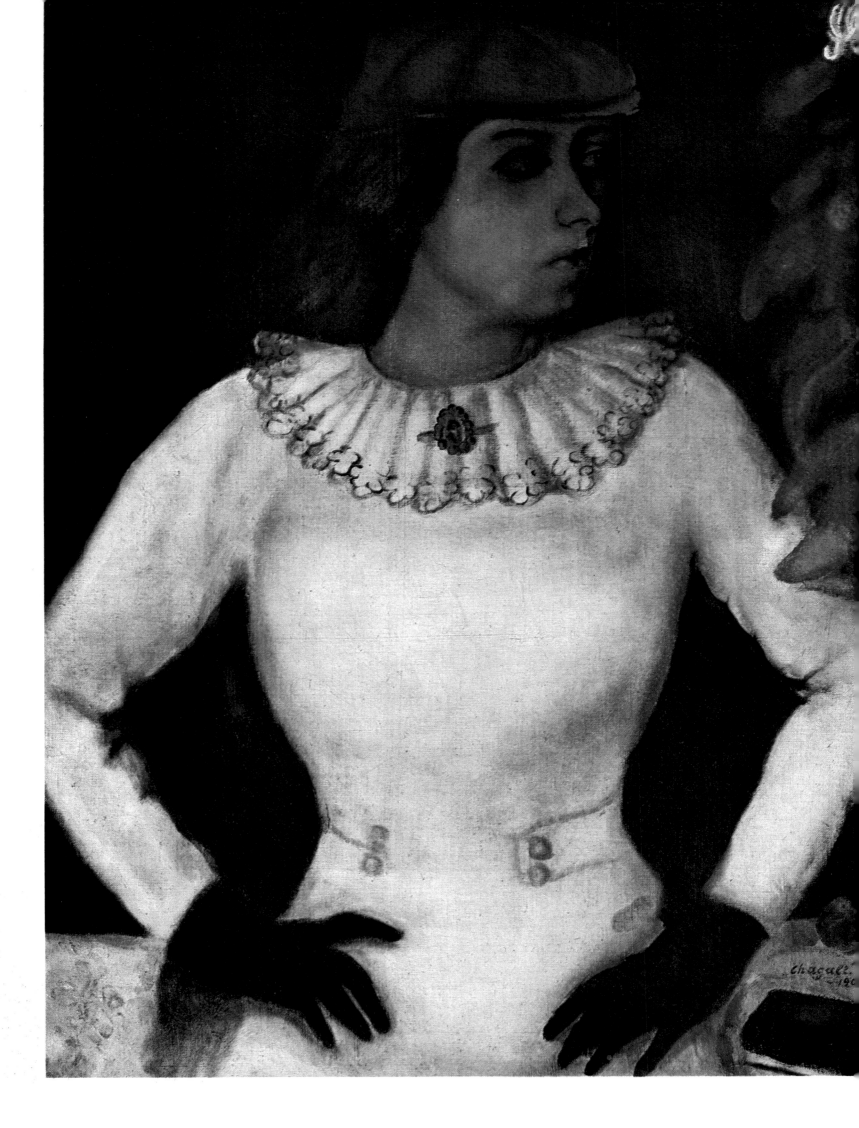

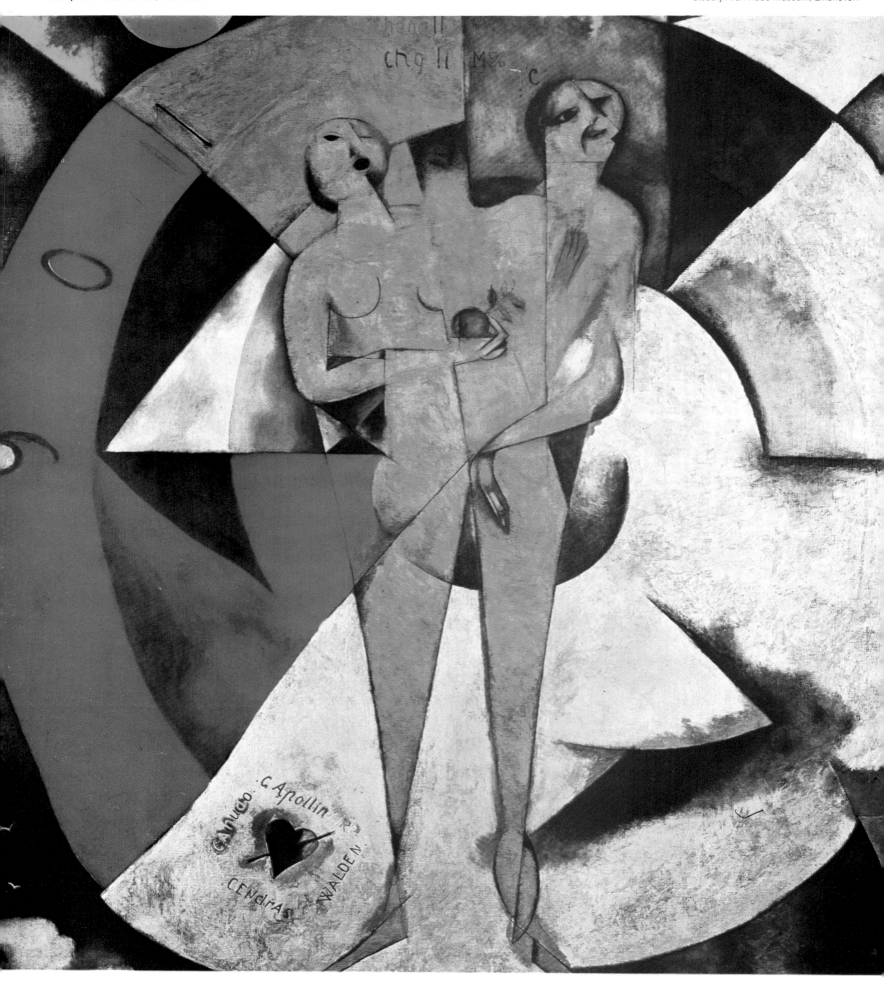

Homage to Apollinaire. 1911-12.
Oil on canvas. 82¼x78″.
Stedelijk van Abbemuseum, Eindhoven.

Hommage à Apollinaire. 1911-12.
Huile sur toile. 209x198 cm.
Stedelijk Van Abbe Museum, Eindhoven.

Apollinaire. 1911-12.
Ink and colored pencil. 10⅝x8⅝".
Private collection.

Portrait d'Apollinaire. 1911-12.
Encre et crayons de couleurs. 27x22 cm.
Collection privée.

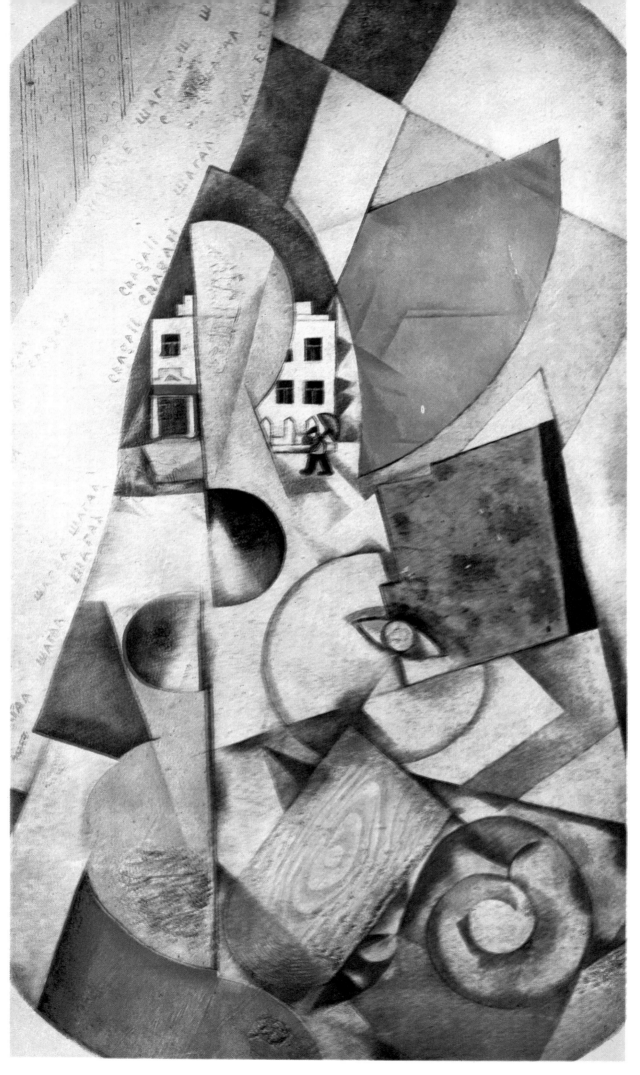

22

Cubist Landscape. 1918.
Oil on canvas. 39⅜x23¼″.
Collection Ida Chagall.

Paysage cubiste. 1918.
Huile sur toile. 100x59 cm.
Collection Ida Chagall, Paris.

The Poet, or Half-Past Three.
1911-12. Oil on canvas. 77⅝x57½″.
Philadelphia Museum of Art.
Louise and Walter Arensberg Collection.

Le poète ou half past three.
1911. Huile sur toile. 196x145 cm.
Philadelphia Museum of Art, Philadelphie.

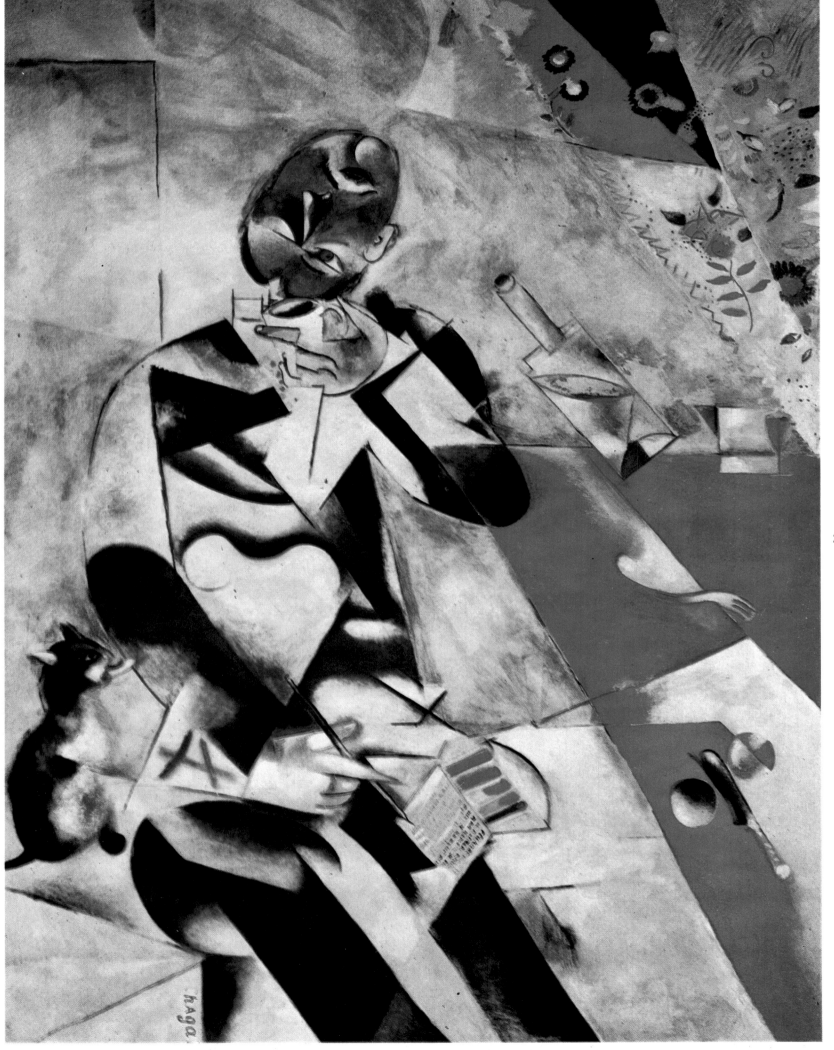

To Russia, Asses, and Others.
1911-12. Oil on canvas. 61⅜x48".
Musée National d'Art Moderne, Paris.

A la Russie, aux ânes et aux autres.
1911-12. Huile sur toile. 156x122 cm.
Musée National d'Art Moderne de Paris.

The Poet Mazin. 1911-12.
Oil on canvas. 28¾x21¼".
Private collection, Paris.

Le poète Mazin. 1911-12.
Huile sur toile. 73x54 cm.
Collection privée, Paris.

24

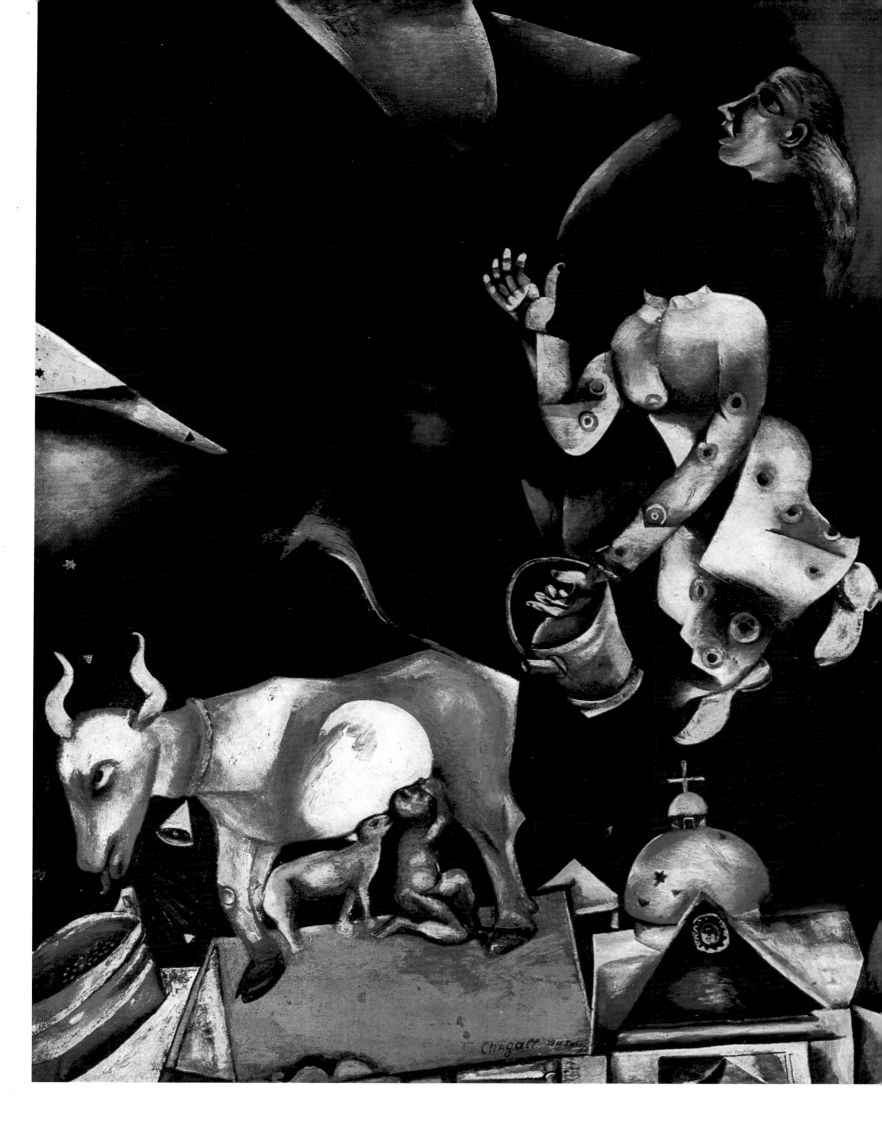

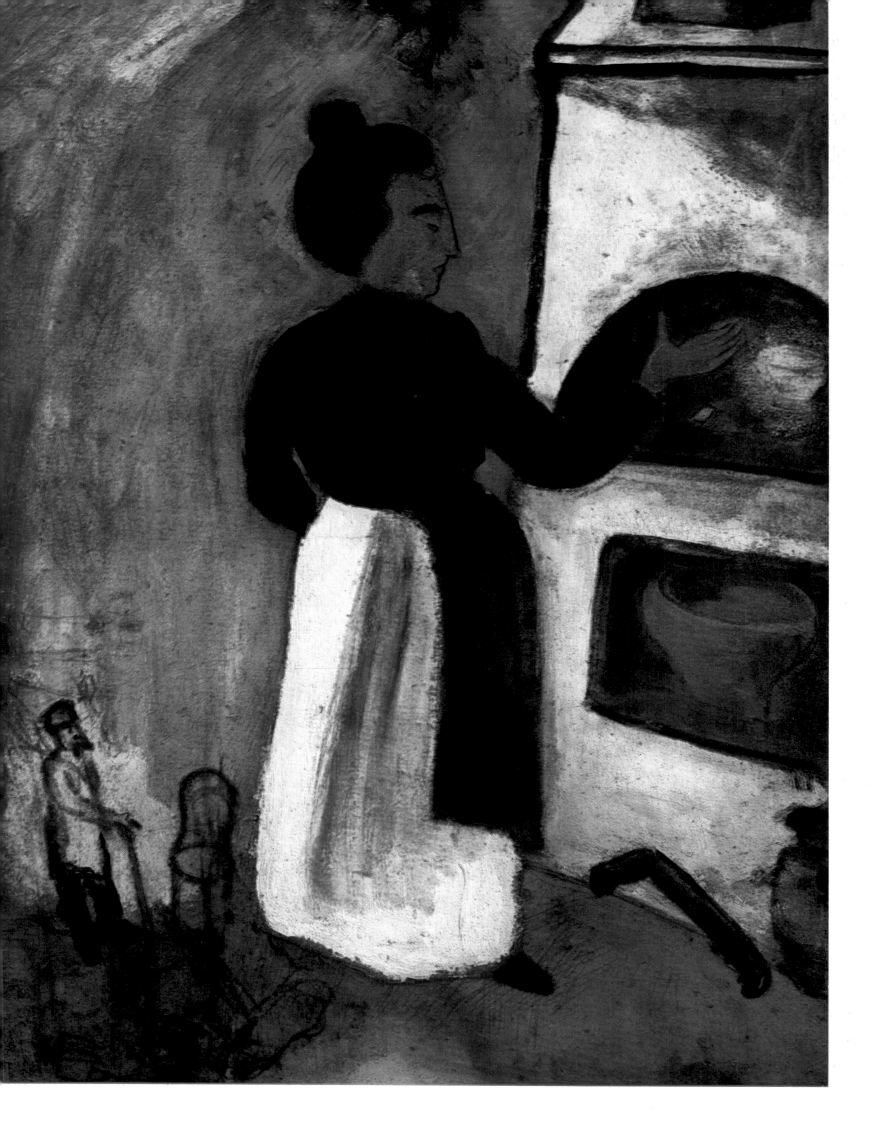

Mother at the Oven. 1914.
Oil on cardboard,
mounted on canvas. 24¾x18½".
Private collection.

La mère au four. 1914.
Huile sur toile. 63x47 cm.
Collection privée.

The Couple. 1909.
Oil on canvas. 35⅜x39⅛".
Private collection.

Le couple ou La sainte Famille.
1909. Huile sur toile. 102x90 cm.
Collection privée.

The Burning House.
1913. Oil on canvas. 42⅛x47½".
The Solomon R. Guggenheim Museum, New York.

La maison brûle.
1913. Huile sur toile. 107x120 cm.
Solomon R. Guggenheim Museum, New York.

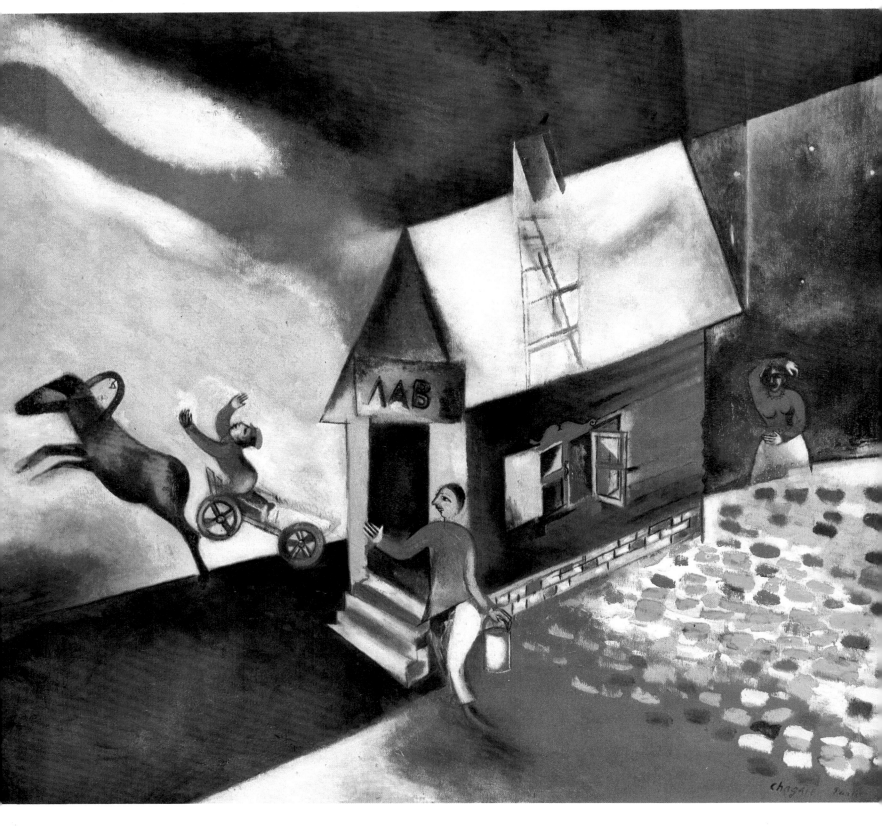

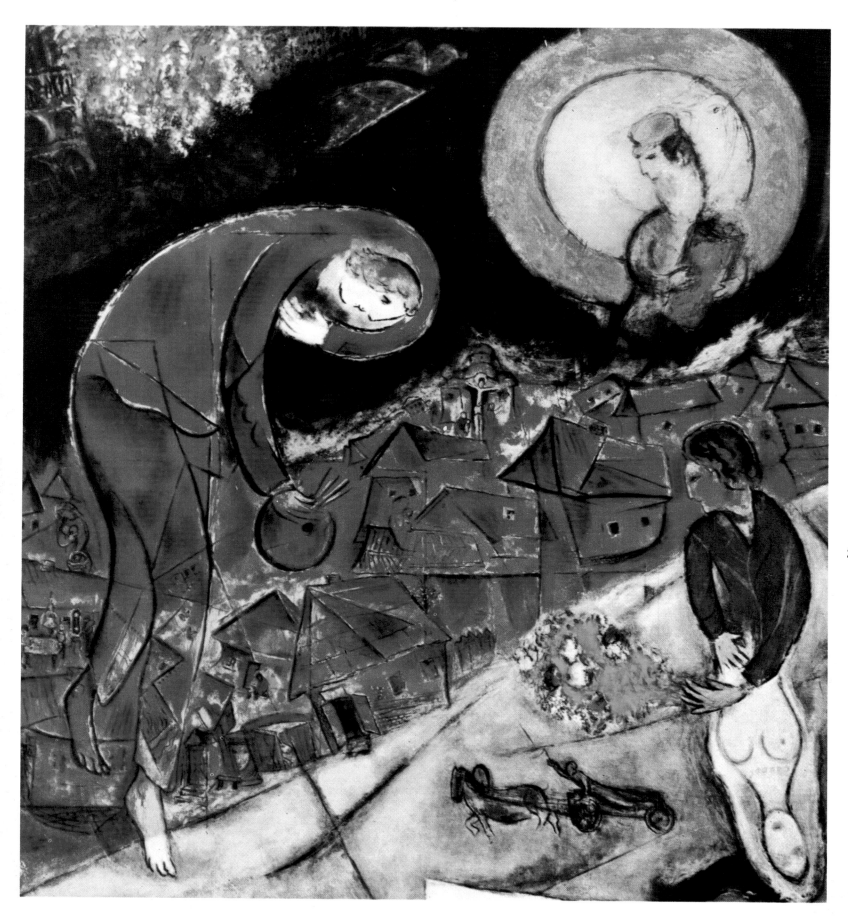

The Red Roofs. 1953-54.
Oil on paper mounted on canvas. 90½x83⅞".
Property of the artist.

Les toits rouges. 1953-54.
Huile sur toile. 230x213 cm.
Propriété de l'artiste.

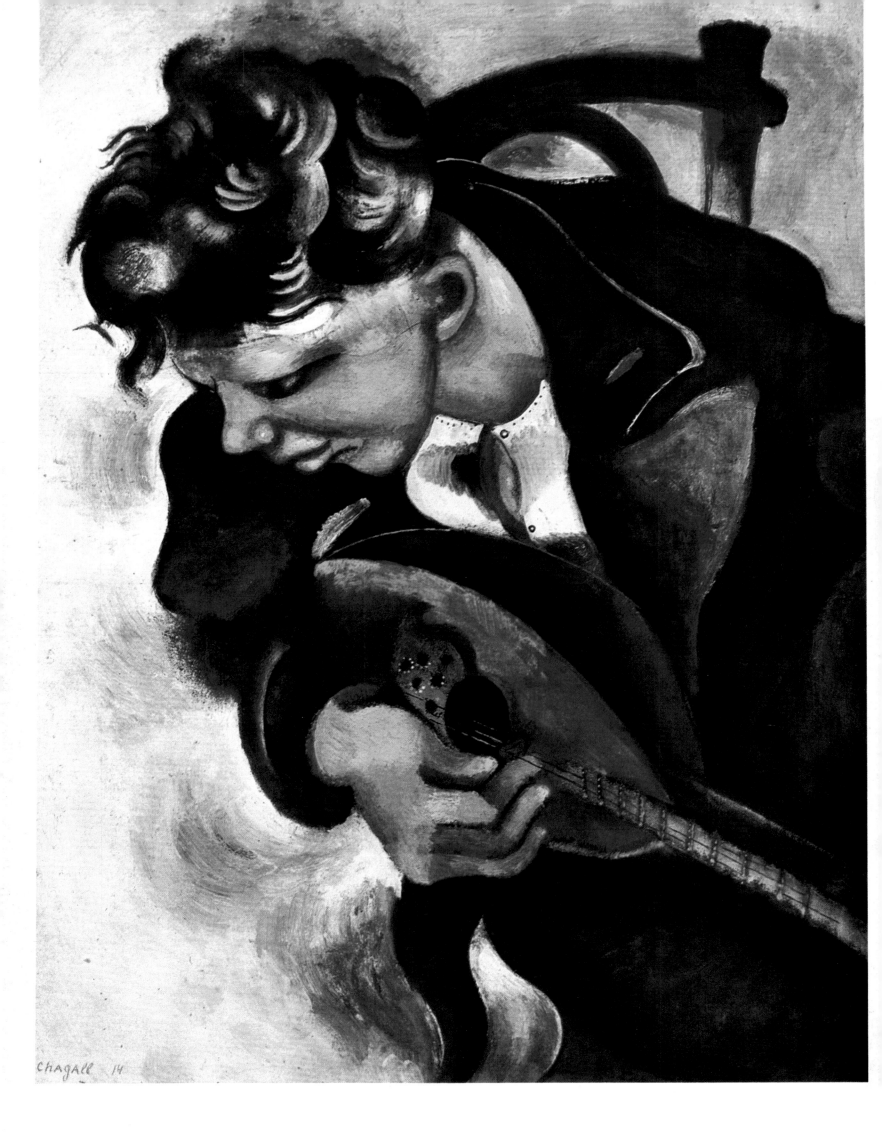

David. 1914.
Oil on cardboard. 19⅝x14⅞″.
Private collection.

David. 1914.
Huile sur carton. 50x37,5 cm.
Collection privée.

Lisa with Mandolin. 1914.
Oil on cardboard, mounted on canvas. 15x19⅝″.
Collection Ida Chagall.

Lisa à la mandoline. 1914.
Huile sur carton réentoilé. 38x50 cm.
Collection Ida Chagall.

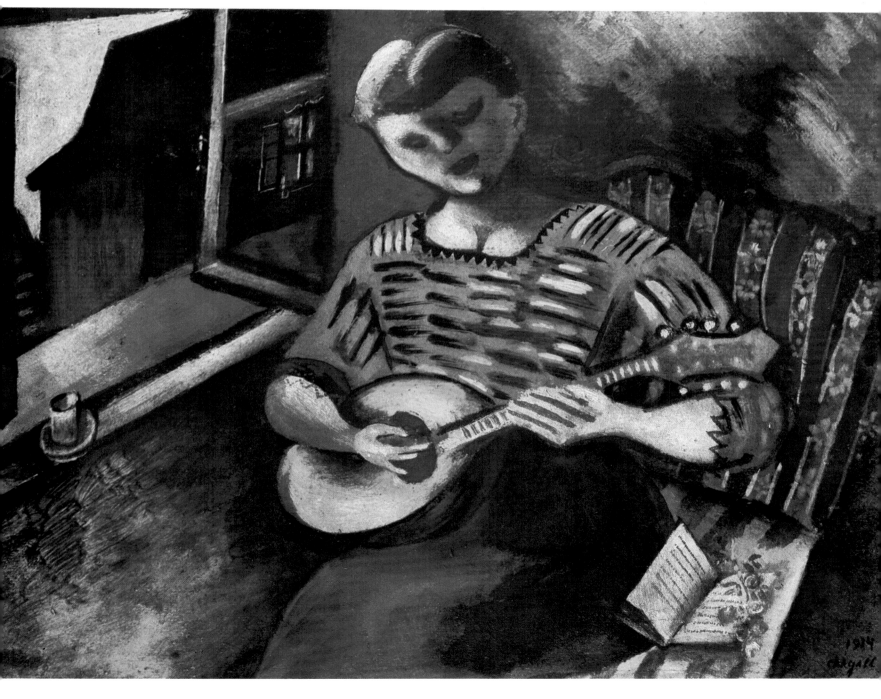

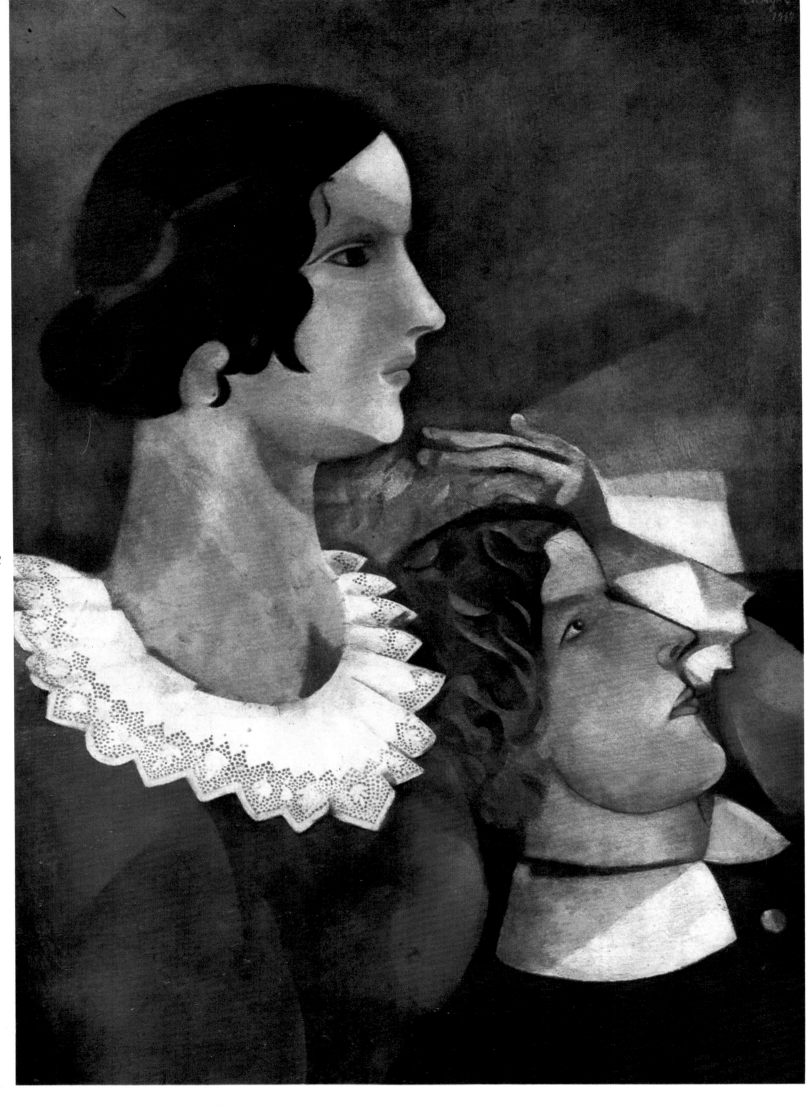

the russian years

Lovers in Gray. 1916.
Oil on cardboard, mounted
on canvas. 27⅛x19¼".
Collection Ida Chagall.

by manuel gasser

In his life and his creative activity, Marc Chagall's Russian years can be reckoned from his birth on 7 July 1887 to 1910, when he first went to live in Paris, then from 1914 to 1922, a good thirty years in all.

His first four years in Paris could also be considered "Russian" in some degree. Although this period had never been intended simply as an episode and although it was cut short by the outbreak of the first World War, Chagall was never more "Russian" than at the time of his first encounter and confrontation with the world of western Europe and its art. So considered, the "Russian years" take in the whole period of the artist's youth and development up to his thirty-fifth year, a portion of his life and of his artistic evolution in which he was not satisfied with laying down foundations for his work but in which he reached heights equal to the finest achievements of his future production.

The most important events of these thirty-five years are as follows:

Marc Chagall was born at Vitebsk in 1887 into a large family in modest circumstances. At that time Vitebsk numbered about fifty thousand inhabitants, of whom half, including Chagall's parents, were Jewish. The boy attended the communal school till the age of nineteen when he was apprenticed to Jehuda Pen, a portraitist and genre-painter of the town. A year later, he became a pupil at the school in St. Petersburg financed by the "Imperial Society for the Encouragement of the Fine Arts". In 1908 he left this academy for a private art school and finally worked as a pupil of Leon Bakst. The most important event of the following year was to be his meeting with Bella Rosenfeld, his future wife.

At the end of the summer of 1910 he went to Paris, where he found his first studio in the Impasse du Maine. The following year he moved into *La Ruche* ("The Beehive"), the studio city in which Léger, Laurens, Modigliani and Archipenko were working at that time. However, his most fruitful contacts were not with painters, but with two writers, Blaise Cendrars and Guillaume Apollinaire. Through Apollinaire he also met Herwarth Walden, the champion of German expressionism.

In the spring of 1914 Walden organised Chagall's first one-man show in his Berlin gallery, *"Der Sturm"*. On this occasion the painter visited the German capital and decided to go on to Vitebsk.

A few weeks after his return to Russia the war broke out, and it was no longer possible to think of going back to Paris. Chagall had to limit his horizons once again to the narrow provincial life of the little town on the banks of the Dvina. In the following year he married Bella Rosenfeld, daughter of a rich Jewish dealer in jewellery, clocks and watches. Shortly after his marriage he was called up and posted to a service dealing

The Studio in Narva.
1909. Watercolor and pencil.
11¾x9½". Private collection.
One of the first studios occupied
by Chagall in Russia.

33

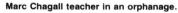

Marc Chagall teacher in an orphanage.

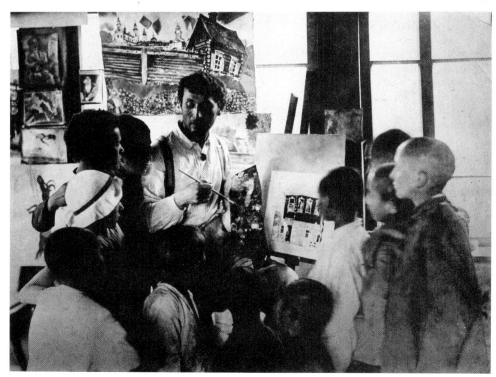

with war economy in St. Petersburg, where his wife was able to join him with their little daughter Ida.

In St. Petersburg Chagall frequented intellectuals and artists who were to play their part after the October Revolution: Demian Bedny, the friend of Lenin, Alexander Block, Maïakowski and Pasternak among others.

For Chagall the 1917 Revolution meant the entry into possession of all civil rights which the Tzarist régime had denied to the Jews. But besides this it aroused hopes that the boldest dreams of the young generation of artists could now be realised.

On Bella's advice the painter abstained from taking an active part in cultural politics on the Governmental level and retired with his family to Vitebsk. There he pursued an intense and diverse activity in the cultural sector; he was appointed Commissar for the Arts in the old government of Vitebsk, and charged with the organisation of art schools, museums, exhibitions, lectures and other manifestations.

He organised the celebrations of the first anniversary of the Revolution with a great display of flags, dioramas, triumphal arches etc.; in a former palace he set up a museum, a collective studio and an art school of which he was the director. But disillusionment was soon to follow this artistic springtime, so full of promise. Violent disputes broke out between Chagall's supporters and the "suprematists" led by Malevitch; Chagall offered his resignation, retired and definitely gave up his post of Commissar for the Arts in May.

Then he went to Moscow and for about a year devoted himself essentially to the theater.

Since before the Revolution he had designed decors for the producer Nicolas Evreïnov and later, for the Hermitage studio, he created sets for productions of the *Gamblers* and *Marriage* by Gogol, which, however, were never staged. This time all went very differently at the Jewish Arts Theatre of Moscow. Not only did he design the decors and the costumes, but also he decided on the style of the production and would not even delegate the task of making up the actors. And finally, and above all, he decorated the auditorium with a scheme of five mural paintings.

His last official activity in Soviet Russia concerned two colonies of war orphans; he taught drawing and painting to these abandoned children whom we saw come alive in the famous film *The Road to Life*. But relations with the bureaucrats concerned with culture grew more and more strained, and in the summer of 1922 Chagall, profiting from an invitation to exhibit his work in Berlin, left Russia with his family.

Now let us briefly consider the work he produced during these years.

In order to judge the originality of Chagall's first pictures and drawings it would be necessary

34

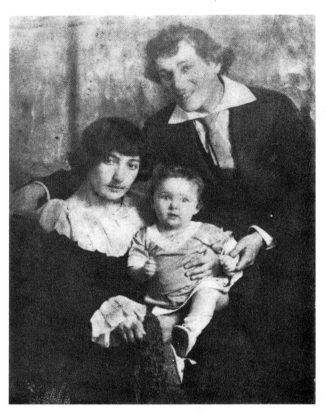

Marc Chagall, Bella and little Ida.

The Russian Soldier.
1912. Tempera. 15¾"x12½".

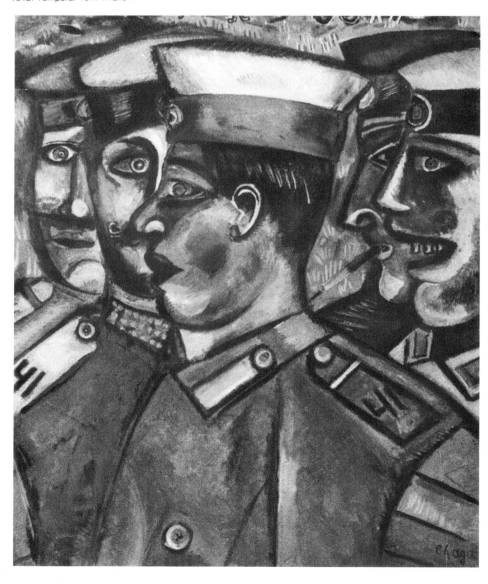

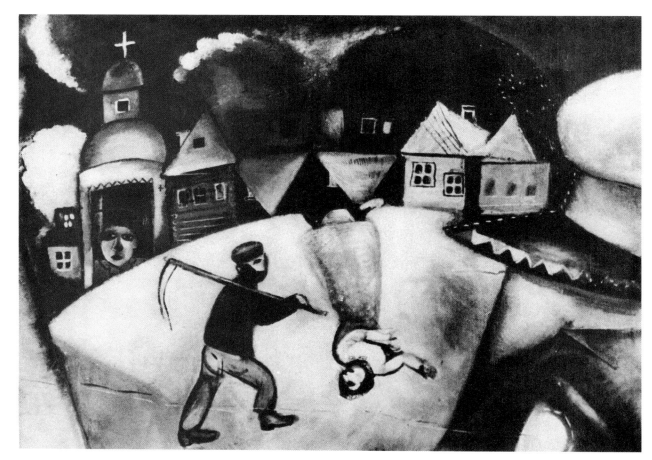

to have a precise acquaintance with the work of his first masters and friends. His originality, however, appears strongly in the water color *The Musicians* of 1907. Though the fantastic element, which was to occupy such an important place in his future work, is not yet present in this popular scene, yet the Chagall we know is already contained in the way in which the figures and their village setting are conceived.

This manner and this state of mind or atmosphere are manifest even more clearly in the canvas *The Dead Man* of 1908. And in the following year, the portraitist in Chagall is revealed in a picture which many connoisseurs consider his best portrait, *My Fiancée in Black Gloves*.

The earliest pictures he painted in Paris seem at first sight to break the continuity of a line so powerfully affirmed. Chagall had to find his measure among the artistic currents of his new environment and he tried out the new means of expression he had thus acquired on the usual themes: landscapes of Paris, still life subjects, interiors, portraits and nudes. But very soon the Russian and Jewish inheritance reappeared forcefully and these new paintings are directly related to the Vitebsk work.

Although the first impulses Chagall received in Paris came from the Fauves, he soon fell under a cubist influence too, but we cannot properly speak of a "fauve" period any more than of a "cubist" period in the work of Chagall, and a canvas like *Homage to Apollinaire*, while doubtless remaining an important episode, is by no means essential in the general evolution of the artist.

The most important event of this first Paris period is certainly the series of masterpieces which are all dated 1911, even if, as Franz Meyer, Chagall's biographer, has shown, all these canvases can hardly have been painted in this single year. The mere enumeration of six of these pictures will be enough to show Chagall's astonishing creative power at this period: *To My Fiancée, To Russia, to the Donkeys and the Others, The Cabman Saint, I and the Village, Self Portrait With Seven fingers, The Poet*.

After this long series of great pictures from Paris there followed, on his return to his homeland, a group of works which were partly intimate, partly contemporary in character—a development which is easily explained by the simultaneous occurrence of private happiness and war experience.

The state of mind of the happy husband and father is expressed in portraits, interiors and landscapes of deep lyrical content. The colors are delicate and exquisitely harmonious, the forms gentle and fluid; with a lover's care the painter has touched in the details of costume and setting of his models, so tenderly cherished by him. There is hardly a trace of the dramatic expression of his former scenes of popular and family life, of the demonism of a picture such as *To My Fiancée*. And when he clothes a beggar in the paternal prayer robe and phylacteries, he creates a masterpiece: *The Jew in Black and White*, so different from his old representations of the Jewish destiny, where power was charged with revolt. But in a later phase, in 1917 and 1918, the intimate and lyrical character of the portraits of Bella and the self portraits disappeared and in the paintings of couples, *Double Portrait With Glass of Wine* and *Above the Town*, the artist rediscovered the grand style of the masterpieces

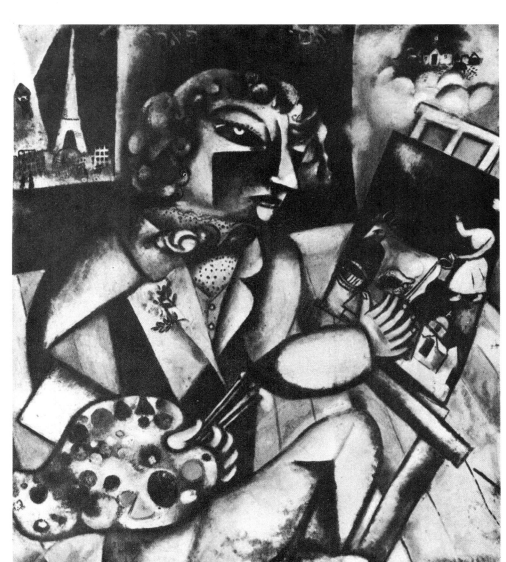

36

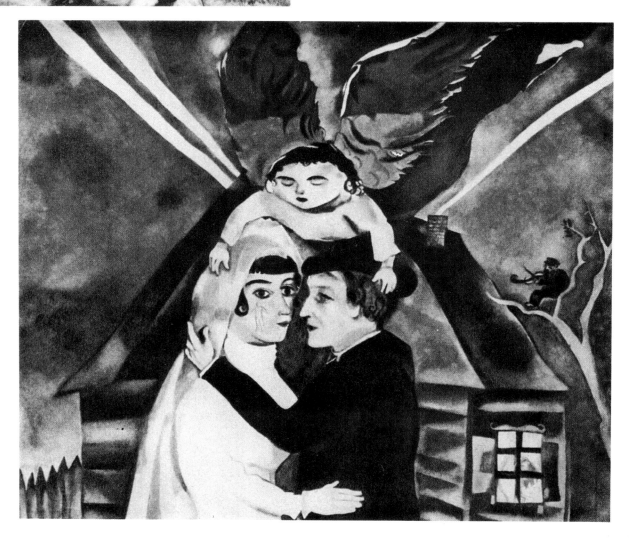

The Wedding. 1917
39⅜x46⅞″
Tretiakov Gallery,
Moscow.

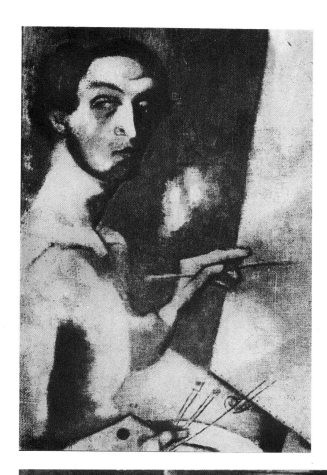

Self-portrait in yellow. 1914. 16½x28".
Ilya Ehrenbourg Collection, Moscow.

The Holy Coachman.
1911-12. Oil on canvas. 58¼x46¼".
Private collection, Krefeld

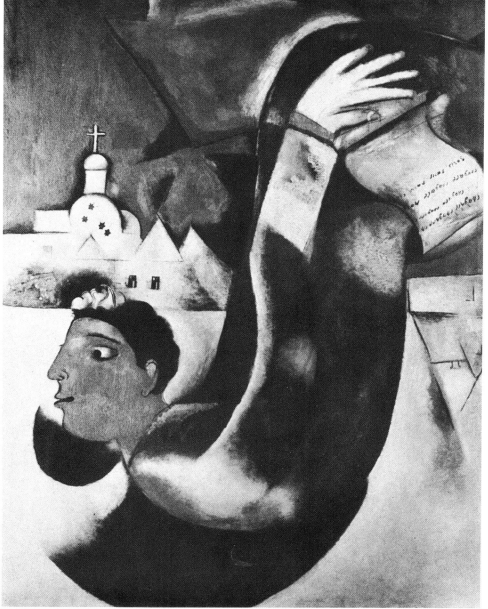

of 1911.

Running parallel to the portraits of the beloved woman and to other family pictures, there are works which testify to a very different inspiration. These are representations of soldiers, of wounded men and nurses, types and scenes which make us remember that Vitebsk was not very far from the front. They link up with those pictures of soldiers and policemen which played an important part in his early work and prove that the man in uniform, in the imagination of the painter, was of greater significance than simply as a picturesque figure.

In Chagall's work as a painter the five last Russian years occupy a fairly modest place, which is most understandable if we remember that he was in uniform for the first time and that later on, after the October Revolution, he was overwhelmed by cultural and administrative responsibilities.

On the other hand, Chagall's work for the theater during these years has assumed great importance. His sketches for decors and costumes are a turning-point in the history of the modern stage and his mural paintings made for the Jewish Arts Theater, the *Introduction to the Jewish Theater*, are numbered among his greatest masterpieces. In this decorative cycle which is the crowning achievement of the Russian years and one of the peaks of Chagall's whole work, we can see the rebirth in an astonishing and seductive manner of impulses absorbed from the cubists ten years earlier. In addition, these works, with all the related material, are not solely of interest to the historian of the art of the theater, they represent also a belated but nonetheless important chapter in the history of cubism.

MANUEL GASSER
Editor of "Du"

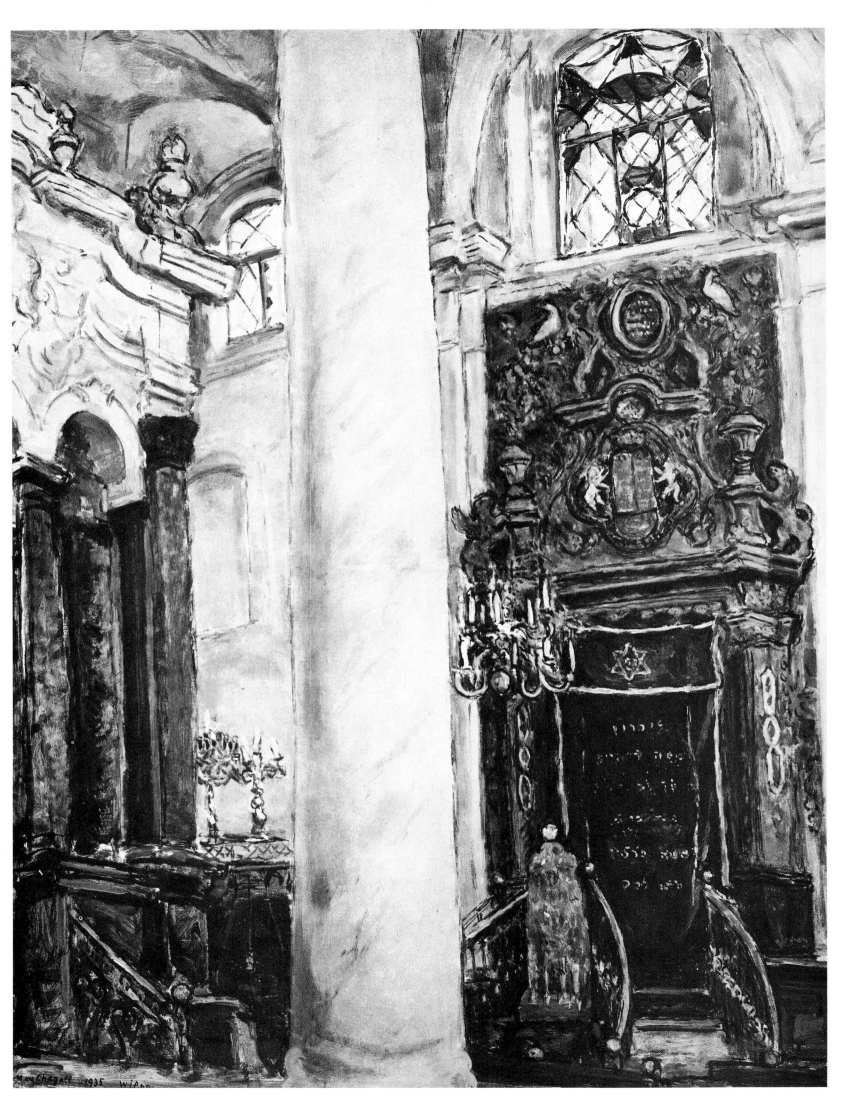

theater and revolution

by alain jouffroy

In August, 1918, Chagall was appointed Commissar of Fine Arts in the old "government" of Vitebsk.... The October Revolution was not yet a year old. Chagall immediately prepared to celebrate the anniversary in his hometown. Lounatcharsky, whom he had met in 1912 during his first trip to Paris, had himself been appointed Commissar of Popular Education and Culture at the end of 1917. He protected Chagall until the latter left Russia, procuring a passport for him so that he could depart in 1922 via Kaunas. This same Lounatcharsky approved, in April, 1918, the founding of the Vitebsk academy. The internal disagreements that stirred the academy, specifically those in which Malevich came into confrontation with Chagall, underline some of the major characteristics of the work of the master of the imaginary: indomitable individualism, antidogmatism and aloofness. Chagall's association with the academy he founded lasted eighteen months and can help us both understand his ideology and conception of painting and analyze the relationships of the first avant-garde Soviet artists with their own revolution. These eighteen months plus the last episode marking Chagall's stay in his revolutionary country—he taught war orphans for four and a half years, notably at the "Malakhovka" settlement—enable us, better than any other period in Chagall's life, to decipher his work in the light of his convictions, his reveries, his most personal needs. His friendship with Lounatcharsky, who also defended Meyerhold, was a decisive factor in Chagall's participation in the Russian Revolution between 1917 and 1922.

This is not the place to give in to our feelings about the differences and similarities between revolutionary *political* work and revolutionary *artistic* work, and we should avoid taking a particular intellectual position vis-à-vis the problem, no matter what. Whatever our own position on this subject may be, the facts are there, cataloged. They speak, and we must try to understand, to receive what they are conveying to us from faraway, across time. This is not the place, either, to decide if Chagall was right, in what concerns his work and himself, to act as he did during those four years, or to determine what influence his extraordinary destiny might have had on the history of ideas and forms. But we can underline, to start with, this *monumental* fact: an individualistic painter was confronted with a collective revolution, and he effectively participated, as a painter, in this revolution.

Chagall, doubtless on the advice of Bella (they were married in July, 1915), refused to participate in the so-called "Department of Culture" which, in the aftermath of October, was bandied about a bit and would have been made up then of Mayakovsky for poetry, Meyerhold for theater and Chagall for the fine arts. But this refusal, which perhaps took him away from Petrograd, where he lived at Perekoupnoï Pereoulok, not only brought him closer

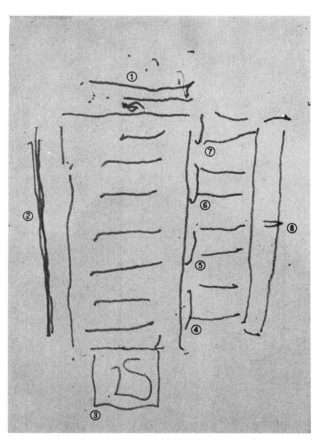

Sketch of Chagall showing the locations of the paintings that he executed for the Moscow Jewish Theater in 1920/21: 1 - Drop Curtain; 2 - Introduction to the Jewish Theater; 3 - Love on the Stage; 4 - Literature; 5 - Theater; 6 - Dance; 7 - Music; 8 - The Marriage Table.

39

to his hometown but also developed a sense of public responsibility in him: first he organized celebrations for the first anniversary, then he founded the academy. Hence, skirting the Department of Culture (which incidentally never took shape), he became involved in an even more generous social and cultural experience: the teaching of avant-garde painting in a country where everything was in the process of changing; the contemporary importance of this should not be underestimated. Personally, I feel that it concerns me, which is why, in this introduction to Chagall's monumental work, I have tried to situate him in his initial historical orbit.

The first artists that Chagall invited to come and teach with him were—along with his teacher Pen—the painters Lissitzky and Pougny; shortly afterward, Lissitzky asked him to invite Malevich. Everything opposed Chagall to the latter. Or almost everything. Yet Chagall accepted Lissitzky's proposal, despite his unconcealed hostility, since the advent of Cubism, toward every kind of "realistic" reduction of the image to abstraction. For Chagall, in effect, a triangle, a circle and a square are as much objects as a cross, a metronome or a chair. To the author of *Black Square on a White Background* of 1913, he said, for example: "A square is something I can sit on, you understand: a square is an object." In his interviews, writings, and even more obviously in his painting, he has never stopped evincing his hostility as much toward realism as toward abstraction: he has even completely assimilated one with the other. Which is simply a way of saying how much the presence of Malevich, the suprematist, in the academy he directed must have been unpleasant for him. Nonetheless, to satisfy his friend Lissitzsky, who admired Chagall a great deal but soon would yield to Malevich's point of view, Chagall invited him. This is an indication of his freedom, of his independence in regard to himself; he is against every kind of dogmatism, beginning with any that he might be able to draw out of systemizing his own ideas. But in 1919, at a time when Chagall was in Moscow, Malevich took control of the academy and completely transformed it, without the consent of the professors' committee. On the door he even replaced the words "Free Academy" by "Suprematist Academy." Chagall then sent his resignation to Lounatcharsky, but after a few discussions he changed his mind and continued directing the school until 1920.

He had a triumph in April, 1919, in the old Winter Palace, which was changed into the *Palace of the Arts* for the first official exhibition of revolutionary art: the two entrance rooms were devoted to him through June, and the State even purchased a dozen of his works. Immediately after the October Revolution, he had painted a few large autobiographical pictures celebrating his love for Bella: *The Double Portrait with Wineglass, Over the Town, The Apparition* and *Promenade*, in which Bella is painted as his own flag, his emotional oriflamme. Here the flamboyant individualism of Chagall clearly erupts. And yet these same pictures carried Chagall's youthful glory to the center of the palace that had been won by the Bolsheviks. Of course, this didn't happen without jealousy and intrigues: they are inevitable, especially around such a precocious triumph and in a period as electrified as that one.

Chagall, in 1917, was just thirty, and the beauty of the couple he formed with Bella had, it is said, something provocative about it. When he was organizing the celebration of the first anniversary of the revolution in the streets of Vitebsk, an official critic spoke about a "mystical and formalistic Bacchanal," simply because cows were floating with violinists above the roofs. But the identification of

40

Marc Chagall and his wife, Bella.

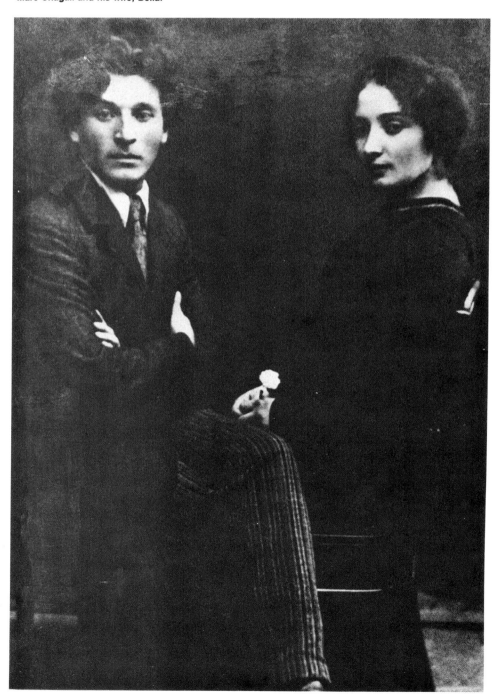

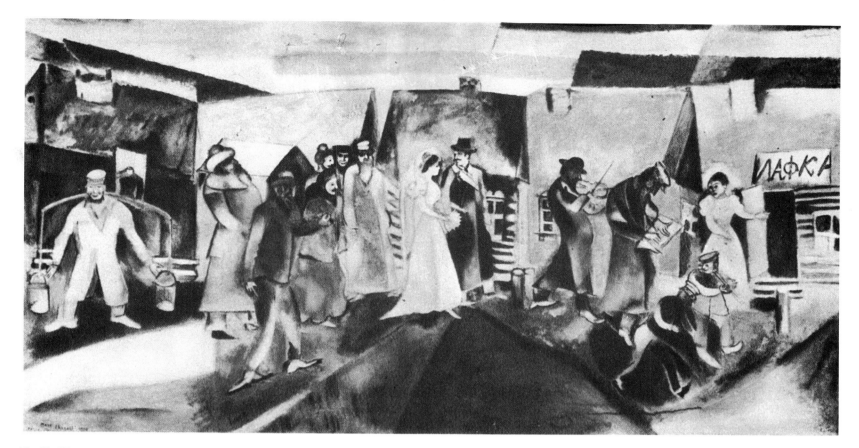

The Wedding.
1910. 38½×74″.
The artist's collection.

revolution with the festival, with individual liberty and love, cannot be doubted: the sketches he made on this theme in 1937 develop, allegorically and retrospectively, this first experience. So we can say that if Chagall participated despite his political unpreparedness in the world's first socialist revolution, it was not through intellectual and political adhesion to the theories of Marx and Lenin, but through a sort of enthusiasm for the physical rotatory movement that in his pictures makes couples revolve and fly above the horizon.

Like the planets around the sun, Chagall incessantly returns, flying and revolving, to his point of departure, and I will not scandalize anyone by affirming, in his place, this totally cosmic conception that he has of revolution. The history of the world, for him, is only constructed of the dream of the individual, who discovers and loses himself in it and rediscovers love. Man only engages in history to recognize, to find all of himself; but if history should dispossess him of the image he has forged of himself, then he ceases being able to participate in it. In fact, it is as if that were what finally convinced Chagall to break away from his country and come back to live in Paris, where another revolution was waiting for him, over whose birth he secretly presided through the intermediary of Apollinaire: Surrealism. Thus, from the red freight cars in which he travelled in Russia with Bella and little Ida to the great intellectual upheaval prepared by Parisian Dadaism,

Chagall was one of the first and few to have established the fragile link that binds, in the thoughts of men as in the nerves of poets, the political avant-garde of the Russian Revolution with the diverse artistic and poetic avant-gardes whose heirs we are today, namely, Futurism, Constructivism, Dadaism and Surrealism. If this link has been dramatically severed, it is not just on account of his leaving Russia: the artistic revolutionaries in power have, in their own way, renewed the classic Platonic exclusion, which consists in chasing the poet out of the city. In 1922, Chagall simply drew this lesson from the experience to which he had given himself wholeheartedly for more than four years with that kind of candor and vertigo inspired by success, friendship and love. He lived with the sacrifice of his own ideas to the point of giving lessons to war orphans and accepting to be treated like a "third-rate artist" by a committee composed of the greatest names of avant-garde Soviet painting. The difference between his personal avant-garde and that of the others perhaps constitutes the invisible key to his departure from Russia. Sectarian intolerance, intellectual fanaticism à la Malevich, perhaps triggered by a ricochet effect, the blind reaction against realism—to which, as we know now, the same Malevich finally yielded—thereby confirming the presentiments and intuition of Chagall, who always identified abstraction with realism and even told Malevich so to his face.

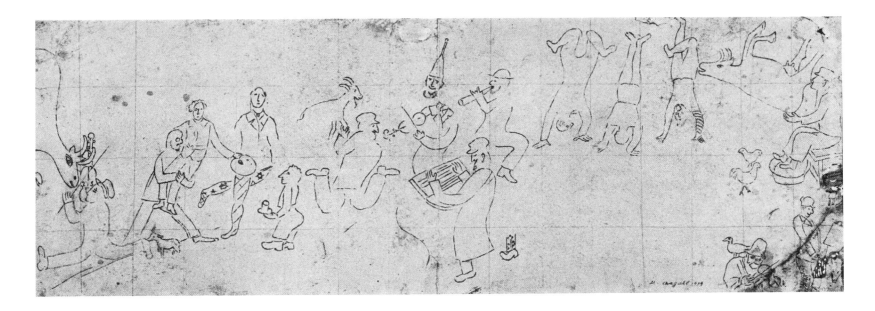

From Theater to Festival via Revolution

Not only does Chagall identify revolution with a festival, but he also associates theater with festival and revolution. This should be clear if we compare the first sketch for the *Introduction to the Jewish Theater* with the 1937 sketches for the *Revolution* itself. He painted the *Introduction* sketch at Vitebsk for the Kamerny Jewish Theater, which in 1920 was installed in a Moscow apartment with a capacity of ninety seats, and where Chagall painted the sets for three plays by Scholem Alei-chem: *The Agents*, *Lie*, and *Mazeltov*. The final picture *Introduction* like the sketch, is a fresco over twenty-six feet long and nine feet high, hence the most monumental painted work by Chagall. Today it forms part of the reserves of the Tretiakov Gallery in Moscow, but like the four pictures *Music*, *Dance*, *Drama*, *Literature* he did for the same Kamerny Theater, the large still-life *The Marriage Table* that faced the *Introduction*, and the background picture entitled *Love on the Stage*, these works are not accessible to the public. We can only wonder in what kind of a state they are today (they were sized) and hope, along with the rest of the world, that they can be restored. Their historical importance, comparable to that of the Cubist pictures on display at the Hermitage in Leningrad, would in itself provide enough justification for this. Yet they were not included in the Chagall exhibition at the Grand Palais in 1969, a fact all his admirers regretted.

It is all the more regrettable because this theater/festival/revolution association I have just mentioned might make it possible to reinterpret Chagall's work in a new perspective and quite another light than hitherto. Chagall did not wait for October '17 to paint theater sets: Nicolas Evreï-nov, an old friend of Meyerhold, had asked him to do those for a play he himself wrote (*To Die Happy*), which was to be put on in a sort of cabaret-theater located in a cellar not far from the Winter Palace, a place oddly called the Place de la Concorde, where Mayakovsky came from time to time to *spit* on the public. Thus, even before the Revolution, we can see that this explosive contact was operating—Mayakovsky/Winter Palace/Chagall/theater—in which I see, secretly introduced,

42

Love on the Stage.
1920/21. Tempera and gouache on canvas.
110¼x96½". Mural for the back wall of the
Moscow Jewish Theater. State Tretiakov Gallery, Moscow.

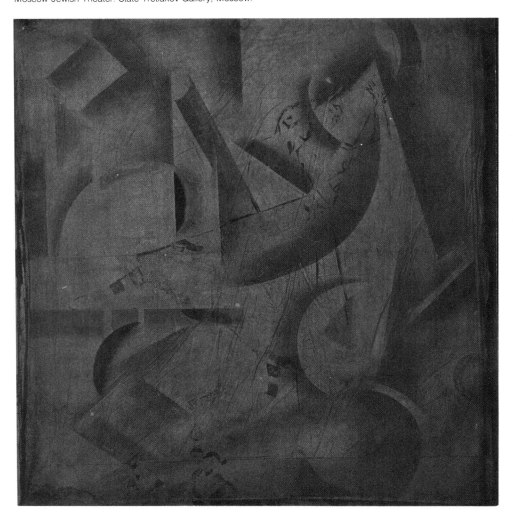

the most enigmatic fuse of the bomb. There was enough converging, in any case, so that the painter of the *Decapitated Poet* could enact with that band of itinerant actors, that *prival kommediantov* which included Block, Essenine, Mandelstamm and Mayakovsky, a preview announcing not only the future victory, but the forthcoming diaspora of the revolutionary intelligentsia.

The Enemy of All Systems

Chagall detested the "psychological realism" of Stanislavsky, preferring the novel ideas and explorations of Taïroff and Meyerhold. But his hostility to Stanislavsky's realism led him into difficulties after the Revolution. Wachtangoff, a well-known student of Stanislavsky and director of another Jewish theater, the "Habima," invited Chagall to collaborate on the set designs for Anski's *Dibbuk*. Chagall was particularly happy about this since Anski, like himself, was from Vitebsk; but when he presented his project, Wachtangoff opposed it: "All your acrobatics and tricks are nothing," he told him, "there's only one path and that's Stanislavsky's." Chagall, who, as we have seen, wouldn't accept any kind of dictatorship, pounded on the table and cried, "You'll end up copying me anyway," and then left. Wachtangoff later tried, in effect, more or less openly to imitate Chagall, whose work and cult were preserved in Russia for a few years after his departure, until the Kamerny Jewish Theater was shut down during the darkest years of Stalinism. But we can see that Chagall's enemy between 1917 and 1922 was less the bureaucratic and authoritarian spirit of the politicians than the sectarianism of the avant-garde artists themselves.

Apollinaire—who had pronounced the word "supernatural" in 1913, in Chagall's studio in Paris, who would later invent the word "surrealism," and

to whom Chagall rendered one of his biggest and most beautiful homages, a picture he had begun to paint in 1911—evaluated Chagall correctly when he wrote in the *Intransigeant* (April, 1913) that "Chagall reveals a curious and tormented spirit" and specified in 1914: "He is an extremely varied artist, capable of monumental paintings, and he isn't troubled by any system." It could not be better put, if we recall that it is precisely systems that Chagall has fought most violently his whole life; and nothing sheds more light on his behaviour during the years of the Russian Revolution, both at the Vitebsk Academy and among the theatrical world of Moscow: he fought Malevich who had joined forces with Lissitzky, as well as Wachtangoff and the partisans of Stanislavsky.

Lenin the Acrobat

It was Alexis Granovsky, Director of the Kamerny Jewish Theater, who accorded Chagall the freedom he needed to fulfill his potential. We must compare the large-scale pictures he did for this theater with the *Revolution* sketches of 1937 if we wish to understand the analogies Chagall perceives between the social upheaval of a festival and that of a revolution. An attentive comparison of the actors in the *Introduction to the Jewish Theater* with that picture which Chagall destroyed in the United States after Bella's death during one of the crises of doubt that have occured rather frequently in his life, reveals at once the most glaring fact: Lenin, standing on one hand on the corner of a table, plays the equilibrist just as do the actors of the Kamerny Theater who are portrayed not far from the musicians. This posture of Lenin, contrary to all the iconography that has accumulated around the leader of the Russian Revolution, in a way makes the history of the world dance, literally turns its meaning upside down: people dream on

The Revolution.
Study for the large picture that was executed in 1937 and later divided into three pieces. Oil on canvas. Property of the artist.

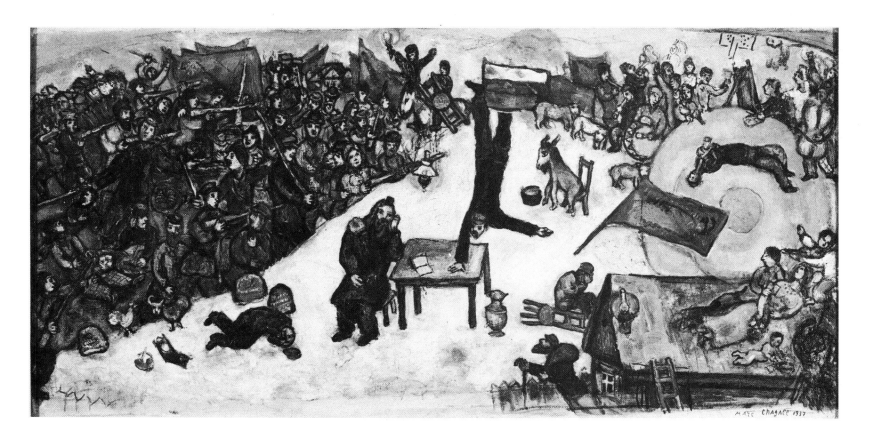

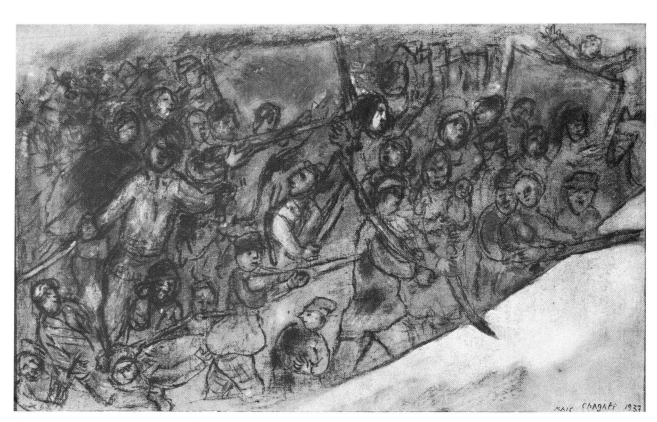

44

Study for the left panel of **"The Revolution."**
1937. Property of the artist.

Study for the central panel of **"The Revolution."**
1937. Property of the artist.

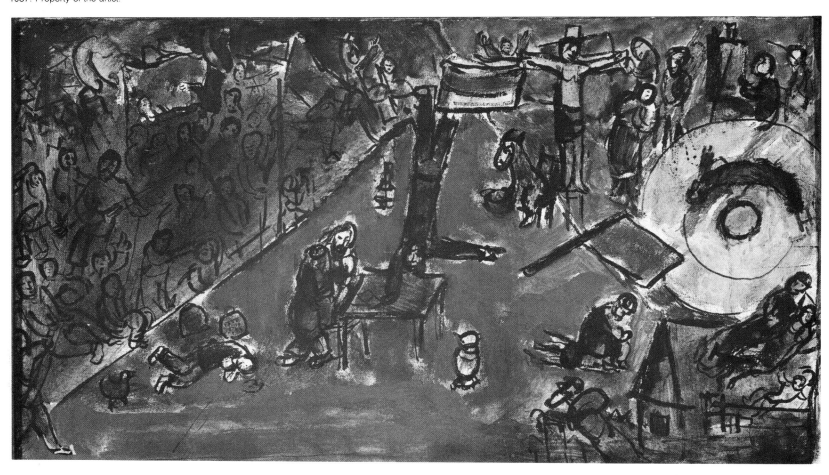

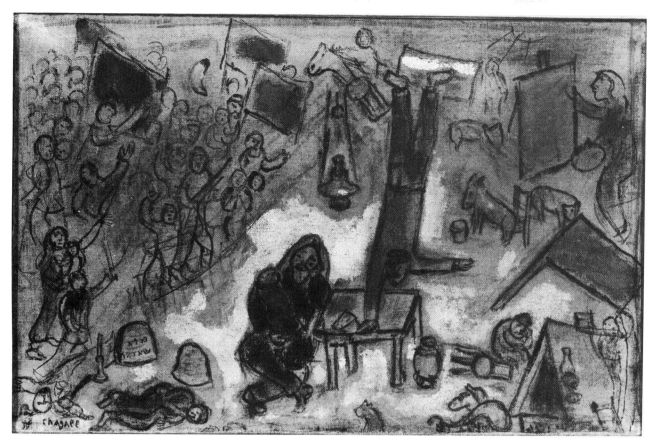

Study for **"The Revolution."**
1937. Property of the artist.

Study for **"The Revolution."**
1937. Property of the artist.

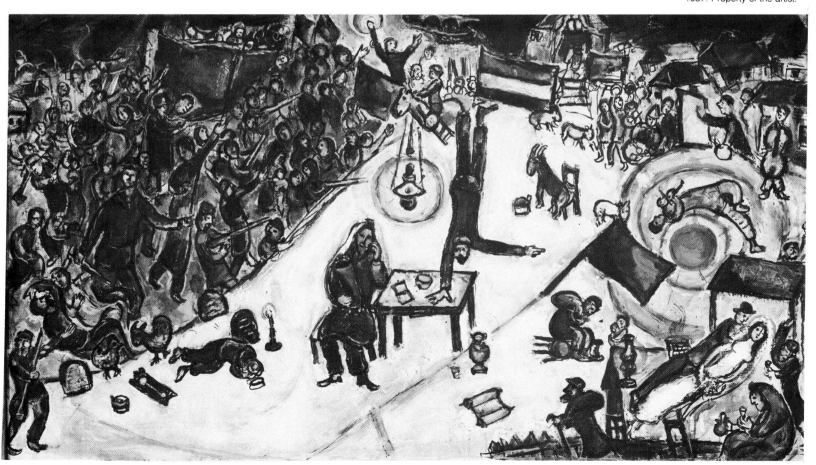

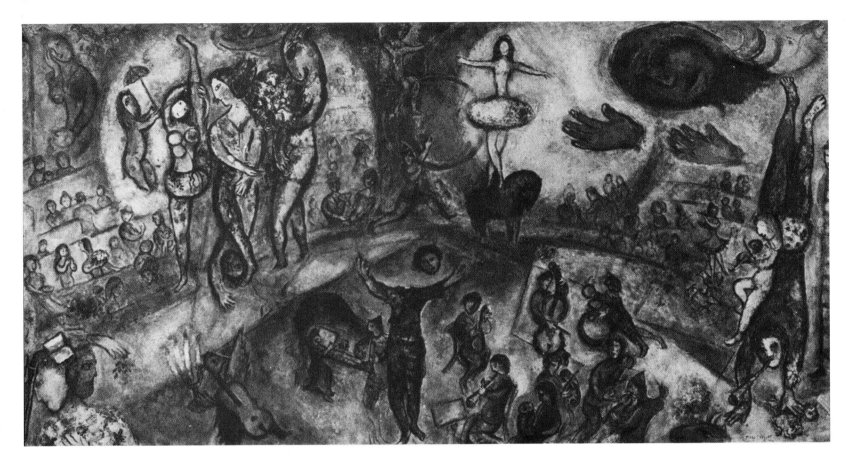

The Big Circus. 1956.
Oil on canvas. 59x127⁄8″. Gustav Stern
Foundation, New York.

the earth, or play the violin around a sun that has fallen to the earth, while a donkey sits patiently on a chair. The armed masses, gathered under the red flags, look at the spectacle of Lenin the equilibrist as if he were a great actor, I was about to say the actor Michoëls, the most fervent Chagall enthusiast at the Kamerny Theater. In the two compositions, the oblique space is the same and the figures are placed as though in a parade or anniversary celebration in the street. Chagall perhaps remembered the one he organized himself in 1918 in Vitebsk.

In spite of his success at the Kamerny Theater, Chagall was unable, among the sets and costumes he designed for the theater before leaving Russia, to do those for the *Players*, Gogol's *Marriage*, Synge's *Playboy of the Western World*, and Anski's *Dibbuk*, which Wachtangoff had turned down in '21. Only the sets and costumes for Gogol's *Revizor*, which Razoummy, the director of the "Satirical and Revolutionary Theater," had gone to Vitebsk to ask him about, were completed; Chagall says somewhere that they were very "amusing." A few of his designs have survived however; in particular, the set for *The Playboy of the Western World* in which a silver Christ, hanging upside down from a thread above an immobile golden calf, was to have revolved continuously throughout the play. But this Christ, after fifty years, turns in the same darkness, the same emptiness in 1972, as it did in Moscow in 1920 and '21, exactly as if

it had never existed for anyone except historians and Chagall connoisseurs.

The *Introduction to the Jewish Theater* is still the Chagallian archetype of the allegorical representation of the life and role of the creator, artist and poet in society. As one of his exegetists says on this subject: "The circus and art lead to nothing but are everything." Thus *The Big Circus* of 1936 picks up the themes of the picture of 1920-1921 in which the strolling acrobats extended an invitation to the festival by standing the world on its head. In the *Introduction*, it is the head of the central violinist that flies away; in *Absinthe* (1913) it is that of the poet; and in *The Big Circus*, it is that of the orchestra conductor. As to the figure walking on his hands at the right of the *Introduction*, he can be seen as following the acrobatic troop of the Jewish Theater; it is as if Lenin, in the *Revolution* of 1937, were only one of the travestied acrobats from the Jewish Theater or the circus, a reinventor of the world, a clown of history. The world, for Chagall as for Jarry, is nothing but its own parody, its mask, its double, but at the same time this double, this travesty, unveils its truth. The game creates the beauty, and if the game should stop, death alone would triumph.

The continuity we can decipher in the *Introduction to the Jewish Theater*, *The Big Circus* and the *Revolution*, defines the omnipotence of the Chagallian dream, which refuses to barricade the frontiers between domains that everyone separates: love,

reality, society, poetry, revolution, the circus. In any case, painting enables him to unify, to reconcile what daily life everywhere fragments and opposes. Painting saved Chagall from misery and the unhappiness of living, but above all it permitted him, as at the time of the first anniversary of the Revolution when he dreamed "of transforming ordinary houses into museums and the vulgar inhabitant into a creator,"[1] to connect painting to the history of the world rather than to the history of forms. Certainly, the circus, the theater, revolution "are not life," but precisely what makes it possible to act out, illumine and change life. For Chagall, painting was only the instrument of this transformation: treating one or the other subject, he recaptured all his dreams. That is why the *monumental paintings* that Apollinaire felt Chagall "capable of" in 1914 principally deal with the major, constant theme of this identification of painting with mental revolution and theatrical play, and of this play with life. The pictures of the Kamerny Theater make it possible to establish historically this general interpretation of Chagall's entire work. Their remoteness is therefore all the more meaningful.

Perhaps we should take the fact that most of the sets Chagall designed in Russia are still buried in boxes or cellars, if they have not simply disappeared, as a sign. The picture of the *Revolution*, which Chagall exhibited at Zervos's, then at the Pierre Matisse Gallery in New York before tearing it up into three pieces, also indicates, by its symptomatic presence/absence, the drama that binds, releases and then connects Chagall anew to the history of this country and the revolution he began by applauding. Like his works, the private storms of his life coincide with those that have for the longest time shaken artists and poets throughout the world. The work and life of Chagall can be thought of as a parabolic mirror of the intellectual history of the twentieth century whose principal events he has lived through, endured and surmounted. With this mirror, he has erected one of the most enigmatic monuments to freedom and the imagination.

Today, Chagall is as old as Juan Gris would have been. In one breath, so it seems, he has responded to Mayakovsky's wish that he keep on "chagalling like Chagall"; he has stridden across the twentieth century.[2]

The point of all this is simply that the theater represented for Chagall the most direct intermediary between himself, the world and history. His painting inaugurated a revolution that encountered and intersected the start of a social revolution but that could never identify itself with the State the

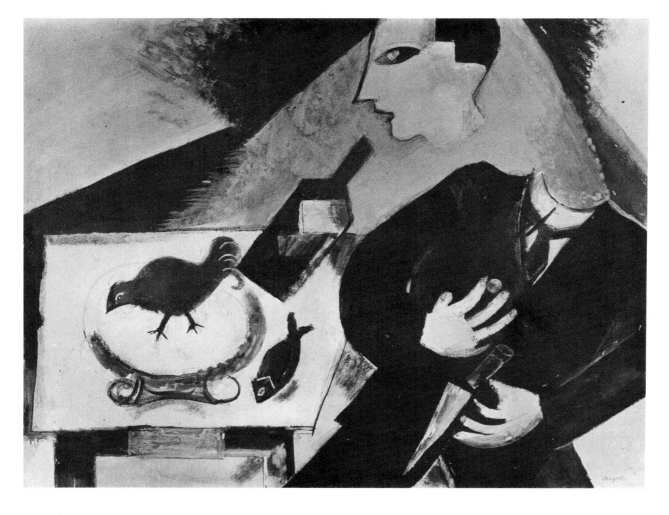

Absinthe. 1913. Gouache on cardboard. 17¾x20½". Private Coll.

My Life.
1964. Oil on canvas. 116½x160".
Maeght Foundation, Saint-Paul-de-Vence.

revolution gave birth to. And yet power fascinates Chagall insofar as it is related to the secret disturbance of his work. Painting allows him to see the world as *a stage* on which, as in the circus, the collective forces are travestied. In the center of this whirlwind he sees himself as the poet *who has lost his head*. There is no authority in the world capable of convincing him that he could not lose it, as the exuberant fantasies of his pictures prove.[3]

Postscript

"I am always crazy," Chagall said to the Soviet Minister of Culture, Mrs. Furtevsa, during his trip to the Soviet Union last June. It was his first visit to the country of his birth since 1922. The occasion for the trip was an exhibition of sixty-four lithographs and five paintings by Chagall that were shown at the Tretiakov Gallery in Moscow, but the Soviet press buried any mention of this event in the back pages of the Pravda and Izvestia. There was, however one surprise: he was allowed to see the paintings that he did for the Jewish Theater. Yet one can only regret that Chagall's "craziness," which testifies in every respect to a certain quality of experience and knowledge, failed to inspire some Soviet acknowledgement of the necessity of an individual madness in the increasingly stifled sphere of "culture."

[1] *My Life*, by Chagall.
[2] "Chagall," in Russian, means "to take long strides."
[3] Cf. *Théâtre et révolution*, by A. V. Lounatcharsky (Paris: Editions Maspero, 1971).

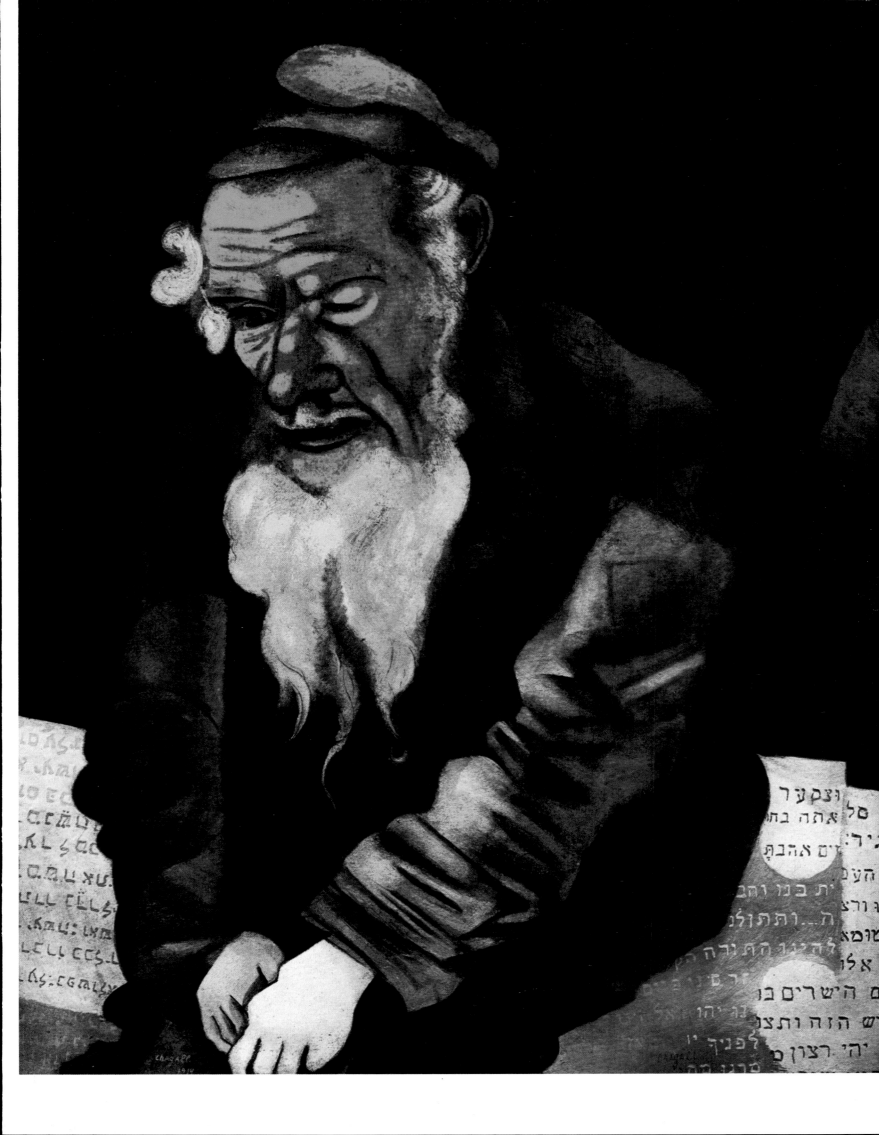

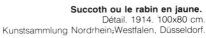

Succoth.
Detail. 1914. 39⅜x31⅝".
Kunstsammlung Nordrhein-Westfalen, Düsseldorf.

Succoth ou le rabin en jaune.
Détail. 1914. 100x80 cm.
Kunstsammlung Nordrhein-Westfalen, Düsseldorf.

Jew in Black and White. 1914.
Oil on cardboard mounted on canvas, 39⅜x31⅞".
Collection J. Im Obersteg, Basel.

Le Juif en noir et blanc. 1914.
Huile sur carton réentoilé, 100x81 cm.
Collection J. Im Obersteg, Bâle.

Jew in Red. 1914.
Oil on cardboard mounted on canvas, 39⅜x31½".
Collection J. Im Obersteg, Basel.

Le Juif en rouge. 1914.
Huile sur carton réentoilé 100x80 cm.
Collection J. Im Obersteg, Bâle.

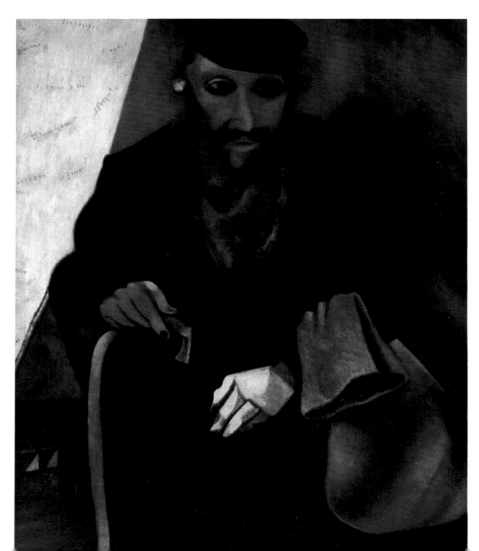

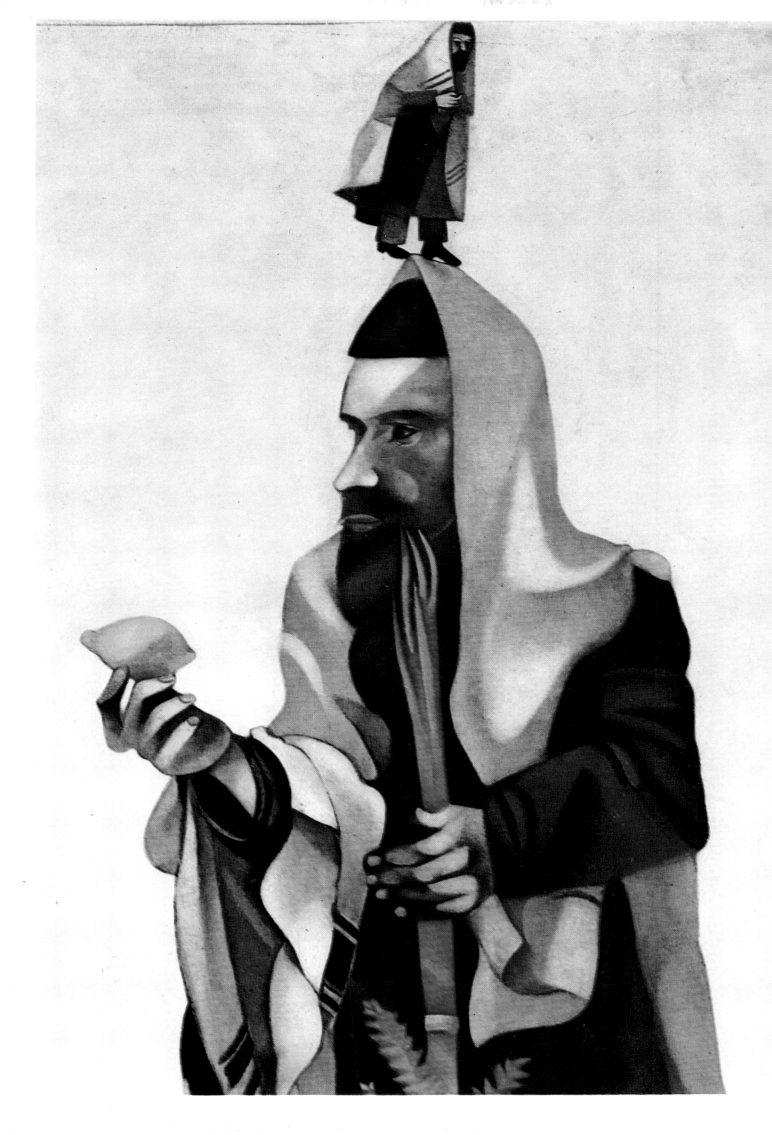

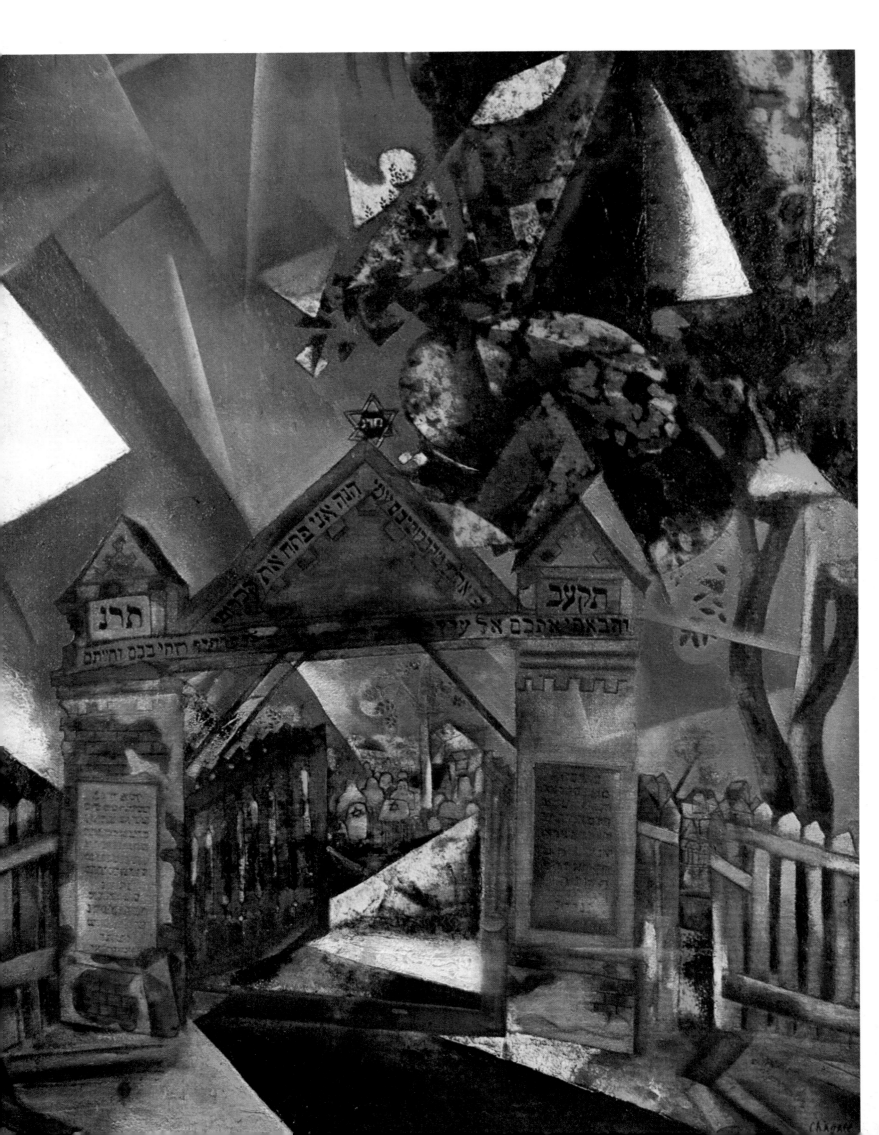

Cemetery Gate. 1917.
Oil on canvas, 34¼x27″.
Collection Ida Chagall, Basel.

Les portes du cimetière. 1917.
Huile sur toile. 87x68,5 cm.
Collection Ida Chagall.

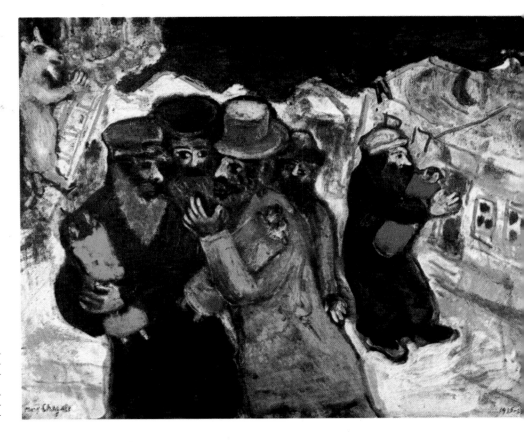

The Return from the Synagogue. 1925-27.
Oil on canvas, 35⅞x28⅜″.
Collection Lucien Lefebvre-Foinet, Paris.

Le retour de la synagogue. 1925-27.
Huile sur toile. 91x72 cm.
Collection M. Lucien Lefebvre-Foinet, Paris.

Solitude. 1933.
Oil on canvas. 40x66½″.
Tel-Aviv Museum, Israel.

Solitude. 1933.
Huile sur toile. 102x169 cm.
Musée de Tel-Aviv, Israel.

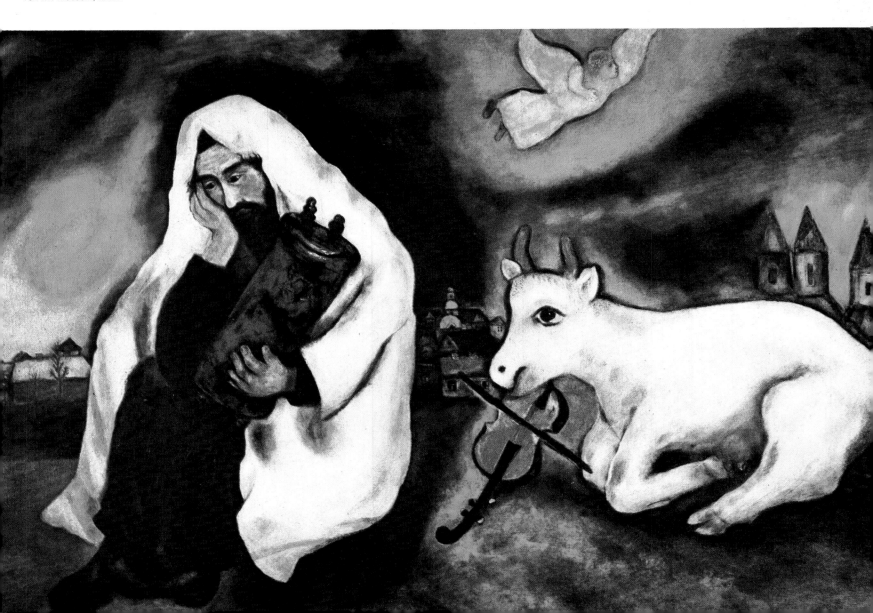

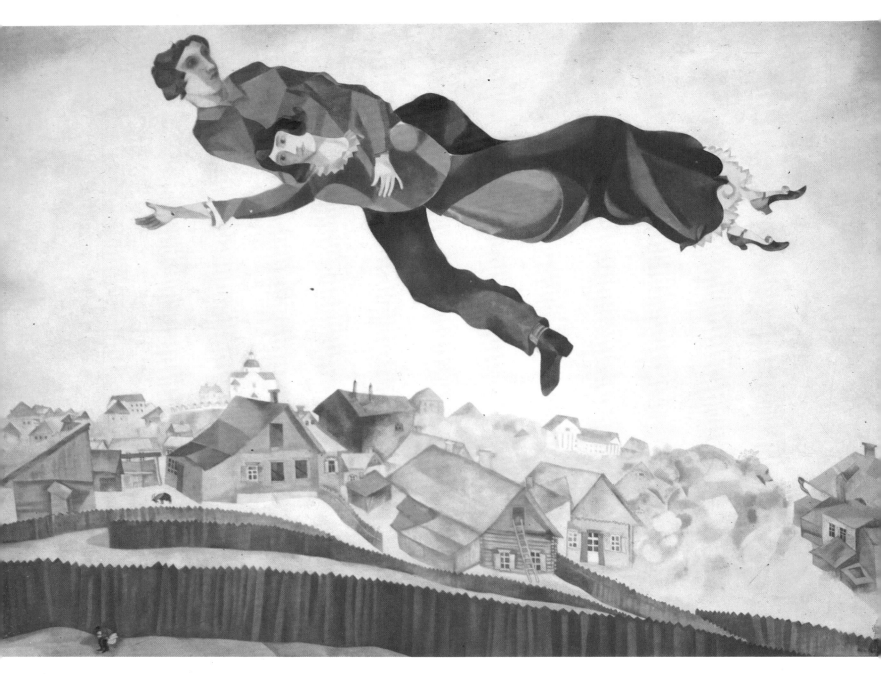

Lovers Above The Town.
Detail. 1917. 61⅜x83⅝".
Tretiakov Gallery, Moscow.

Les amoureux au-dessus de la ville.
Détail. 1917. 156x212 cm.
Galerie Tretiakov, Moscou.

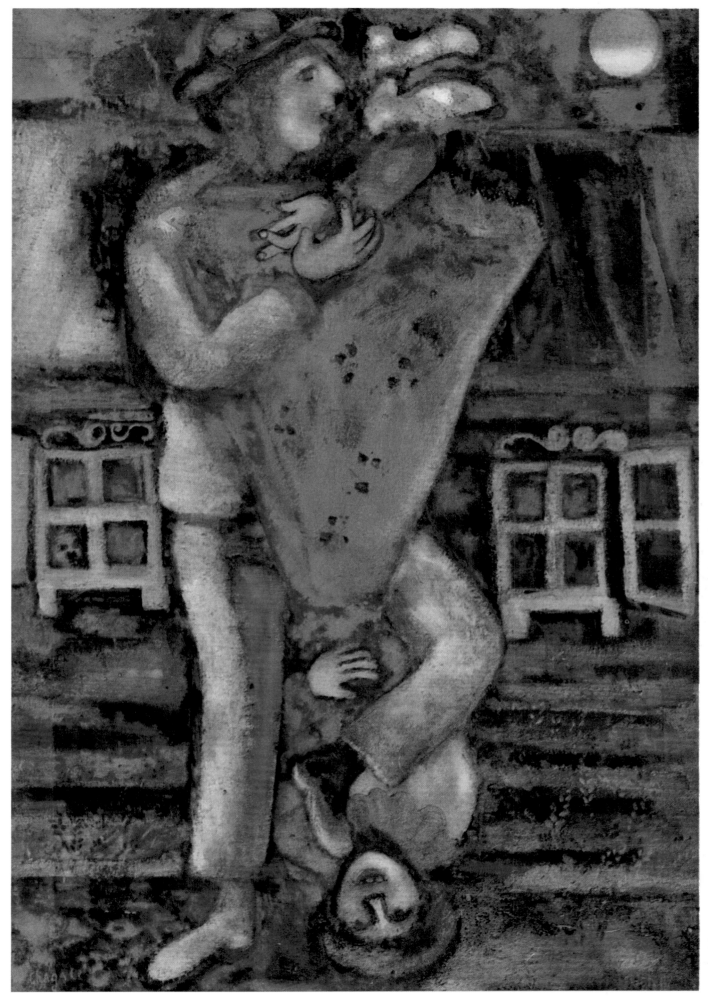

The Walk. 1929.
Private Collection.

La promenade. 1929.
Collection privée.

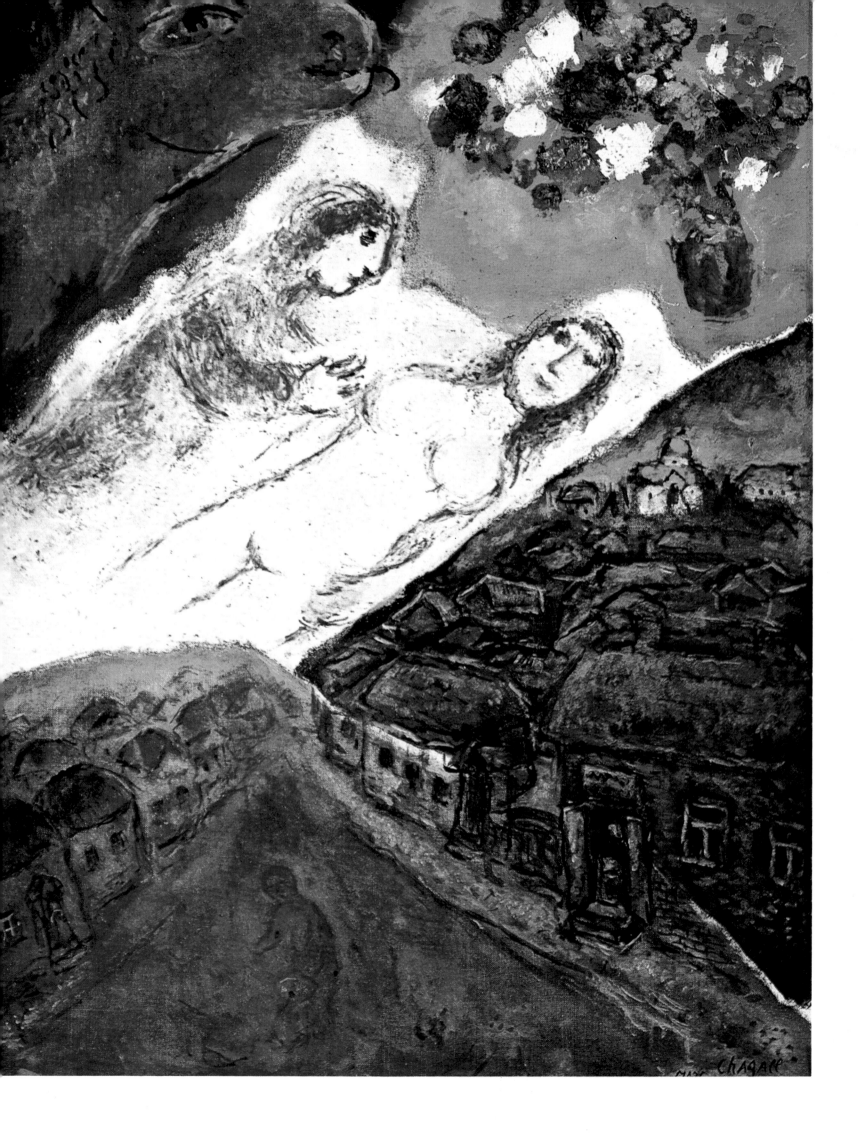

The Dream. 1976.
Oil on canvas. 31⅞x23⅝".
Private collection.

Le songe. 1976.
Huile sur toile. 81x60 cm.
Collection privée.

The House With The Green Eye.
1944. 15x20⅛".
Ida Meyer Chagall Coll., Basle.

La maison à l'oeil vert.
1944. 38x51 cm.
Coll. Ida Meyer Chagall, Bâle.

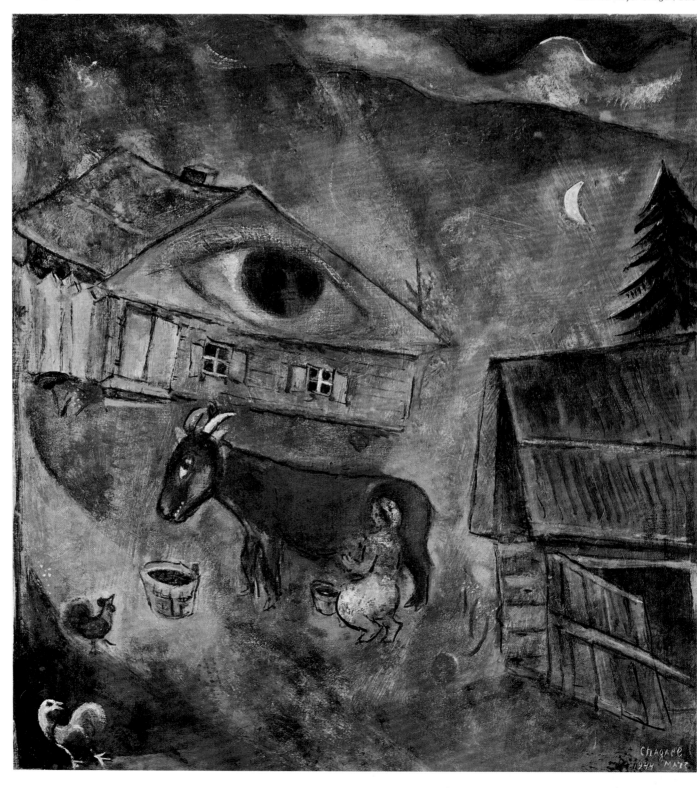

The Champ de Mars. 1953-56.
Oil on canvas. 59x41⅜".
Private collection.

Le Champ de Mars. 1953-1956.
Huile sur toile. 149,5x105 cm.
Collection privée.

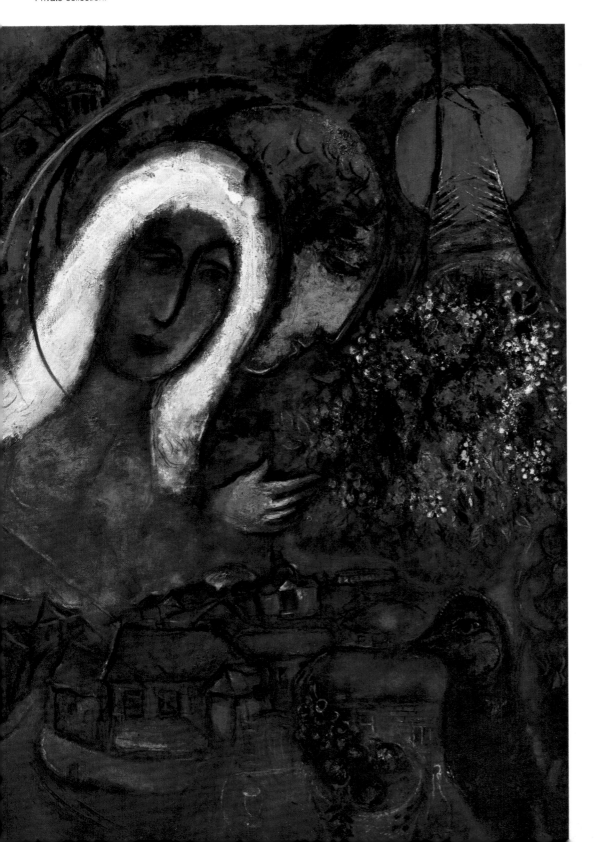

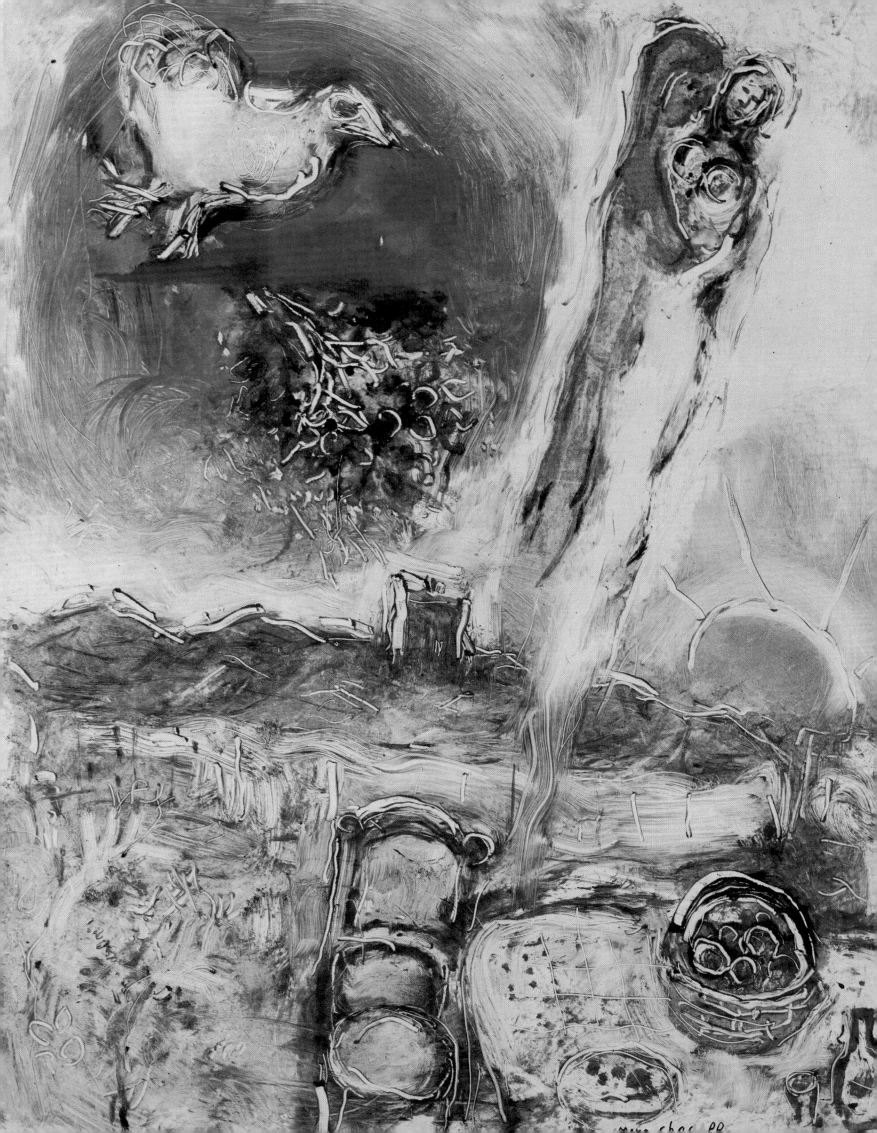

Bouquet of Liliums. 1966.
Oil on canvas. 39⅜x31⅛″.
Perls Galleries, New York.

Bouquet de Liliums. 1966.
Huile sur toile. 100x79 cm.
Perls Galleries, New York.

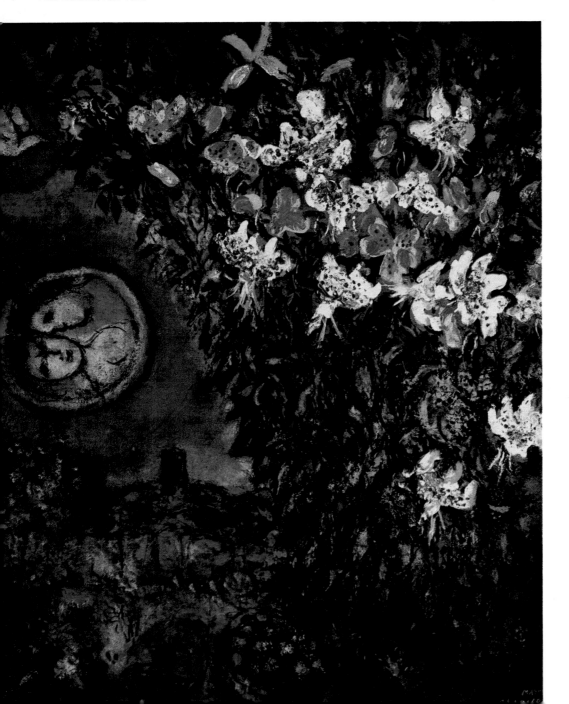

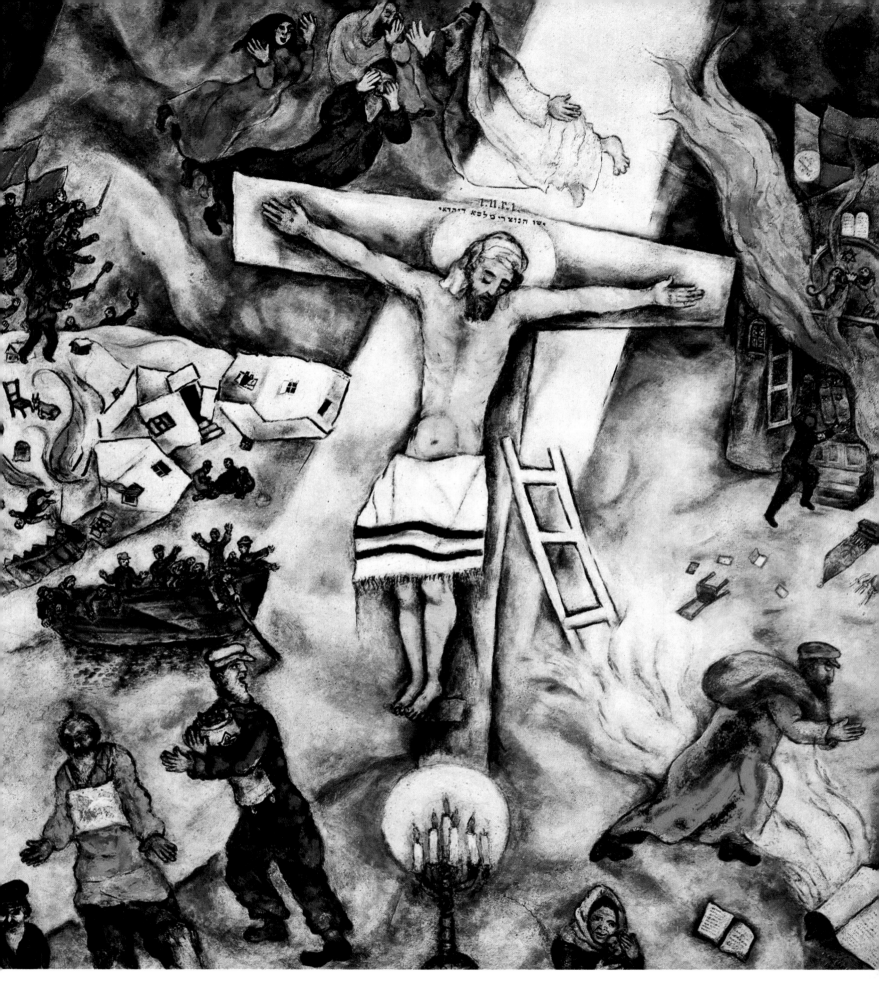

White Crucifixion. 1938.
Oil on canvas. 61x55".
Art Institute of Chicago.
Coll. A.S. Alschuler.

La Crucifixion blanche. 1938.
Huile sur toile. 155x139,5 cm.
Art Institute Chicago.
Coll. A.S. Alschuler.

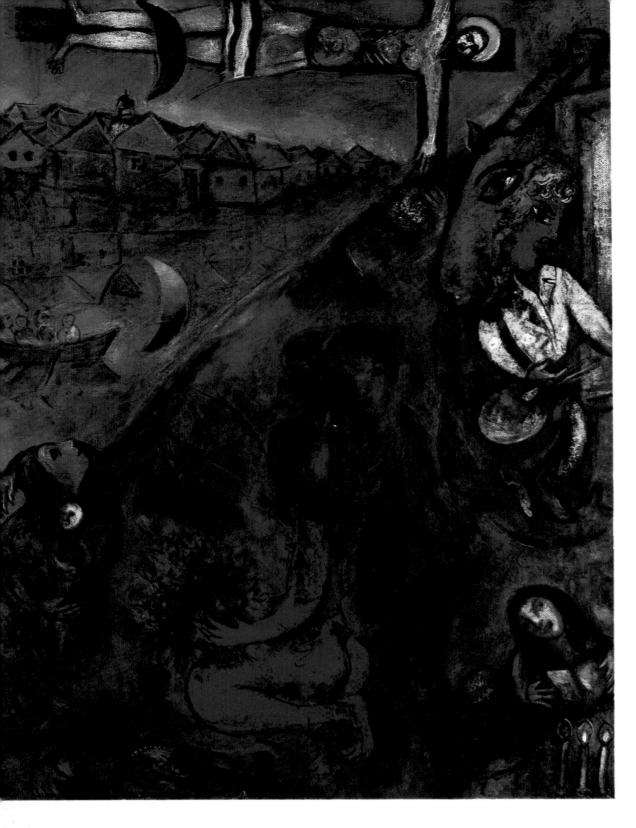

Resurrection at the River.
1947. Oil on canvas. 38⅝x29⅛".
Collection of the artist.

La résurrection au bord du fleuve.
1947. Huile sur toile. 98x74 cm.
Appartient à l'artiste.

The Fall of the Angel.
1923-1933-1947.
Oil on canvas. 58¼x74⅜".
Kunstmuseum, Basel.

La chute de l'ange.
1923-1933-1947.
Huile sur toile. 148x189 cm.
Kunstmuseum Bâle.

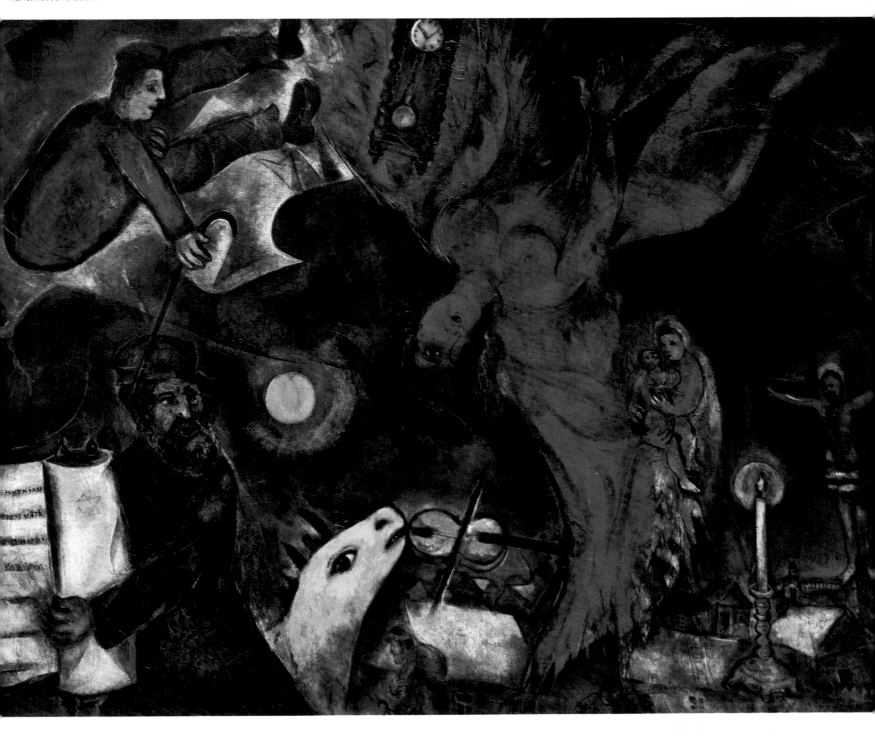

64

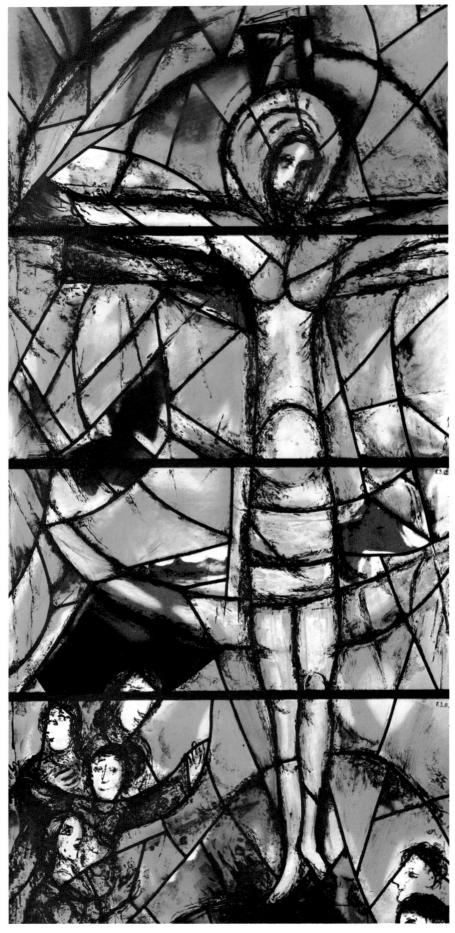

Madonna, Child and Offering.
Stained-glass window. Detail.
Fraumünster, Zurich.

La Madone, l'Enfant et le Sacrifice.
Vitrail. Détail.
Fraumünster, Zurich.

monumental paintings

by gilbert lascault

It is important to remember that several of Marc Chagall's canvases are enormous, monumental works: *Homage to Apollinaire* (1911-1912), 82$^1/_4$"×78"; *Golgotha* (1912), 68$^1/_2$"×75$^1/_2$"; *The Cattle Dealer* (1912), 38"×80"; *To My Wife* (1933-1934), 52"×77$^1/_2$"; *The Red Roofs* (1953-1954), 90$^1/_2$"×83$^7/_8$"; etc. Today, at a time when, as a popular song puts it, "everything is mini in our lives," the right of an artist to paint large-scale canvases must be defended. We should acknowledge that large pictures create their own particular aesthetic effects, which the critical eye accustomed to viewing small reproductions tends to overlook. This is an unfortunate consequence of the extension of the imaginary museum which reduces everything to the same scale—that of the postcard and the book.

There is every reason not to consider modest, discreet works as necessarily minor. But it would be equally absurd to disregard the power of works that unfold in space. We must learn to appreciate again the action of the painter who is not content with simply trying to center a wall or a part of a wall differently, but who wants to substitute his canvas (sometimes from floor to ceiling) for the architecture. By the bold multiplicity of his figures he seeks to replace the habitually neutral environment (often grey) of museums and apartments. Large paintings refuse to make any compromise with the neutral appearance of walls, which they neither orient nor enliven but struggle against and seek to exclude. Avoiding its share in the grey banality, art no longer tolerates playing a lowly

The Cattle Dealer. 1912.
Oil on canvas. 38"x80".
Kunstmuseum, Basel.

role; it wants everything, and at once. Upon walls that help man to protect his wealth and the platitudes of his daily life, it distributes its carnival of colors, hoping to explode this mediocrity by the space and dynamism embodied in it.

A small or medium-size canvas often only escapes from its decorative function by responding to a critical one. Its frame then redoubles and clarifies the limits constituted by the walls. Its strictly geometrical, rectangular form recalls the outside authorities who come to organize our lives and who, often unknown to us, rigidly structure what we believe is the space of our freedom.

There is a critical force in Chagall's large canvases. They do not aim at producing an illusion of reality nor attempt to make us believe in the illimitable nature of our measured, encircled spaces hedged in by political and economic powers. They do not pierce the walls in an illusory way but initiate, on the level of feeling, a dialectical struggle between the recognition of limits and the desire for the unlimited, between gravity endured and gravity conquered. But their critical force, far from restricting them to a purely negative function, to a reticent analysis of how things are, has its origin in a wild affirmation, in a joy that sweeps everything along with it.

Victorious over time, the radiant hermaphrodite in *Homage to Apollinaire* floats on the strange face of a clock. The prosaic details, the oneiric plants and the transparency (making it possible to see the foal turned upside down in the belly of the mare) make *The Cattle Dealer* an instrument of

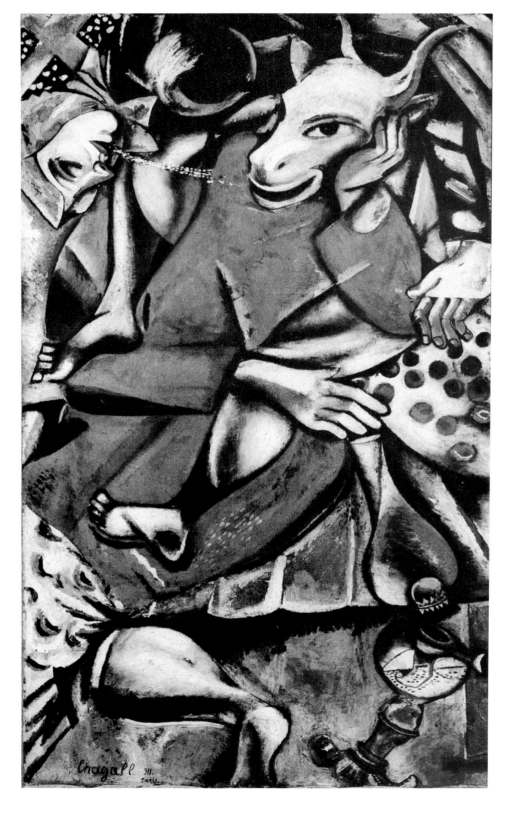

To my Fiancée. 1911.
Oil on canvas. 84″x52″ with frame;
77⅛″x45⅛″ without frame.
Museum of Fine Arts, Bern.

66

disorientation. In the *Double Portrait with Wine-glass* (1917), a man is perched on the shoulders of his beloved, but he is weightless, his love and intoxication cause him to float and the couple becomes a bridge, a sort of rainbow between earth and sky: the erotic as a means of marrying the terrestrial and the divine. The acrobat in the *Blue Circus* (1950-1952) scarcely makes any use of his trapeze but swims in the air accompanied by a fish whose hand is extended by a bouquet. In the Chagallian universe there is no dependence on nor possession of anything; free of any support, things float, travel and exert force; flowers become extensions of hands (as in *The Dance*, 1950-1952); the moon may fraternize with a violin and there is no stability. On the wall (which a large canvas makes transparent and opens onto something other than everyday banality), *The Pregnant Woman* (1912-1913), who is enormous, points to her belly, which is also transparent, while a goat leaps from cloud to cloud and the roof of a house becomes the shoulder for a head that extends it.

Neither purely negative criticism of constraints nor total obliviousness to limits, the large paintings of Chagall introduce the spectator inside a circus universe, an obvious theatrical set. The sheer size of the canvases, the phenomena of transparency, the disturbance of physical laws, the abolition of gravity and the geometry that makes love with a cow or the moon, all contribute to create the madness of the theater, or the theater of madness. In the *Prose of the Transsiberian* Cendrars exclaims: "Like my friend, Chagall, I could make a series of crazy pictures." There is no reason then to be surprised at the fascination the theater exerted on Chagall after the Revolution; in this issue of *XXᵉ siècle*, Alain Jouffroy's analyses of the painter's theatrical work are pertinent. For Chagall, the truth of the theater lies in its unreality. The set is a picture that envelops the characters in order to free them. In a sketch for the set for Gogol's *The Revizor* (1920) everything floats: a ladder, geometrical forms, an enormous carriage pulled by a locomotive-ant.... A new world is produced in which the impossible becomes the rule, where dream and reality, joy and sadness celebrate a marriage festival, as in Sholem Aleichem's stories and plays (for which Chagall designed many sets).

But now we must insist again on the scale of the works and show why the monumentality of certain pictures is lost on us (a fortunate loss). From this point of view, Chagall's large paintings constitute the exact antithesis of the famous lace collar in the portrait by Clouet—that collar painted in *trompe-l'œil* and smaller than life-size which Claude Levi-Strauss refers to in *La pensée sauvage* (p. 33). In relation to it, Levi-Strauss analyzes the strange charm of small-scale models; the reduction of size leads man to believe, correctly or not, that he dominates the object in its entirety more easily; he thinks he has a more direct, immediate knowledge of it:

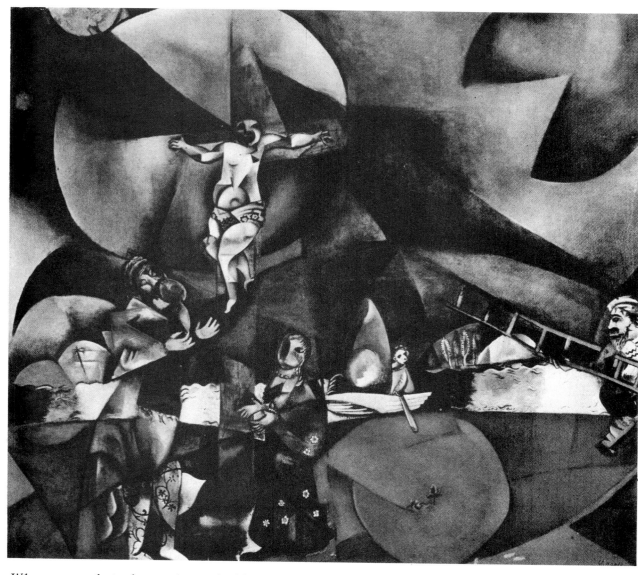

Golgotha. 1912.
Oil on canvas. 174x191,5 cm.
Museum of Modern Art, New York.

*When we seek to know the real object in its
entirety, we always have a tendency to begin from
its parts. We surmount the resistance we encounter
in the object by dividing it. The reduction of scale
reverses this situation: smaller, the totality of the
object appears less frightening; because it has been
quantitatively diminished, it seems qualitatively
simplified to us. More precisely, this quantitative
transposition increases and diversifies our power
over a homologue of the thing; through it, the
latter can be seized, weighed in the hand, ap-
prehended in a single glance.*

Chagall's works never allow us to take posses-
sion of them, master and know them in this way.
The larger the picture, the more our lack of power
becomes evident and the more the mystery of the
visible endures. Chagall's world cannot be divided,
put into compartments, broken down into com-
ponents; on the other hand, it cannot be dominated
as a coherent whole, weighed and measured. The
grandeur, the monumental quality of certain can-
vases is thus one of the means Chagall uses to
flout any attempt at structuring them and to lead
us astray, away from any path or ownership and

into the chaotic and joyous field of personal
freedom. The *Homage to Apollinaire* remains
(*partly* because of its enormous size) one of the
least comprehensible, and most fascinating and
secret pictures of the twentieth century. Even
when he does smaller works, Chagall never uses
the reduction of scale in order to imprison a world,
knqw and control it.

For that matter, Chagall never has recourse to
"objects" (to borrow another term from the *Pensée
sauvage*). Chagall's painting is not abstract; it
rejects every kind of "formalism," but it takes no
interest in objects, desires no knowledge of nor
power over things. A pictorial storyteller, Chagall
likes the narrative form; he moves not among
things but among stories.

The Hasidic tradition has often been pointed out
as one of Chagall's formative influences. In Vi-
tebsk, where Chagall was born, a Hasidic com-
munity had existed for a long time and, according
to Franz Meyer, the painter's parents were Ha-
sidim. Meyer also mentions that the disciples of
Abraham Kalisker (a Hasid) made, in the course
of certain preaching activities, "dangerous leaps

Double Portrait with Wineglass.
1917. Oil on canvas. 91¾x53½".
Musée National d'Art Moderne, Paris.

68

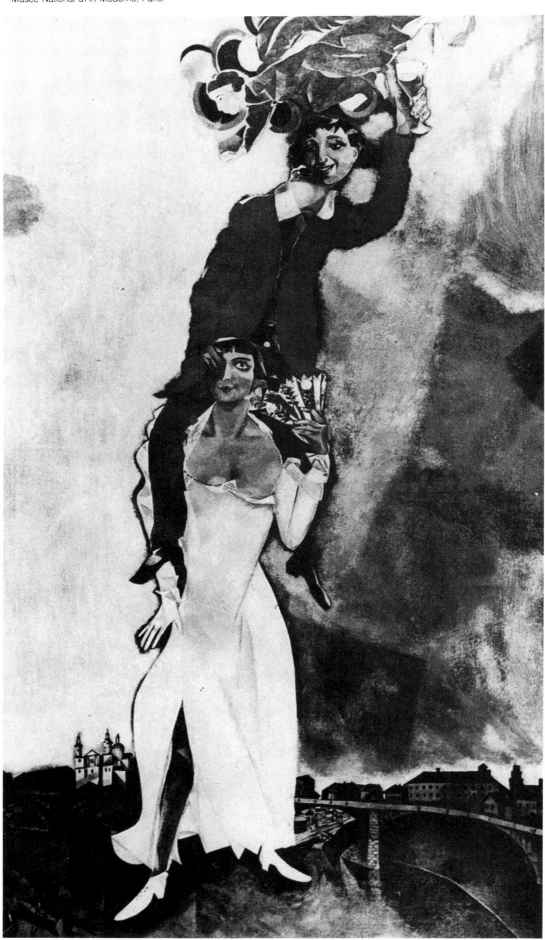

The Blue Circus.
1950. Oil on canvas. 91½"x68⅞".
Property of the artist.

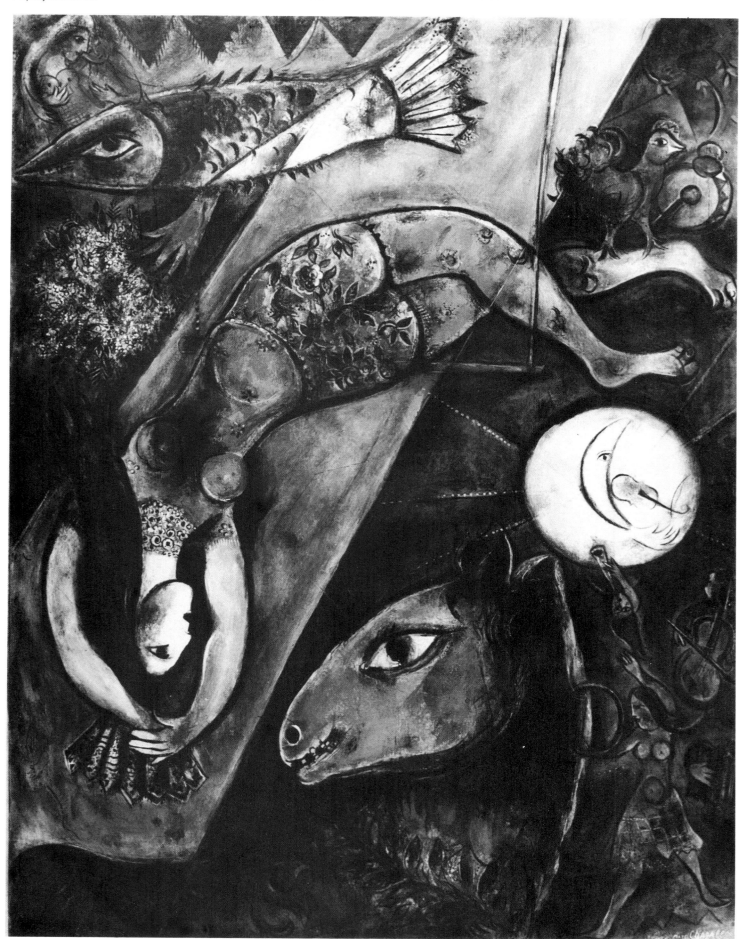

in the street and on the public squares" and lost themselves in "farces." They were, in a way, clowns and acrobats intoxicated by God, and Meyer relates them to the clowns and acrobats of Chagall.

Hasidism probably had more of a profound and less of an immediately observable influence on Chagall. It taught him to love stories, to see in narration not a simple means of distraction but a way of *waking* people up. The Hasidic tradition is made up of countless anecdotes, short stories and fables, which it prefers to reasoned arguments. As Rabbi Nahman of Bratislava states: "Most people believe that stories are made to put you to sleep; me, I tell them to wake people up." In this universe the narrations have a life that precedes their expression; they are much stronger than the person who tells them. As Rabbi Bounam puts it: "One day there was a story that wanted to be told."

The rabbis and the profane storytellers accept the disconnected, broken structure of these stories, the holes, gaps, sudden transitions and omitted explanations. One need only read *The Magic Tailor* by Sholem Aleichem to see how difficult it is to know what the story is talking about, whether it is joyous or sad, and to remain forever in the dark about how the thing reluctantly called a "goat" was bewitched.... Without doubt Rabbi Nahman of Bratislava developed the art of uncontrolled narration the furthest. In his stories Elie Wiesel (*Hasidic Celebration*) writes:

Each fragment contains the whole and threatens it.... The human condition, made up of questions, is translated by its very explosion.... If Rabbi Nahman tightens the episodic events and lets the narrative float, it is because he prefers the infinitely small to the infinite, a life with leaps and starts to a life without surprises.

Chagall has the same preferences. In particular, the changes in scale and the absence of supporting points on the large canvases disorient us; there is no concern for the habitual rules of composition: figures are massed together in certain areas of the picture, whereas other areas remain empty; we never receive a message, but the existence of an enigma is imposed upon us. Chagall multiplies the signs but provides us with no key. Why, in the *Homage to Apollinaire*, did the painter inscribe his name twice near the upper edge, once in the normal way and the second time without the vowels? Why did he write his first name nearby, half in Roman characters, half in Hebraic letters? How is this repetition of the name, this fragmentation of the first name, related to the bisexual being figured in the work and to the four names inscribed at the bottom of the picture?

70

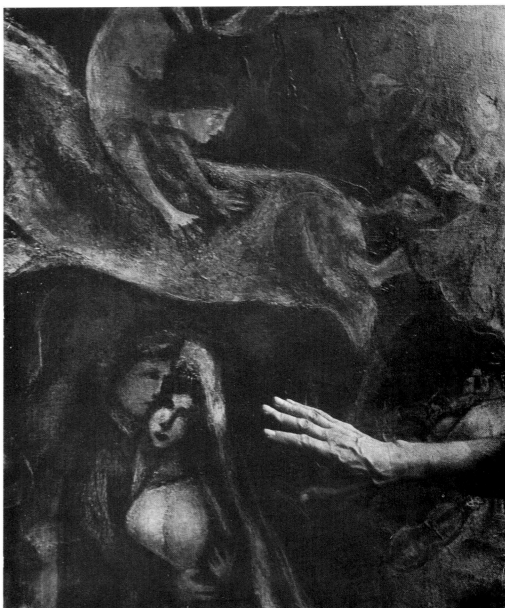

the master of the imaginary

by camille bourniquel

For the illustration of Camille Bourniquel's article we have preferred to forgo the usual chronological order to present the themes dear to Chagall: gravity, work, celebrations, the "crystallization of childhood memories", but also forebodings and anxiety over coming events: war, racial persecution, themes already found in his works of 1911 and even before the artist left Russia.

Such as Marc Chagall was on his arrival in Paris in 1911, when he worked in a studio at La Ruche, so he is today. Between the paintings he displayed at the Salon des Indépendants that year in the cubists' gallery, and the ceiling of the Opéra, the stained-glass windows of Metz and Jerusalem, there is, of course, an evolution, a discovery of light and color, a plastic fulfilment, but the vision itself has not changed. There are still the same accessories, the same privileged actors, the same fusion of disparate elements, the same "total lyric explosion", to use the words of André Breton. A world springing from the unknown more than half a century ago and which, throughout so much tragedy, so many rents, has retained its youth, its ascendant vitality, its faith, its ambiguity. A world that would not exist without those trajectories, those levitations, and that seems to have been born already complete like an earlier dream, without hesitations or alterations, with its celestial menagerie, its fluidic bouquets, its exalted couples floating above roof-tops and pursuing the curve of meteors.

There is a Chagall phenomenon—I was going to write a Chagall *mystery:* the very presence of this unusual work situated in the heart of our era but not resembling it, rebellious to appearances, having nothing to do with disputes between schools and purely formal research—perhaps anachronistic... like all prophecies—blending the end and the beginning in a single symbol: duration.

It is this presence—this presence as timeless as everything that helps us to conjure up the platitudes of our time, above all technical and incapable of transposing the imaginary into anything but numbers—that comes to mind first when one thinks of Marc Chagall. The presence of his work is all around us, in museums, theaters,

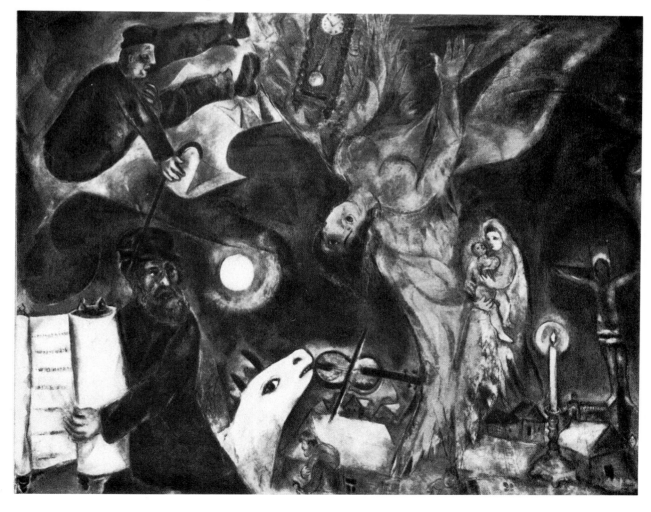

The Fall of the Angel.
1923-33-47. 58½"x58¾".
Museum of Basel.

books, engravings, stage settings, ceramics... but, perhaps, especially in our lives and the cycle of our daily activities: multiple and unique, found almost without surprise in countless gallery windows or bookstores and provoking the same halt each time in our urban bustle.

Time has not touched it; it has kept that almost fairy-like freshness of some countries where we might have often wished to visit and travel, far from the usual frontiers. Chagall has a totally personal way of belonging to his time: he makes it fall into a sort of sleepless dream. He has always refused to take part in aesthetic disputes and to define himself through manifestoes—which has most certainly contributed to the absence óf his works in certain superficial chronologies on twentieth century art—but life has put itself in his hands. A life that has kept the sense of unforeseeable élans, of diverse solutions and sudden mutations, marked, it would seem, by the irony of a demiurge amusing himself by upsetting natural laws, mixing up species and kingdoms, and extending to the limits of the absurd the variations of possibilities.

Chagall was, perhaps, the first expressionist. In any case, he far preceded Dadaism and surrealism; nor did he wait for psychoanalysis to discover the unconscious mind. Perhaps also, sensing the menace hanging over Europe that was to take definite form between the two wars, he was a Kafka before Kafka and, along with the latter, the most authentic prophet.

For Chagall to exist in his time and yet remain timeless, there must be an eternity promised to man, that he come from a past not devoid of sense and that he direct himself towards something other than a progress that is measurable and already established by statistics and prospectives. Chagall resembles us only in what there is of most intemporal, most mysterious in each of us: that hope to give the world other laws than those that govern it; that hope that dreams of escaping from the existential framework by destroying the poorness of previsions and calculations. Invention, for him, is the exact opposite of logic and of a rule accepted once and for all. What he invents has always freed him from standard techniques and, today as yesterday, from the petrifying experiments of doctrinarians who lock creative genius in geometry or abstract reckonings. Not that he has remained apart from these experiments: all the important trends in modern art have passed through his work without, for as much, becoming the key. There was certainly, as the art critics tell us, a *fauve* Chagall, a cubist Chagall, an expressionist Chagall, a surrealist Chagall. Thus, every period can claim him for the list of their originators—he himself has remained true to his own style and its source sprang from elsewhere.

Nothing, in this respect, seems more conclusive than his *Homage to Apollinaire* (1911), in which the geometric network—diagonals and circles—inscribes the monumental mythical, two-headed figure without breaking its linear unity or its verticality. This figure, which escapes the disjunction of form, with its complementary harmonies of clever geometry (of which Chagall was perfectly capable; consider another work of the

72

Detail of
The Newlyweds of the Eiffel Tower.
1928.

same period: *The Poet or Half Past Three*), is rather more reminiscent of the enigma posed by certain alchemic illustrations in which the Uralian creatures of William Blake still carry the weight of the world on their shoulders and sweep away the shadows before them. Yet, even in that moment when he had just come in contact with the School of Paris artists, Chagall never stopped belonging to himself. *To Russia to Donkeys and to Others* and *I and My Village* are contemporary proofs and one could see in them a sort of crystallization of his childhood memories. In any case, this great mythical figure implies no renouncement and therein lies the least servile homage that, through Apollinaire, has ever been paid to cubism.

In truth, pure research and rational organization—Delaunay or Malevitch—that proud *satisfecit* that so many artist permit themselves in measured doses and harmonious proportions, have never been enough to satisfy his instinct. He must have his Russian land; he must have Vitebsk, Paris, the French landscape, Greece, Palestine, Vence and then Vitebsk again. He needs a reality directly and, occasionally, naïvely observed to nourish his unrealism. Even the angel who came to him and whom he painted while he was making his own portrait, that angel he claims to have *truly* seen.

But Chagall knows too that unrealism has meaning only if it leads us towards a less discernable reality; that any form of art that is not a transcendent interrogation is apt to be only a simple play of mirrors. And it is certainly this that distinguishes him from so many other artists who have sought in symbolism and dream images only an artificial liberty and a cheap fantastic.

His choice is obvious. Adventure for him is of a spiritual order—even mystic, that word doesn't frighten him. His strangely weightless world is not an empty world devoid of sense and finality like those of Beckett or Ionesco. Objects can suddenly assume a disproportionate place, and man can exchange his head for that of an animal; derision is not total; the spirit is not driven out of its dwelling by those monstrous proliferations and man does not have to fade into the background before chairs and rhinoceros as is the case with our modern tragedians of the absurd and senseless.

Whether he illustrates Gogol or Longus, Stravinsky or Ravel, La Fontaine, Mozart or the Prophets, the passage from reality to dream is scarcely noticeable in his work. There is not a moment in Chagall's work when it suddenly plunges into the fantastic and when he must tug on our sleeve to remind us that we are floating in a balloon. The fantastic is the very essence and *raison d'être* of the work. It is less a question of symbols than of an unveiled reality set before our eyes. Chagall knows that reason is often an obstacle to knowledge of the being and the world. This confusion of appearances that can perplex us carries us beyond the illusions that it creates before our eyes. The visionary does not hem himself in here in enigmas and phantasms. His creatures are not mere puppets or robots. These hybrid beings cannot be wound up like toys: they

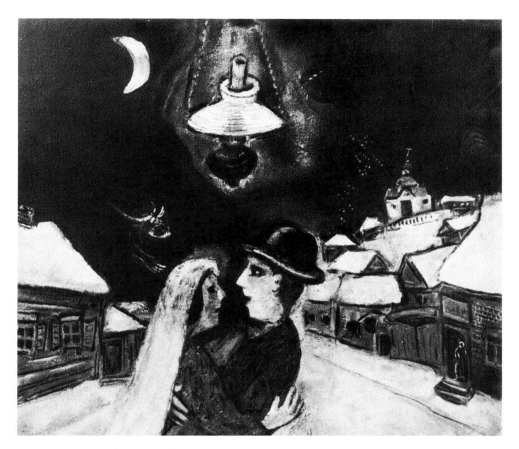

At Night.
1943. Stern Foundation.
Museum of Fine Arts, Philadelphia.

The Green Night.
Gouache. 1948.
Jardot Collection.

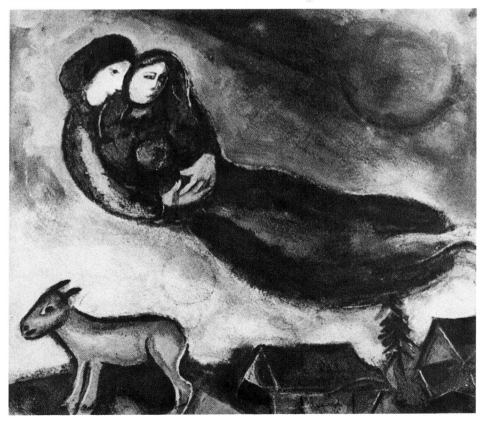

lead their own lives, are fragments of energy, symbols of the spirit which forever passes through matter and tricks logic. What counts here is not that donkeys fly, that roosters become gigantic canopies, that rabbis are green or red or blue like the seraphim in some apocalyptic vision, but that these infractions of natural laws, this illegality of form bring forth for us the light of the being in the heart of these mutations. The fantastic, or rather the imaginary, in Chagall's work is a form of knowledge, a gesture to embrace the world in its totality.

We are at the antipodes of gratuitousness, facing evidence so profound and yet so natural that it seems almost useless to seek its sources and models.

> *My only country*
> *Is there where my soul dwells.*
> *I enter without passport*
> *As if going home.*

Let us remember this affirmation. There is no intentional delirium, ecstasy or anguished discovery of abysses, but a free and open entrance into that mysterious domain that is the meeting place of the closest reality and transcendance, naïvety and illumination. This partially dual universe, as Chagall himself reminds us, was that of Douanier Rousseau: "It is the greatest miracle. He had need of fairy tales, nude women in forests and exotic plants. Here is a painter of the people and for the people. More innocent, more grandiose than Courbet or Seurat." In Chagall's paintings, the impatience of the mind demands other extensions beyond the visible. Aragon was right in saying, *"You paint the gravity whereby the body is made soul."* The soul, there is the key word and the final goal of this whole quest. Here the artist recaptures the old Slav and Jewish heritage: nothing in his life has made him budge one inch from these certitudes. He knows how to hide methodical concern, exemplary diligence (repitition of the same themes, preparatory studies and sketches, reconstitutions of his lost paintings) under the guise of the freest fantasy, naïvety and even improvisation and stays in this spiritual trend that remains almost constantly ambiguous and out of balance beneath irony and paradox. Here, the symbol is only a marker, a sign on that road to knowledge. Everything brings us back to that vision which we gradually discover as we study the whole of his work, the depth, the seriousness and the extraordinary coherence.

"Come back, you're famous and Vollard is waiting for you," wrote Blaise Cendrars to Chagall in Berlin in 1922 when the artist had just left Russia for the second and last time. Few works have known such quick success in the world of art. Few men have had such a pre-destination.

That is a fact that greatly exceeds the usual data found in a biography. Chagall possesses an energy, a power of persuasion, a communicative and emotional force that are almost impossible to ignore. One has the impression that he has always existed: that before Chagall there was already a Chagall and that he will always be here, flitting over frontiers, scrambling all the pasts of a Europe that, through him, has rediscovered

the old Biblical sources and the most ancient revelations.

Chagall feels himself to be heir to a tradition more mystic than humanist, and although that tradition is basically Judaic, his personal temperament urges him towards a syncretism. "I remember my distant ancestor who painted in the Mohilev synagogue." But, at the same time, Christian art began to fascinate him even in his youth, and especially the gallery of icons in the Museum of Alexander III in Saint Petersburg. He calls Roublev "our Cimabue", thus confirming from the beginning his debt to those other images whose mysterious kinship he tries to evaluate. "My heart became calm before the icons." Never has he obeyed the law that banishes the representation of the human figure. It has often been claimed that the importance of animals in his paintings is a means of avoiding this forbidden iconoclasm: I cannot accept this theory, for to depict the common man, his neighbors and himself remains one of those vital needs of which he has never deprived himself. Even if his Christs, according to some authorities, seem to fit a more Jewish than Christian conception, He is as central and essential in his work as He was in Dostoevski's and so many other Russians haunted, they too, by the idea of human misery and redemption.

Such a fusion—must it be pointed out?—does not take place on a theological level but on a spiritual one. A recent pope reminded us that spiritually we are all Semites. A certain religious ambivalence in Chagall seems to illustrate this statement. Furthermore, one realizes very quickly that this syncretism is identified with an instinctive need that urges him to join the sources of his inspiration in a single creative movement. "My poetry is unexpected, Oriental, suspended between China and Europe," he said, thus opening even larger horizons. He has a need of that absence of intellectual, historical and religious frontiers to encompass in a single vision realism and enchantment, a certain ritual fidelity (The Tables of the Law, the seven-branch candelabrum, the celebrations in the Jewish calendar...) and a pantheism (numerous nudes, his late discovery of Greece...); on the one hand, adoration and, on the other, a fundamental disrespect that alone permits a dialogue with God.

This fusion is not total. As in any baroque work, the gamut of possibilities remains essential. Metamorphosis passes through this universe, as in Kafka's, and it often seems that man has trouble establishing his privilege in the midst of those gravitations of which he is not necessarily the center. As in Shakespeare, reality is crossed with fairy tale. The angel mixes with the beast, the musician becomes the 'cello, the donkey's profile blends with that of the artist.

For those who see in this jumble of unusual objects passing through a strange and drifting cosmos only caprices of the imagination, happy or gloomy humor, zoomorphic deformations, tricks and facileness, Chagall reminds us that all painting—and his, in particular—is a tragic language, often marked by blood and tears, in any case, for him by dramas he has experienced

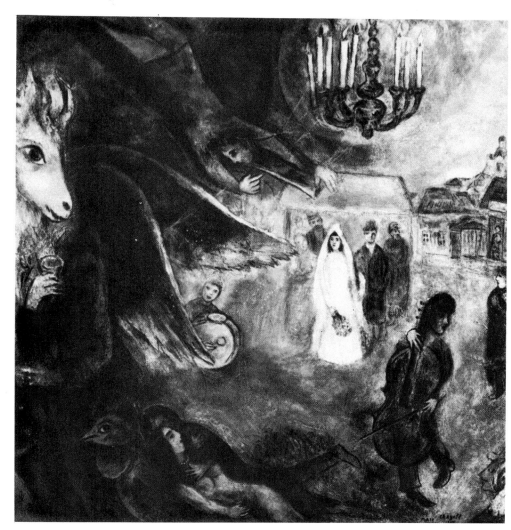

The Lights of the Wedding.
1945. 48⅜x47¼".

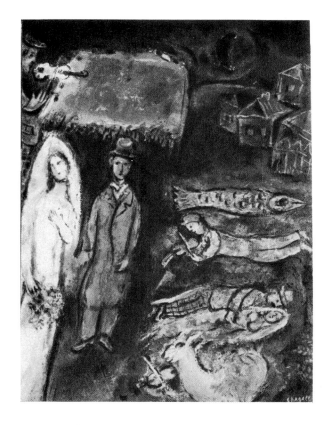

Marriage with Fish.
1955-56. Maeght Gallery.

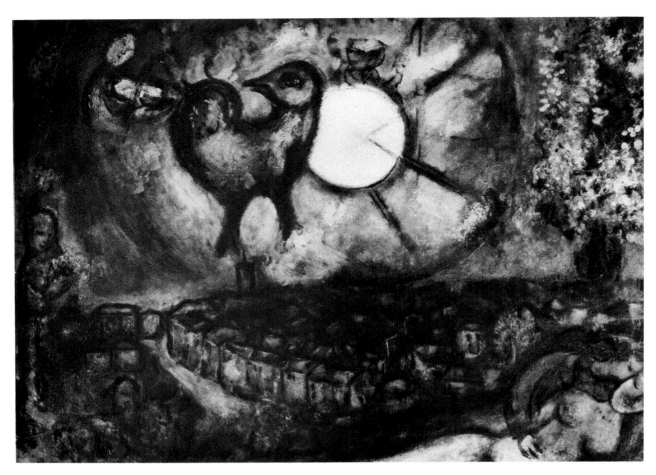

Night in Vence.
1952. 38¼"x51".
Private Collection, Zurich.

or witnessed: the Russian revolution, a double rootedness and, finally, the Germans' massacres of eastern European Jewish communities. It is possible that nothing remains today of the Vitebsk that he knew as a child, returned to during the Lenin period where he married Bella and founded an academy for the working classes in those days of famine and denunciations: the image, in any case, remains primordial and has colored his whole life. That retrospective tenderness for those streets, those houses "destroyed with infancy" and its "inhabitants wandering about in the air," those artisans, those woodcutters, those fishermen in the Dvina, those old men, those rabbis, those fiddlers in front of isbas find other justification than the nostalgia of an exile, another setting than picturesqueness. Something unusual is added to the picturesqueness, mixing animals and men, the synagogue and the street, weddings and funerals: a masked menace, the flames of burning towns and pogroms. It is in that presentiment of inevitable tragedy hanging over that little world where his fantasy has given itself free rein that gives the vision of something so poignant and so human. "Sometimes there stood before me a figure so tragic and so old that it looked more like an angel." A very revealing phrase: misery, instead of immobilizing appearances, encourages a sort of gliding towards the invisible. Chagall has always seen in those old men in prayer, those humble and menaced men, the true witnesses of eternity.

That distant, premonitory vision has not lessened his liking for life and creatures, for present and fleeting things. Chagall has an optimism that can accept appearances and transitory things. Above all, there is in him a man who has studied himself a great deal; I might even say chosen and loved himself such as God made him. From this springs the series of self-portraits marking his work and making him his own principal interpreter. He himself seems to have wished to establish and bequeath the entire geneology of his own faces from the Apollo of Vitebsk. He loved his youth, and the companionship of the angel of the unusual has not added a wrinkle of bitterness to his features.

Thus, he marks his presence in an imaginary universe ordered by the law of multiple and constant mutations. It is not mere self-complacency, for this liking for oneself is almost immediately diversified and balanced by the presence and mythology of the couple. Chagall does not remain in that obsessive phase where his own face fascinates the artist more than any other enigma and becomes a sign of solitude as was the case of Van Gogh. His ego splits, becomes enthusiastic, and fulfills itself, in a way, in the description of the loved woman. We find the image of Bella, fiancée, wife, mother, in a whole series of portraits, drawings, compositions that, beginning with an occasional element—black gloves, a birthday bouquet, a carnation, a shawl, a white collar—recounts, until her death in 1942, a long and splendid poem of an inseparable presence in Chagall's destiny.

Perhaps there has not existed in all of the history of art an artist who has transposed in such a constant way his private life and consecrated it to the apothesosis of the couple. His admirable *Lovers above Vitebsk* (1917) shows us how, from the beginning, this image integrates itself with that imaginary universe and even gives it new dynamic breadth. The theme of his double levitation will be repeated endlessly: Bella appears to play the constant role of mediator and inspirer.

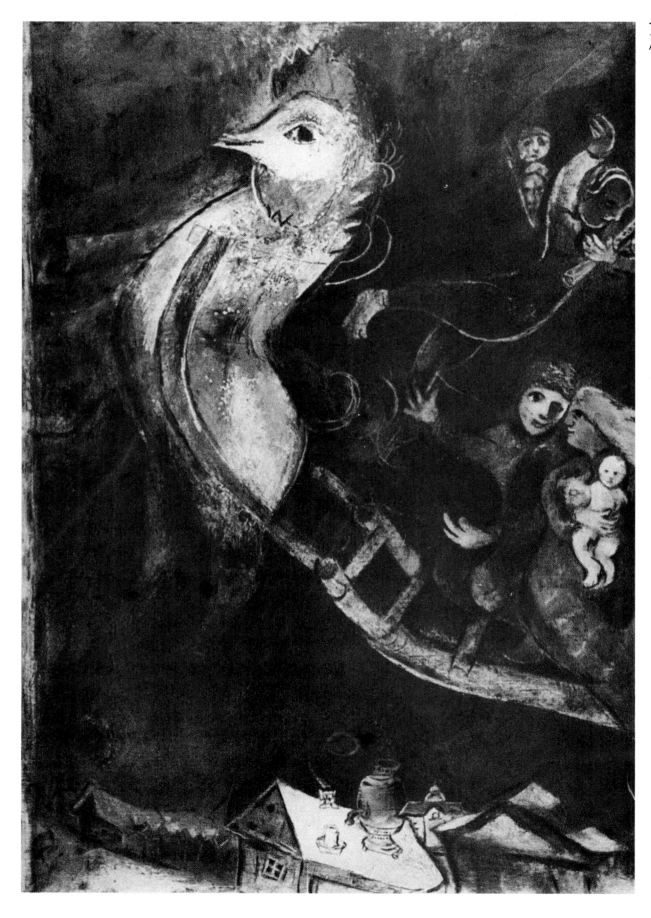

The Flying Horse.
1948. 51″x27½″.
Abrams Collection, New York.

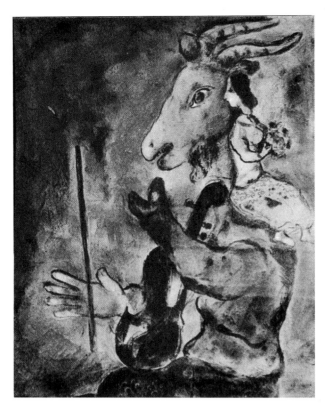

The Springtime.
1938-39. Watercolor. 27"x38¾".
Museu d'Arte Contemporanea, Sao Paulo.

The Donkey with the Large Bouquet.
Maeght Gallery, Paris.

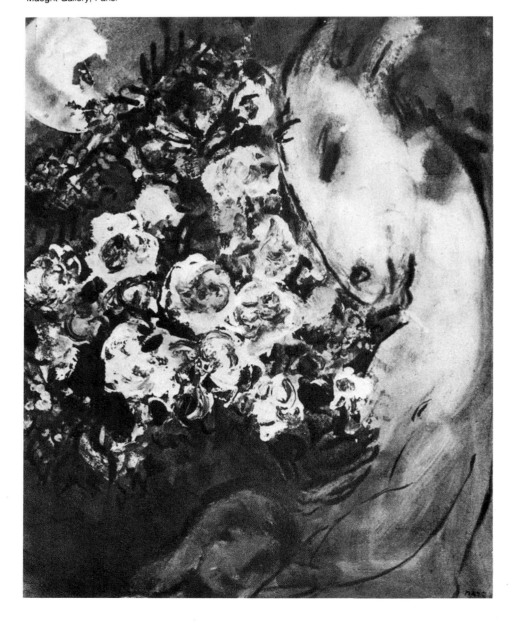

In some moments she is the axis of that universe. The famous *Double Portrait with a Glass of Wine* (1918) in which Chagall depicted himself straddling his young wife's shoulders expresses, of course, a joy bordering on intoxication but, above all, the real meaning of the couple. The two of them form a column of which Bella is the foundation of unvarying strength and security and he, Chagall, the dionysiac crowning.

The imagery of happiness involves the same sentimentalism, the same naïvety, the same thematic variations as the memories of Vitebsk or Lyozno. The imaginary has no other stepping stone than this lived reality. From this stems the importance, for Chagall, of the human milieu and emotional and family surroundings. Love and sentiment are not for him mere motivations, simple narrative incidents: they create exaltation, encourage the harmonious liberation of the being freed from that ultimate anxiety, that senselessness: solitude.

Nature and landscapes also participate in this exaltation of the consciousness, and if one can speak of a French influence it is much more in this domain than in the ideologies of form that it will be found. Here, an inner illumination joins the visible. Chagall discovered through the years all that attaches him to France, composed of living contrasts, of nuances, where snow does not extinguish light or smother reliefs during six months of winter's white mourning. The necessity of leaving France during the Occupation only made him more conscious of that intimate mixture of Paris and Vitebsk in his mythology. "Absence, war and suffering were necessary for all that to awaken in me and to become the framework of my thoughts and my life. But this is only possible for a person who has retained his roots. To keep the earth on one's roots or to find another earth is a true miracle."

The world has, of course, changed in fifty years in its rhythm and obsessions; Paris is no longer exactly the city that Apollinaire and Blaise Cendrars knew and loved; but Chagall is here among us, not as a survivor of an age but continuing, to the contrary, to make his way between reality and dream, the tragedy of man and the experience of human and divine love.

What strikes me in his most recent large compositions: the ceiling of the Opéra or the stained-glass windows depicting the Twelve Tribes of Israel, is Chagall's power to be himself completely in every instant. It is the sovereign ease with which he masters his invention, summoning once more to himself all the astrological figures of his sky, all the symbols of his faith, and moving without apparent effort through the world he created.

Language, poetry, music continue to exchange their powers in this universal metaphor. Perhaps Chagall has never felt a desire to cross the

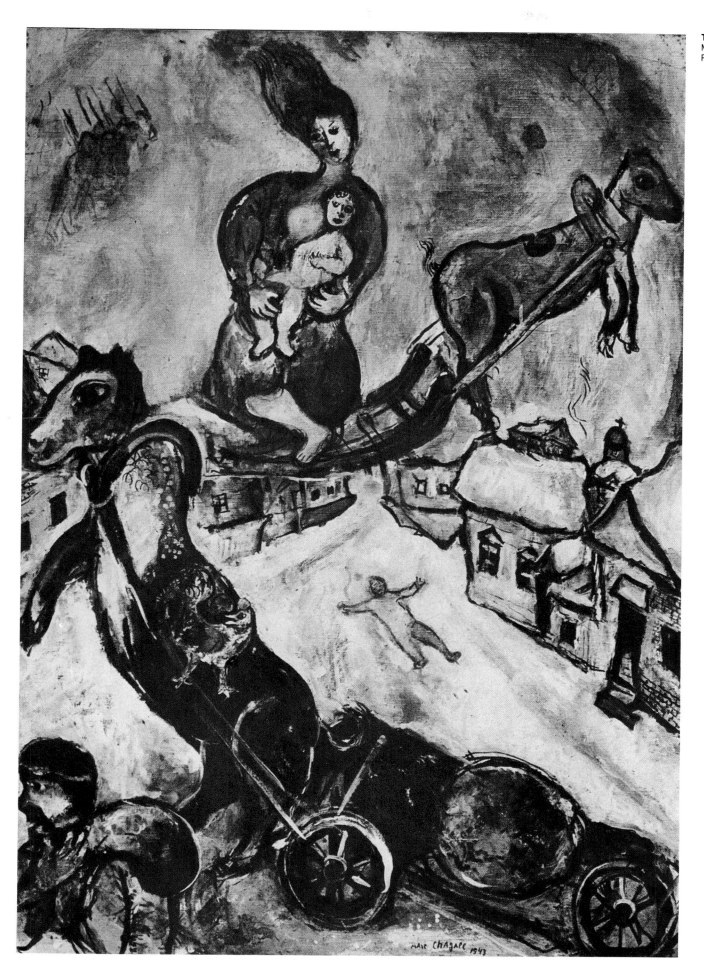

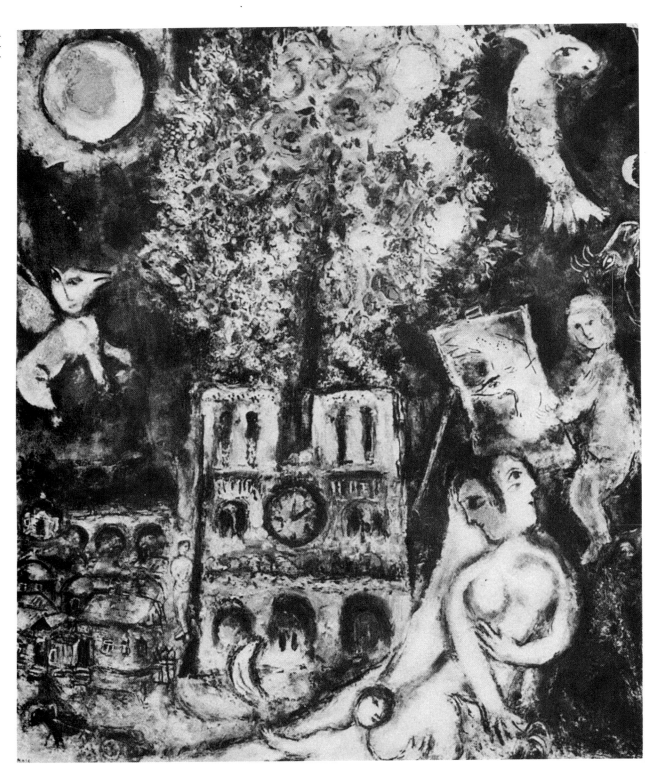

80

threshold of revelation to choose a permanent style between illumination and wisdom. This unstable equilibrium between two temptations is, perhaps, the last moral of a man who has long meditated on his fate and on that of his fellow men.

I went to talk to him, or rather to see him and listen. He touched the leaf of a plant in front of him and said, "There you are... what counts, what is the most important of all is the texture!" I tried to complete this thought in my own mind. Texture... yes, that which joins depth and surface, the upper and the lower, the beginning and the end, the shimmering and that thing which the hand can grasp and retain.

CAMILLE BOURNIQUEL

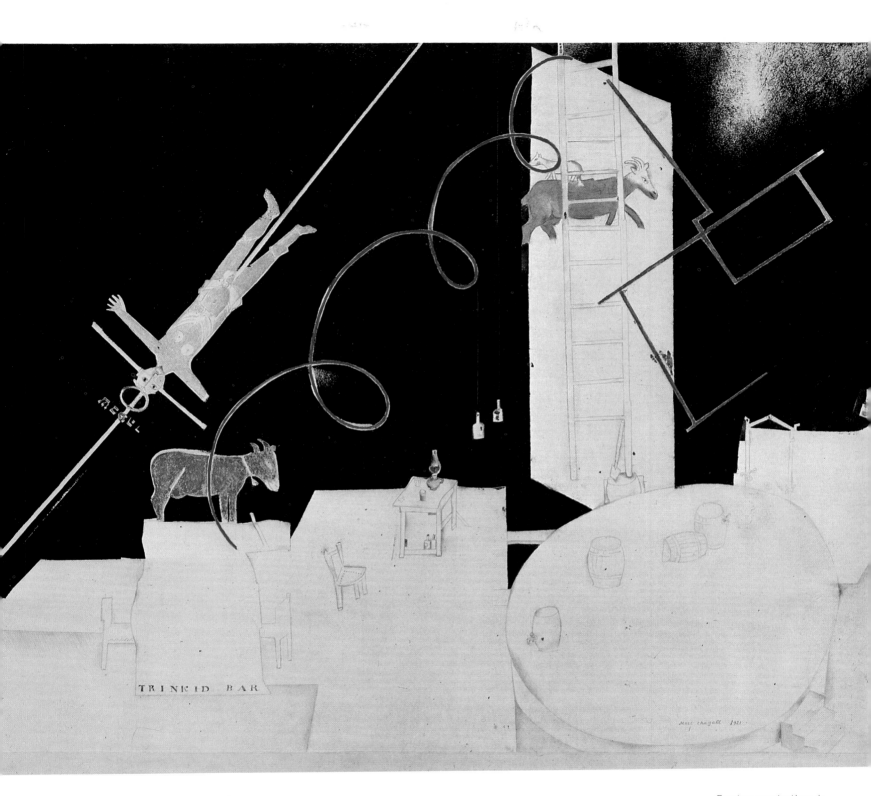

Sketch of the set for
"The Playboy of the Western World"
by Synge. 1921. Property of the artist.

Esquisse pour le décor du
"Baladin du monde occidental"
de Synge. 1921. Propriété de l'artiste.

Introduction to the Jewish Theater. 1919. Sketch of the monumental picture executed in 1921 for the left wall of the Moscow Jewish Theater. 9'3"x25'10". Property of the artist.

Introduction au Théâtre juif. 1919. Esquisse du tableau monumental réalisé en 1921 pour le mur gauche du Théâtre juif de Moscou. 2,83x7,90 m.
Propriété de l'artiste.

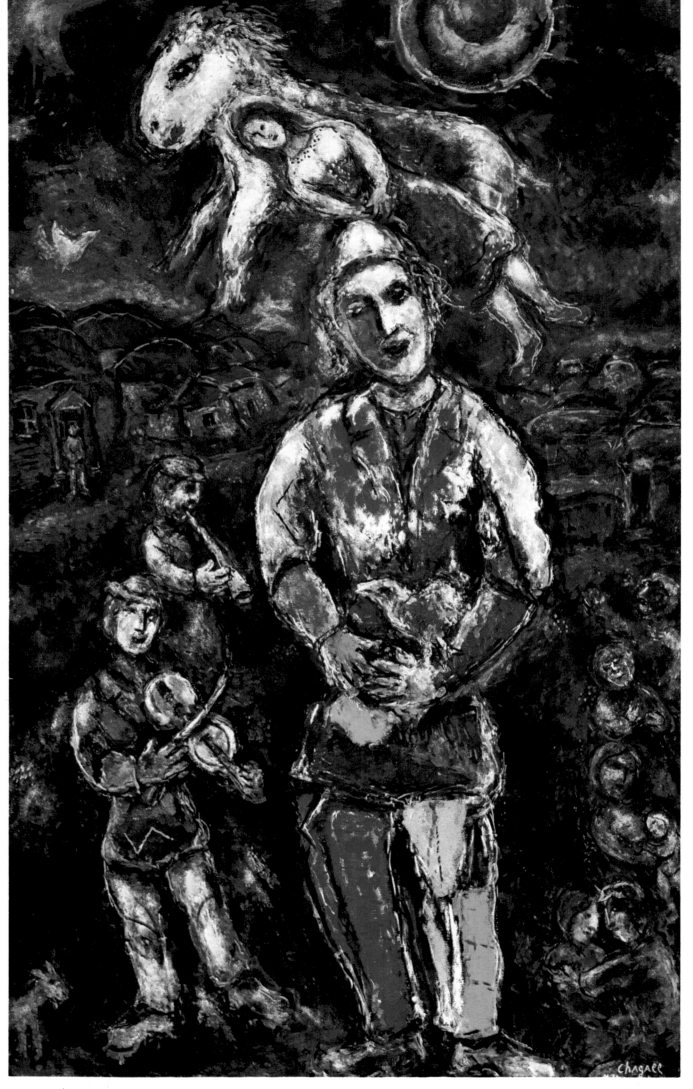

84

Circus in the Village. 1969.
Gouache. 31⅞x25⅝".
Private collection.

Cirque dans le village. 1969.
Gouache. 81x65 cm.
Collection privée.

The Saltimbanque. 1975.
Oil on canvas, 47¼x28⅜".
Private collection.

Le saltimbanque. 1975.
Huile sur toile. 120x72 cm.
Collection privée.

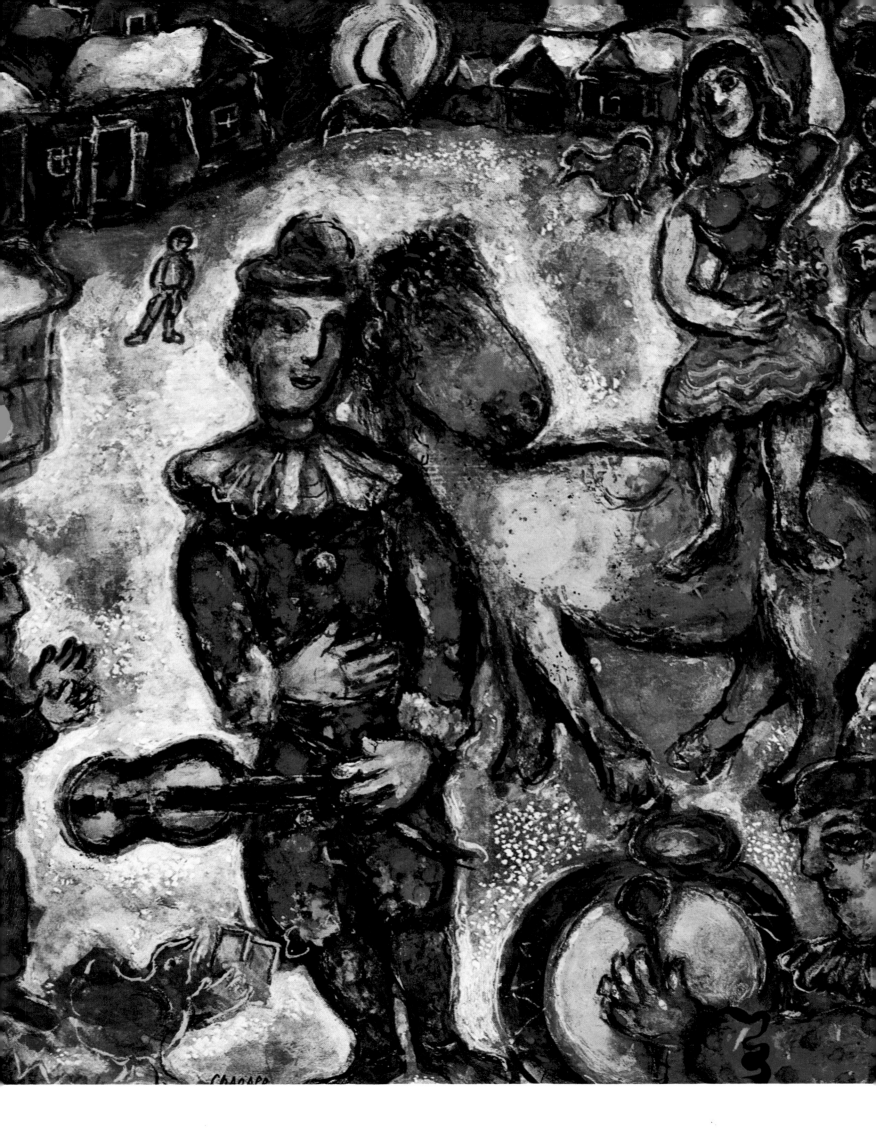

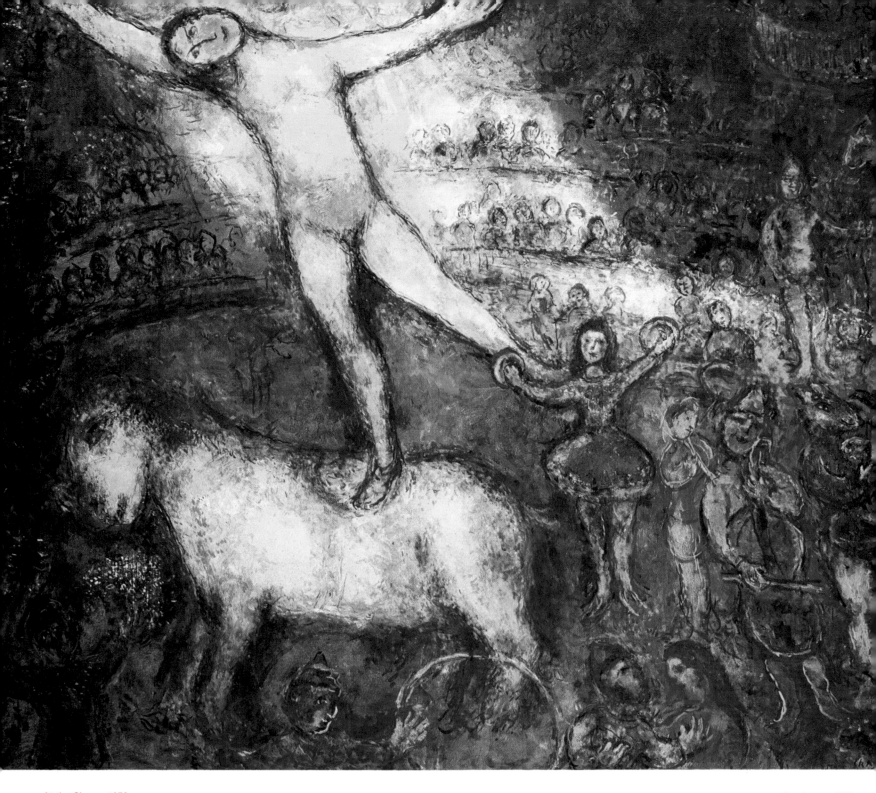

At the Circus. 1976.
Oil on canvas. 43⅛x48″.
Private collection.

Au cirque. 1976.
Huile sur toile. 109,5x122 cm.
Collection privée.

The Avenue de l'Opéra. 1969.
Oil on canvas. 31⅞x25⅝″.
Private collection.

L'avenue de l'Opéra.
1969. Huile sur toile. 81x65 cm.
Collection privée.

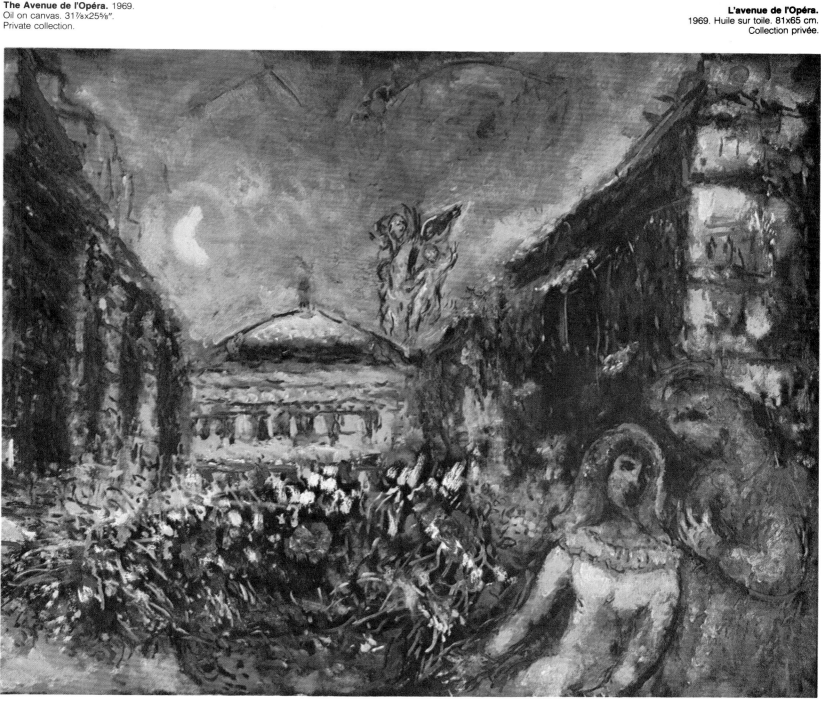

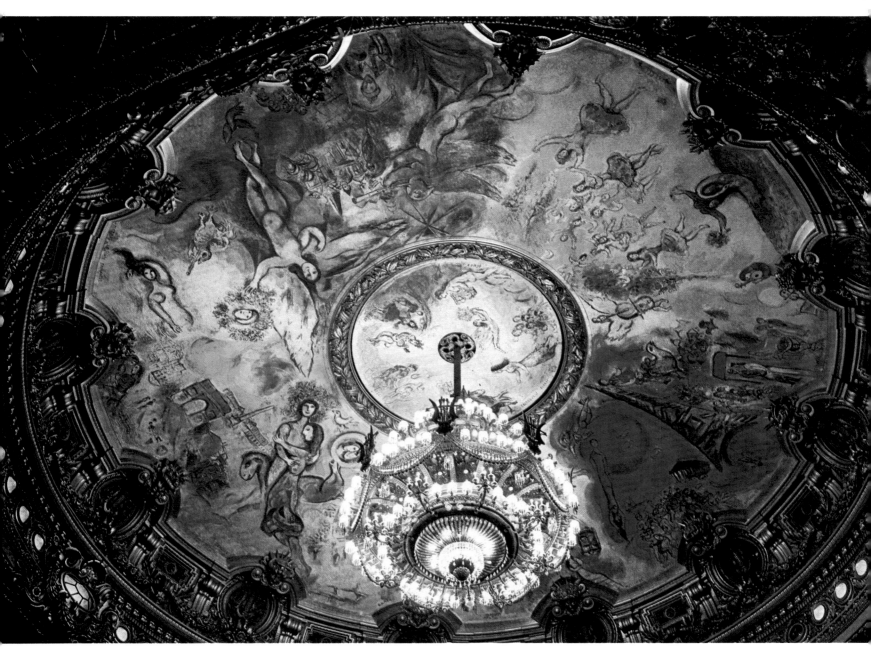

Ceiling of the Paris Opéra.
Inaugurated September 23, 1964.
Oil on canvas, about 2,367 sq. ft.

Le plafond de l'Opéra de Paris.
Inauguré le 23 septembre 1964.
Huile sur toile (environ 220 m2).

chagall and the theater

by denis milhau

The impressive list of ballets for which Chagall did the decor is sufficiently well known for us to be able to form some idea of the role he has played in the history of the modern theater. But this participation in the world of choreography, based as it is on the requirements of an empty stage and the narrative and descriptive needs of backdrops illustrating what the ballet develops in a non-naturalistic way (whatever the choreographer's aesthetics may be), is basically the least theatrical element in Chagall's work. The imagery is dictated by the obligatory front view of the ballet stage, which every commission that was suggested to him entailed, and involved a mere extension of that imagery to the required monumental dimensions. Similarly the art of fantastic and poetic story-telling that he brought to the decor is merely a variant of his easel painting.

Two groups of Chagall's works do point, however, to a dramatic and theatrical preoccupation of a special order: the adaptation of Chagall's original, proper imagery to the invention of new space relationships—arbitrary, but nonetheless real and specific—in order to create a new dramatic milieu. For the ballet, by contrast, Chagall had merely to cope with a transposition of the dimensions of his paintings. These two groups of works are, firstly, the commissions he carried out from 1915 to 1922 for the regular theater and, secondly, his various monumental decorations for theaters and auditoriums.

Up to the beginning of our century, any painter called upon to work for the theater was invited to mount a decor which, whatever its plastic qualities might be (thanks to this or that man's powers of pictorial invention), remained a decor in the strict meaning of the word: i.e. a picture *in front of* which a story was to be enacted. So the theater called in painters to work for it in just the way that Chagall worked for the ballet. Apart from the choreographic forms that have come into being since the war and have taken the lead in dramatic spatial research, without Chagall's being called upon to make any contribution, the world of ballet remained a world of beautiful fairy tales. Chagall, therefore, whose world was closest to the fairy-tale world, must be required to give it its decors.

But when he really did get to grips with the theater Chagall discovered the real problems of theatrical space, and brought an original solution to them. Was it intention or luck, chance or premeditation? Chagall's contact with the theater was made through a small group of men who were much attacked and vituperated. They had set out to destroy the pictorial conception and the impossible naturalism of a theater that remained a willing prisoner of the Italian model. Its last representatives were Stanislawsky and later on even Brecht. The group was Meyerhold's "Théátre de Style", and Chagall met them thanks to the playwright Nicolas Evreinoff. Meyerhold did not envisage the theater as a shut-in place confronting the equally shut-in space where the audience sat, nor as a place in which a representation of the real world should unfold. For him the theater was something wholly fabricated, a work of art, from the spoken text to the actors' interpretation of it. It certainly must not try to deceive, must not attempt to create the illusion of being reality in the guise of a play. It must be a total work of art, fulfilling its poetic, didactic, and mythical function in the form of a show, by creating the necessary conditions for the spectators' real participation: a work of art present

Introduction to the Jewish Theater.
1920/21. Tempera and gouache on canvas. 9'3"x25'10".
State Tretiakov Gallery, Moscow.

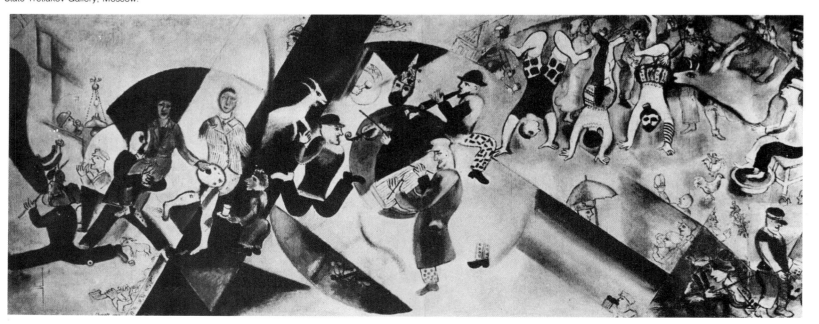

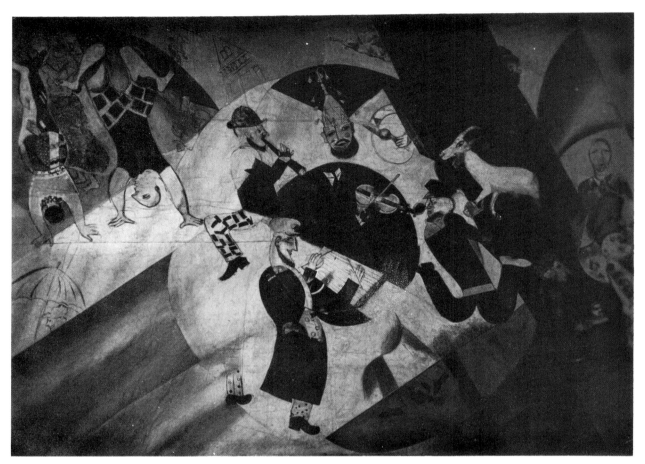

Introduction to the Jewish Theater.
Details.

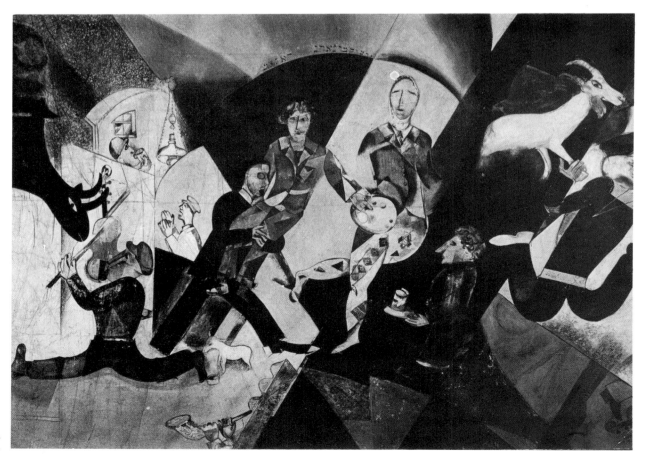

Introduction to the Jewish Theater.
Details.

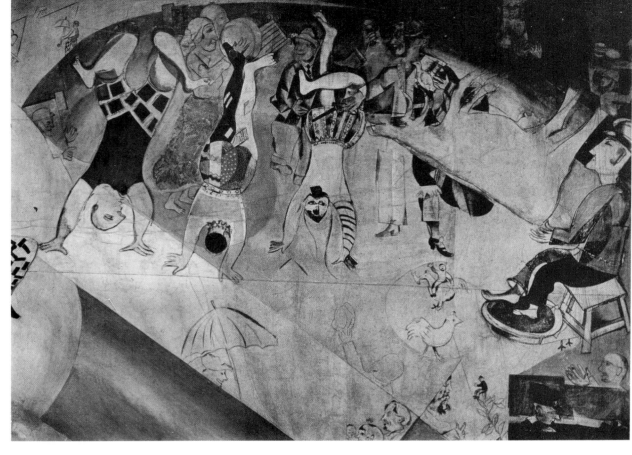

Introduction to the Jewish Theater.
Details.

by the fact of being presented, not a mere illusion of some false reality.

The creators of the "Théâtre de Style" were opposed to naturalism in all its manifestations. They were in complete sympathy with every art form—whether painting, literature, or music—which successfully affirmed the prerogatives of invention and transposition and the specificity of its own productions. Chagall had returned to France with his highly original plastic style, which had developed from his assimilation of fauvism and cubism to his own figurative predilection, with all its fantastic, surrealistic and poetic realism. He became a privileged partner of the group. As Apollinaire first suspected and then proclaimed aloud, he was both painter and poet, poet and painter, the one conditioning the other. Other painters, by contrast, were either illustrators only, in the illusionistic sense of the word, or else they were deliberately opposed to any objective signification, any figurative representation whatsoever of anything at all that could be seen or said. Chagall's very nature drew him to the "Théâtre de Style", just because of his being both painter and poet. The meeting was characterized by such identity of views that from the very first works done in common, in 1915, Chagall could quite happily take up again some of the paintings he had already done, and use them for

sets and sketches. Thus for Evreinoff's *To Die Happy* he simply took up *The Drinker* of 1912 again: his works had enough "style" to adapt themselves to what Meyerhold's group expected. It might seem that you could accuse Chagall of still being just an easel painter blowing his works up to much larger dimensions, the only difference from other established decor painters lying in the stylization. But Chagall's works between 1910 and 1920 present such a tremendous modification in painting of the way of representing space that their transfer to the theater entailed in itself a modification of the nature of decor as it was traditionally understood. With sets such as these the producer was not given a picture *in front of* which he would dispose the action. He was compelled to give the action back its rightful space, i.e. the whole of the stage area.

Between 1917 and 1921 Chagall suggested sets and designs for curtains and costumes either for Meyerhold or for the "Ermitage experimental theater" or for the "Moscow revolutionary satirical theater" or even in the end for Stanislawsky, the plays being by Gogol ("The Government Inspector", "The Gamblers", "Marriage") or by Synge ("The Playboy of the Western World"). But none of them was carried out. The new aesthetic being proposed was too premature, and came up against every imaginable difficulty. All Chagall got from

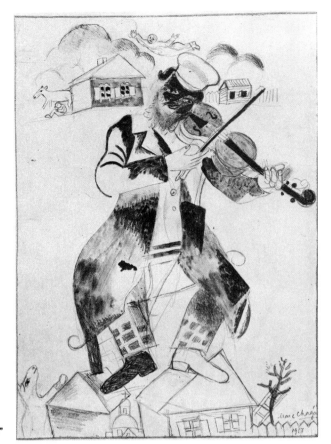

Drawings for **"The Music."**

92

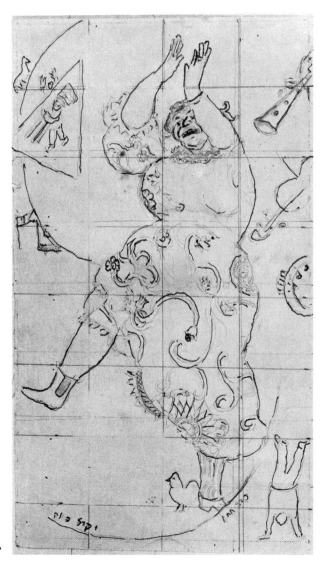

Drawings for **"The Dance."**

the authorities was a long series of refusals.

In these sets, especially the ones for Synge, what we have is by no means a description of an enclosed scene on the stage, in the form of a beautiful picture which the producer has only to spread out and so fix decorative walls for his acting space. What we find instead, in addition to expressive stylized research for characters and costumes, are images for the sets that are a synthesis of the front and perspective views of the stage and of the aerial view of the same stage area, in plan. This means that the entire space, in all its dimensions, becomes the dramatic setting for the action, and not a framework for the decor. The walls disappear, leaving the stage area open on all four sides. So the designs provoked one of the first known breaks with the sacrosanct traditional opposition or confrontation of the spectators' social area and the dramatic area. Chagall is, thus, one of the people who invented the replacing by scenic elements of the framework decor in the form of a descriptive picture of a fully determined place. In the old tradition the theater was thought of as being a "tableau vivant", and the painter indicated a realistic decor, in perspective, on a flat-surface picture. That tradition gives place, with Chagall, to plastic animation of the dramatic area as a whole.

Chagall's only works in this field that were actually carried out, in the period 1919-1921, were the decors and costumes for some little plays, some "miniatures" by Sholem Aleikhem for the "Moscow theater of Jewish art" directed by Efross and Granowsky. They were in the same style and spirit as the Gogol and Synge projects. There the first group of works by Chagall, in which he solved the problem of a theater that was conscious of its true nature, unfortunately comes to an end. Thereafter people took care to demand of Chagall that he remain simply a prodigious illustrator. I mean by this that his illustrations truly are prodigious, but that he was never again authorized to live and act what we could call the real adventure of the theater. The adventure itself was forbidden in the theatrical world, or else it was condemned to that clandestine struggle which is the lot of revolutionaries, in the cultural domain as well as in others.

The second group of works, doubtless more illustrative in character than the first, is interesting for a different reason. It is the group of decorations for theaters and theater halls that stand out as landmarks in Chagall's career: 1921, decoration of the "Moscow Jewish art theater"; 1949, decoration of the foyer of the "Winter Gate Theater" in London; 1959, the foyer of Frankfort theater; 1963, the ceiling of the Paris Opera; 1966, the Foyer of the "Lincoln Art Center" in New York.

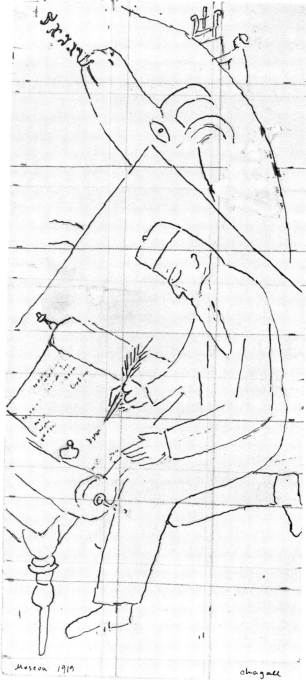

The foyer decorations presented no specific problems, but the hall decorations belong to a certain conception of the theater as a place of communal celebration. At the "Moscow Jewish art theater", which occupied a small rectangular hall that had not been designed for this use, the decoration consisted of a long fresco on one of the longer walls and facing it four compositions on wall sections between windows, together with a stage curtain. The four compositions are allegorical figures of Music, Dance, Literature, and Theater; they are large, cubist figures, dynamic and full of color, at the same time Biblical and bannal in character. The same is true of the stage curtain, representing love in the theater. The fresco is an introduction to Jewish theater, a sort of satirical and picaresque procession of theater and circus characters and accessories. It takes the path of a long ascending diagonal, applied over an abstract, geometrical, ground of bands and circles that accentuate the discursive movement. The style inherent in these monumental decorations, which transform the social area of the ground floor into a space of the same

Drawings for **"Literature."**

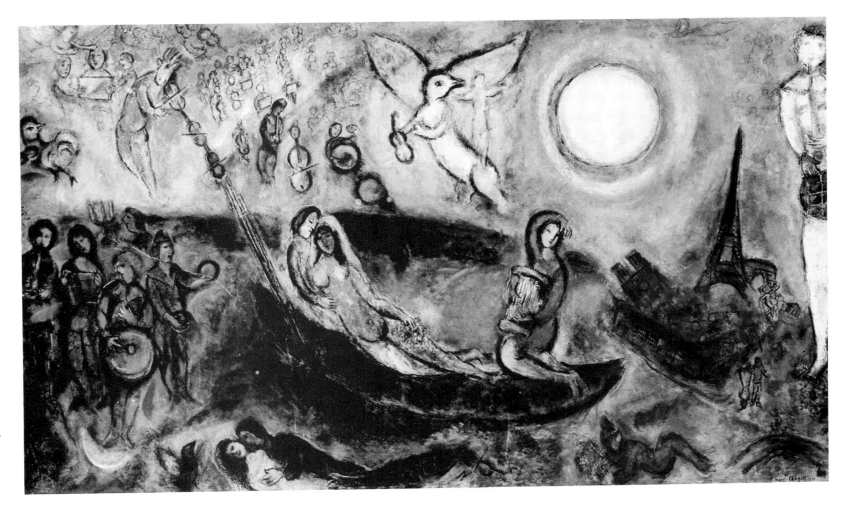

94

nature as the dramatic space confronting it, is the same as that used for the scene on-stage in the plays put on at the theater with Chagall's decors. Thus the ornamentation of the auditorium was no longer a mere prettifying of the walls: in effect it was all part of the invention of that particular, artificial place which the theater in its entirety is.

At the Paris Opera the ceiling is part and parcel of the extraordinary decor which the architecture of the Palais Garnier itself constitutes. Chagall found that he was obliged to respect the amphitheater as being a separate entity, intentionally sharply divided from the stage area, so as to face it. He accepted the challenge, and worked in such a way as imperceptibly to reunite all the separate elements. He created a ceiling that was sumptuous and at the same time discreet. It is based on the circle and the cross, and makes systematic play with asymmetry and displaced motifs. The garland motif appears to be divided up in obedience to the cross, but in fact it obeys the pentagon; although it is apparently balanced by the cardinal diameters and punctuated by a clearly separated central motif, the garland of the motif in concentric registers never actually converges toward the middle nor is it ever divided equally by the diameters. The effect is one of equilibrium and regularity, whereas really the composition is a mass of small but appreciable displaced elements and of dynamically swirling and off-balance units, on the bias. The sky wells up, all movement and scintillation, leading the eye towards the stage area; yet at the same time it holds to its proper place, and is in keeping with the opulent and showy diapason of Garnier's style, by its proper fantasy and baroque spirit.

I must be excused for adding a word to the quarrel that arose from the commissioning of this ceiling; the ceiling is well and truly there, in place, and you have to have looked at it in the course of a performance to understand how great a work of art it is and see how, at the age of 76, Chagall did victorious battle with the space, the theater and the architecture—with what wonderful spirit and fervor—and by his talent put life into them. In the Metz windows and the Jerusalem windows the visionary maker of images had already proved that he knew how it could be done.

DENIS MILHAU

Curator of the Musée des Augustins, Toulouse.

chagall in full flight

by guy weelen

André Malraux was the one who asked Chagall to create a new ceiling for the Paris Opera. It seems that the idea came to him when, during a gala evening, he attentively examined the work of Lenepveu and definitely received no response.

There is no need to make it a secret: the Paris Opera is a pompous, overdone monument. Even if it today forms a part of the glorious image of Paris, it is none the less monstrous because of its overabundant ornamentation, its veritable redundancy, although the architecture on the inside is, so it seems, perfectly adapted to its intended purpose. In his study of Marc Chagall's ceiling Jacques Lassaigne has written:

The Paris Opera is striking on account of its architecture and because it bears the mark of a powerful temperament, that of Charles Garnier, whom we want to see as representative of a definite period although he surpassed and in many ways differed from it. He created an atmosphere, a very personal style, and he was successively praised and violently criticized until finally he imposed himself by his very excesses, his ornateness grafted on a functional and rigid framework.

If we must be grateful to Garnier for having invited Carpeaux to execute *The Dance*, the only group in the mediocre collection of scuptures that merits some esteem, we should be aware that Garnier was not so fortunate with respect to painting. How could he be? The painters that he might have called upon either did not suit his temperament or did not figure on the list of officially accepted painters.

In that enormous edifice dedicated to music and movement, where the line is often displaced, even destroyed, the ceiling had to be like a call, a summons, amid the radiance of the purples and golds. The dome had to have a presence, an ampleness so that in the general tumult it could make its voice heard without becoming imposing or creating a harshness. In a few words this underlines the scope and complexity of the problem with which André Malraux's proposal confronted Chagall. We can understand why, to use his own words, he was "troubled, touched and deeply moved." His uneasiness lasted for a long time, but the offer seemed so interesting and tempting that he slowly began to compose circular sketches, taking into account the particular constraints imposed on him by the general character of the architecture and especially the fourteen gilt heads jutting out from the edges of the ceiling. To someone else these constraints might have seemed burdensome, but I believe they stimulated Chagall's imagination, offering a resistance that triggered both his curiosity and his desire to execute a difficult work.

The numerous sketches and studies Chagall made show the care he took first in determining the areas of color and then in choosing the elements to be distributed over the surface of the dome; these elements, in turn, were meant to be absorbed by the color or to come and float on the surface in order to form a large fluid ring marked by alternating rhythms. As a result, the evocations were selected gradually and, under his hand, they became responsible for singing in their own way the music and the musicians who haunt his spirit. Jacques Lassaigne has observed to what degree the first sketches "reveal two principal lines of research: the installation of great masses of color and a thematic development going as far as an extreme precision of detail." In short, the ceiling was to be divided in five colored areas, each with its dominant color to celebrate the artists Chagall chose to honor. Blue for Moussorgsky and Mozart, green for Wagner and Berlioz, white set off by yellow for Rameau and Debussy, red for Ravel and Stravinsky, yellow for Tchaikovsky and Adam. In these two last parts Chagall pays tribute to the ballet by evoking *Daphnis and Chloe*, *The Firebird*, *Swan Lake* and *Giselle*, but this basically traditional organization, with dominant warm and cool colors sustained by complementary colors or intensified by the mixing of colors, cannot contend with the centrifugal force that imparts a remarkable unity to the composition. The transition between the different zones is no less important than the harmony which is created inside each between the two adjacent walls. There are areas of influence and approach, and the unity is accentuated by three major axes that carefully balance each other, each of which functions like the backbone of the composition: a perpendicular Eiffel Tower answered by the diagonal of Berlioz' lovers and the subtle alliance of the two great angels of Moussorgsky and Mozart.

Chagall invoked Moussorgsky as the father of Russian music, and he has focused on Boris Godunov. If the father is the cruel killer of his son, he also contributes in the drama to the birth of a nation. The tsar is shown on his throne under an array of cupolas and steeples. The geometrical accents of 1917-1919 are visible, and the figures are half personages, half houses. The great angels with their beating wings punctuate the composition. A double-faced red-winged angel for Boris, is contrasted with the smile and inner tenderness of the angel who spreads his wings in Mozart's orb. Here we notice blue palms, stars with crisscross shafts that extend the adornments of the gilt heads of Garnier's border.

For Chagall, Berlioz symbolizes French romanticism, and Wagner transposed into music the most moving pair of lovers to bear the weight of destiny: Tristan and Isolde, who soar in an enormous green expanse along with Romeo and Juliette entwined and carried away on a huge horse. Isolde's gown is transformed into a river, and Juliette's is spangled with stars and crescent moons. She extends diagonally across the whole composition. In these figures Chagall recaptures the tenderness of the lovers with bouquets he did in the 1930s. The

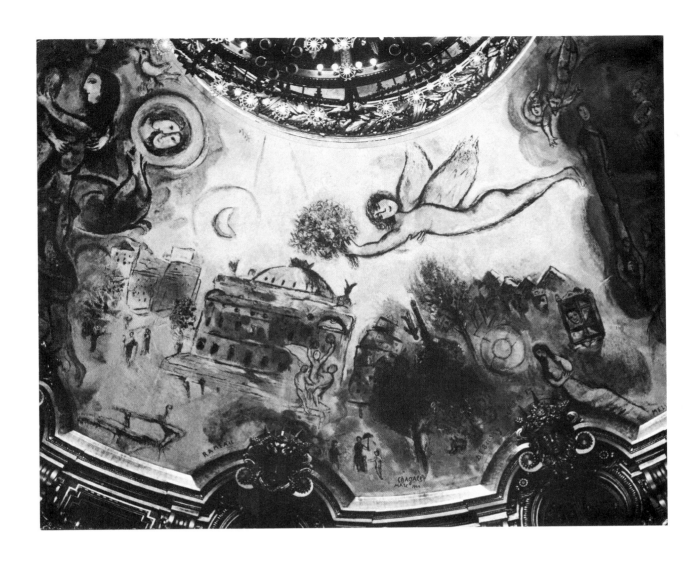

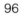

Ceiling of the Paris Opera.
Detail. 1964.

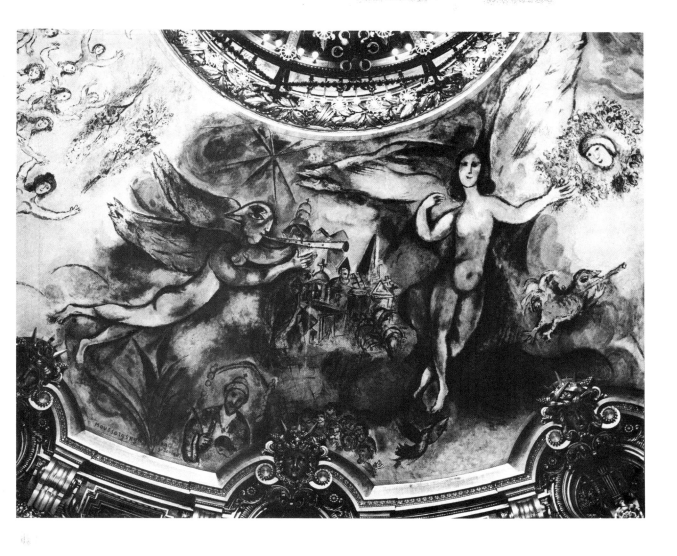

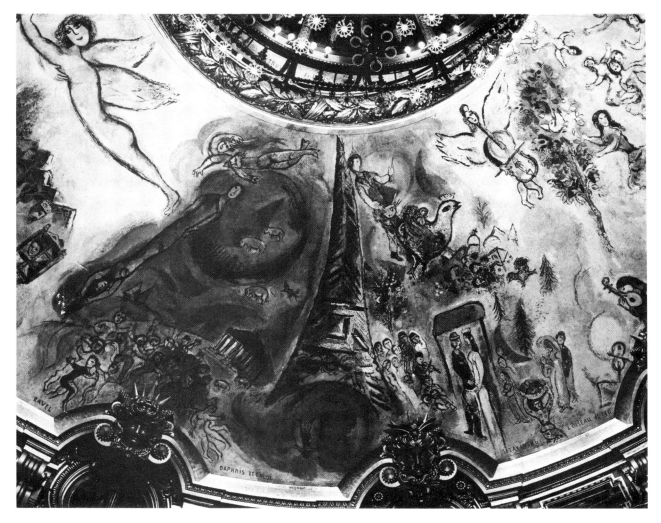

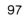

Ceiling of the Paris Opera.
Detail. 1964.

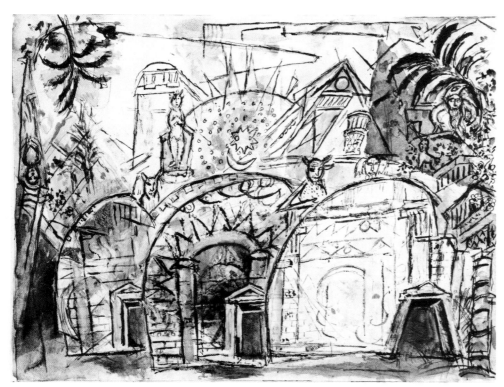

Drawing for curtain of **"The Magic Flute."** Act I. Scene 5.

98

landscape that accompanies them renews the theme already dealt with in the *Lover of the Eiffel Tower.* The Place de la Concorde is evoked by the dawn, and the Arc de Triomphe bursts out with the flaming red of passion. For the artist this series of images incessantly renews the themes of eternal love.

A large, clear expanse scattered with red and gold and a few patches of intense blue opens up to show the continuity of French music. In it the Garnier palace explodes like a red fanfare, and Carpeaux's dance flashes with gold. The trees, blue like reflections, are mirrored in this vast river of music. Not far away, behind the foliage, rises the misty palace of Mélisande, and the princess herself, combing her hair, bends forward at the edge of the ceiling. Suddenly we see, isolated from time and torn away from space, the blue window of an isba in which Pelleas' face appears. The artist has given the face Malraux's features, just as painters did in the past when they wished to honor their patron.

It was by designing the sets for the ballet of *Daphnis and Chloe* that Chagall, so to speak, "entered" the Opera. He chose to honor Maurice Ravel and especially this work. Rather paradoxically perhaps, the painter selected red to signify both, but this violent color can be explained by the passionate nature of the ballet. The grazing sheep, the sea and the sails, as well as that double-enlaced body—like an arrow shooting through the composition—bathe in this fused matter. At the bottom of the group a bacchanal unfolds and starts to beat like a wave breaking against the circumference of the ceiling. All at once, like a rock, a huge Eiffel Tower rises; it is simultaneously a steel framework and a sparkling Christmas tree. This big vertical does not cause a break; rather, it unites the revery of childhood and the world chosen by the artist. The painter leans against it, holding his palette and contemplating the universe he has created. We recognize his fabulous imagery: the crowned cock strutting above roofs and domes, strolling musicians, bearers of offerings, fir trees in a little meadow where a poet reposes, violins that play by themselves, lovers under a marriage canopy.

To represent Russian folklore, Chagall chose Stravinsky, but gave him a relatively small part. By doing so Chagall demonstrated his international sense of art, implicitly answering those critics who thought he would be incapable of forgetting his origins and would only invoke his personal mythology to praise music. Stravinsky could have provided the pretext for the expression of violent contrasts. Instead, Chagall chose a glittering yellow for him in which he makes light, airy dancers whirl. Thus he glorifies ballet, depicting movement free of anecdote and even scenery. *Swan Lake* is represented by a beautiful blue figure carrying a bouquet and reclining on the coiled neck of a swan. Here we can clearly see Chagall's capacity

Papageno. Costume for *"The Magic Flute."* 1967

for wonder, his sense of beauty independent of any geography or country. Hadn't he already in his illustrations been able to appropriate the myths of Gogol in whose humor he discovered his own expression? Hadn't he, illustrating La Fontaine, renewed his technique and his themes? Hadn't he felt like a Greek among the Greeks of antiquity? And to narrate the Bible hadn't he found images that provided the legend and the story with significant additions?

Inside the vast dome of the Opera there is another circle that the branches of the huge chandelier make it difficult to see. Four groups form a homage to Gluck, Beethoven, Verdi and Bizet. Chagall conceived this unit as a separate composition with its own rhythm, as an accompaniment to the general composition.

The extreme care that went into the work on the ceiling is comparable to that of an easel painting; every detail was thought, felt and carried out according to what Chagall had desired. Offering this work to France, his adopted country, he declared:

I wished to reflect, as though in a mirror high above, in a bouquet of dreams, the creations of actors, of composers; to recall the colorful movement of the audience below. To sing like a bird, without theory or method. To render homage to the great composers of opera and ballet.

If I have insisted on first describing the ceiling of the Opera, it is because this vast, superb composition stands like a fixed point in time in relation to Chagall's work with the dance, music and the theater. A set for a ballet or an opera, even if it is used repeatedly, is ephemeral, and the ephemeral is perhaps one of the secret pivots, perhaps the most touching, of Chagall's work. This is why it is important to follow the artist's long association with the world of the theater. It began in his childhood and has a guiding thread that has become more and more apparent over the years: imagination.

In his youth Chagall worked with Bakst, but too many differences put him in confrontation with his elder and with the group to which he belonged along with Benois, Roerich, Golovine and Bilibine. Influenced by the Munich style, these artists created historical reconstructions based on research and documentation of the past. Chagall had other aims, which is probably why he preferred not to respond to the invitation of the Russian Ballet to participate in making collective sets. The work he did between 1919 and 1921 for the renovation of the Jewish theater had helped Chagall discern his path. In 1917 he worked with Evreinov, a friend of Meyerhold, who also sought to liberate the imagination of the spectator. His most fruitful collaboration was with the actor Michöels, whose very acting style was changed. In effect, *Chagall imposes on the characters a new structure that introduces into*

Drawing for curtain of **"The Magic Flute."** Act II, Scene 1.

Queen of the Night.
Costume for *"The Magic Flute."*

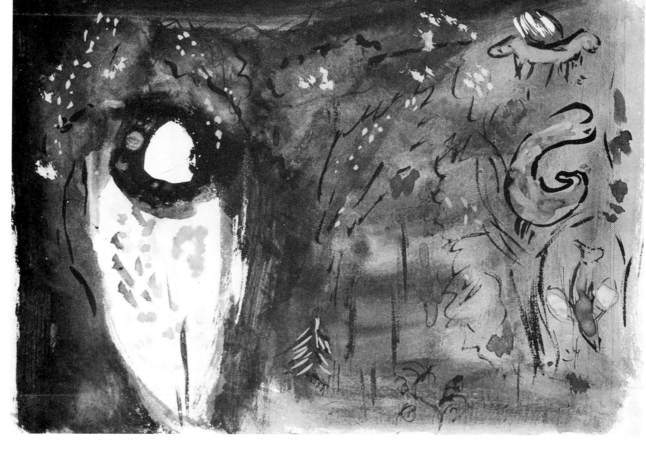

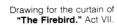
Drawing for the curtain of
"The Firebird." Act VII.

their portrayal, in addition to their character traits, a veritable prefiguration of the action that will sweep them away.... For him, the final spectacle should function as a complete unit in which sets, costumes and lighting as well as the performance of the actors translate the bursting forth and the development of the idea....

In other words, he does not limit himself to being at the disposal of the work but wants to assimilate all the elements in order to cast them in a single, perfectly homogeneous, plastic expression which envelops and represents the work from then on, and corresponds precisely to his intentions. Chagall dreams of a total spectacle, and no part of it should be isolated; the sounds and the forms should echo each other, lines and movement should harmonize, interlock, and every aspect penetrate every other aspect in order to attain unity.

Hence, scorning the relationships of everyday logic, Chagall invents in order to make us lost, mixes everything up in order to disorient us, because his objective is to break the ties that bind the imagination in order to liberate it; he wants to create a state of wonder which we can share. Thus he was able to say to Jacques Lassaigne: *I wanted to penetrate the spirit of* The Firebird *and* Aleko *without illustrating them, without copying anything. I don't want to represent anything. I want color to play and speak alone. There is no way of equating the world we live in with the world*

we enter in such a way.

The plot of the ballet *Aleko* is based on the very beautiful poem *The Tziganes* by Pushkin. It is a tragic love story in which a fantastic delirium takes possession of the young poet-assassin. Tchaikovsky illustrated it in his *Trio in A Minor* for piano, violin and cello; he himself considers that "the general tone of the work is gloomy" (letter of January 12, 1882). The sets and costumes for the ballet *Aleko* were commissioned from Chagall at the end of 1941 by Lucia Chase and Sol Hurok for the New York Ballet Theater company. Chagall, always meticulous about details, worked for months in New York with Leonid Massine, the choreographer, steeping himself in the music, listening over and over again to Pushkin's beautiful verses read to him by his wife. For various reasons the ballet was never performed in New York but in Mexico, and it was thus on the spot that he size-painted the four big canvases for the set. Despite their imposing dimensions, they are still intimate as well as evocative; they resemble enormous reveries that are more impregnated with the atmosphere of the ballet than they are with references to the actual vicissitudes of the plot.

In the first set, a pair of lovers surges up in a cloudy tempest, a pale moon pierces the mist through which, like a clap of thunder, a red patch in the form of a cock suddenly busts. These four elements are quite separate from one another, yet

the eye is irresistibly attracted by the spots of color on the young girl's dress and is drawn along a path from the white expanse to the white halo.

The second set depicts an immense green and violet bouquet stamped with black and suspended above a red bear brandishing a violin. In the upper left are two very freely placed blues; then, under a delicate pink mixed with yellow, the horizon curves, and we discern the faint outline of a village.

On the yellow background of the third set, a huge sun with diffused rays and an enormous red, white and yellow target appear and form a cosmic whirling above a river bordered by high grass; a blue boat floats indolently on the river and out of it suddenly rises a large scythe, the apparition of death. This scenery instantly recalls and underlines the circles and rhythms which occured in Chagall's pictures around 1911.

The fourth curtain is certainly the most intense and the most moving. Above a red line, monuments, rise up evoking Saint-Petersburg. Blocked off by the green mass of a cemetery hill, the entire composition is barred by a broken-down white horse pulling a cart. An illumined chandelier is poised in a golden orb.

All these canvases evince Chagall's concern with the idea of building up pictures by juxtaposing and distributing clear and dark masses on a surface. The idea of fluidity constantly haunts him, and he is careful not to dam it up by using forms that would be too evident or imperative. Under the brilliant beams of the spotlights Chagall wanted his work to manifest a radiance of colors and to conserve a character of passionate effusion.

The Firebird, for which Stravinsky composed his explosive music in the first decade of this century, is based on an old Russian fairy tale. The Russian Ballet Company performed it for the first time in 1910. The new version, performed by the New York City Ballet was directed by Balanchine and had its world premiere in Covent Garden in London on July 20, 1950. Chagall began working on it in 1945, after the terrible period that followed the death of his wife, Bella. Assisted by his daughter, who helped him mainly with the costumes, Chagall painted, once again by himself, the enormous curtain and the three sets for the ballet. This legend of triumphant love reached deep into Chagall's soul, and he passionately threw himself into this new undertaking, giving free rein to his familiar fantastic ideas.

On the opening curtain *The Firebird* appears shrouded in midnight-blue above an uncertain horizon line, with its great wings spread wide bearing a woman, her head thrown back, who represents a homage to Bella. On the ground a horseman gallops; an angel hovers above the domes, a monster stretches his limbs and the dampness of the earth contrasts with the freshness of the sky.

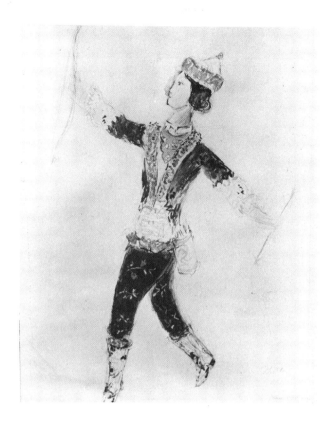

Prince Ira.
Costume for *"The Firebird."*

The Princess.
Costume for *"The Firebird."*

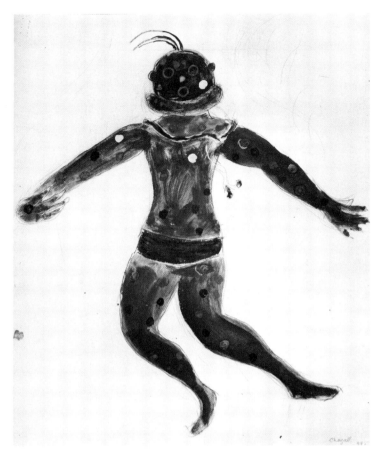

The Demon.
Costume for "The Firebird."

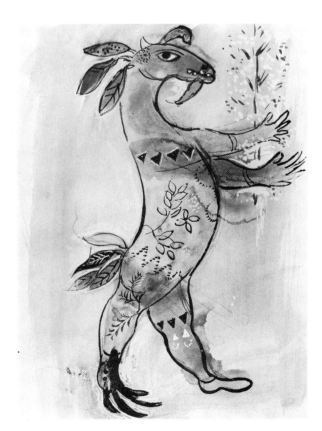

The Monster.
Costume for "The Firebird."

The first backdrop is a forest so enchanted that it is repeated twice, as if it were looking at itself in a mirror. Winged animals, lost birds, wakeful griffins are huddled under the foliage, and the forest is full of mysterious paths that go nowhere, like a lot of traps meant to lead one's footsteps astray. A vast blue zone in the middle seems to be at once a river and a sky in which the moon and the sun are simultaneously reflected. The composition of the second backdrop has great suppleness. We see the explosion of a bouquet of flowers bursting out from a forest where lions prowl, and this is balanced by a fantastic animal, a mixture of feathers and scales, whose flank bears the castle of the Sleeping Beauty. Between the two extends a large pale pink space in which a young girl climbs a ladder leading to the palace. The whole curtain is endowed with extreme lightness. We understand what Chagall expects from color: power and surprises. The third backdrop is organized around a harmonious interplay of reds and whites. It consists of sweeping, dynamic circular forms out of which emerge angelic musicians, blue cows carrying torches and bells whose sound is lost in the wind. Triumphant love shines and blends with the sunlight. Like an arrow, the young girl, freed at last, and the prince spring toward another world.

With great lightness Chagall reinvented the circular forms that structured the space in his large compositions of 1911-1912 and which he resumed in 1933, 1949 and 1953. His sets, although related to the past, are the manifestation of new concepts. Chagall assigns to color the role of organizing space. The scattering of objects and figures creates systems of tension in which the solids have the importance of the voids. Thanks to them the scattering technique becomes a prelude to fluidity; it is a stratagem in the rules of the game perfected by the artist.

For a long time Tériade, the noted publisher, had cherished the idea of having Chagall illustrate the pastoral romance attributed to Longus, *Daphnis and Chloe*. Before undertaking this delicate work, Chagall felt he had to go to Greece, which he visited twice, in 1952 and 1954. These voyages made very deep impressions on him, revealing to him the Mediterranean miracle. He had already started work on the illustrations when, in 1958, he received a commission for the sets and costumes of a ballet for the Paris Opéra based on the symphonic suite, *Daphnis and Chloe*, by Ravel. Chagall, who greatly admired the composer, was delighted by this proposition and saw in it a chance to break the chain of unfortunate events that until then had always seemed to obstruct the attempts to bring this work to the stage. The ballet had been performed by the Russian Ballet at the Chatelet Theater in 1912 with costumes and sets by Leon Bakst and choreography by Fokine. which at the time was sharply criticized; but, times having

changed, it nonetheless was used by George Skibine as the basis for this new homage to Ravel. The musical work is delicate and complex, balancing impetuous vitality with almost static moments. Aside from the kidnapping of Chloe by pirates, it contains few dramatic elements; it is above all a mood work in which Ravel exalts youth and the lyrical emotions of the young lovers. This impressionistic poem loans itself to the subjective vision of each listener, and how to clothe it seemed to be a sort of wager which, however, did not frighten Chagall.

Rather than trying to provide a description, Chagall decided to create an unsubjugated, independent work, and with this in mind his primary recourse was to use color and intensity. The richness is excessive but fully satisfying for the spectator who, once swept away by the sounds and the color, surrenders totally to it. Chagall here used light, mottled paint which the luminous effects support, giving it an almost phosphorescent sparkle. The costumes have no precise character; elements from the forest, flowers or vegetation, they blend in the general fairy-like atmosphere. Color then becomes a sort of prolonged vibration of the music. Yellow and blue predominate in the first curtain; dark blue spangled with a few reds, yellow and white in the second; glittering yellow in the last. Chagall created a magic space, favorable to passion, where the spirit of Greece seems present and that was ideal for the incarnation of the fable. Just as the midday heat makes a landscape shimmer, so all the forms lose their contours in the trembling radiance of the colors.

Once again, the precise outlines of the composition must not be defined by geometry but by other criteria. The figures, temples, fish, gods and goddesses are dispersed around the circumference of a huge oval where, as in the *Nympheas*, fragrant groves are reflected. We lose all consciousness of a fixed place, of the idea of above and below. On the contrary, the second curtain opposes the flashing mass of the waters to the distant line of the islands, which takes on the look of a gigantic fish. A red moon explodes like the clash of cymbals. Pursuing his idea to its limit, Chagall created for the third scene the equivalent of the lofty exaltation of a shimmering light. We can barely discern the line of a road with temples alongside or that of the crest of the hills; in its illumined outburst, the color becomes like the stridulous flute of a young shepherd in the beatitude of noon.

Here, as in no other ballet perhaps, Chagall has attained the high point of the incandescence of color, the fluidity of the great works of Monet, the secret tension of Mallarmé. It was difficult to do, but he did it. In its very structure, the decor exaltedly depicts the first innocence of a world where love was pure.

Chagall was offered yet another opportunity to execute a total spectacle in which sounds and

The Horse.
Costume for *"Aleko."*

103

The Cat.
Costume for *"Aleko."*

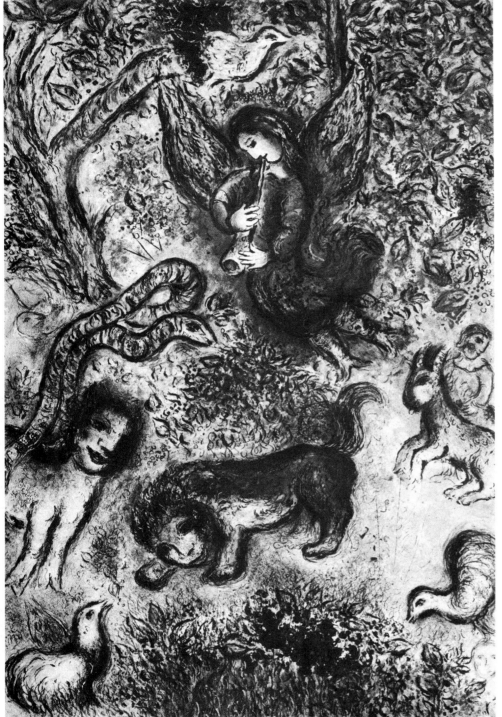

The Magic Flute. Poster executed for
the performances at the Metropolitan
Opera, New York. Color lithograph,
1967. 39⅜x25⅝″.

colors, intermingled, would seem to have the same
essence, the same origin. He undertook the sets
and the costumes for Mozart's *The Magic Flute*
which was to be performed by the Metropolitan
Opera of New York in 1967. Chagall has a pre-
dilection for Mozart and especially for that her-
metic and fantastic work:

I adore Mozart, I couldn't refuse. He's a god, and
The Magic Flute is divine, the greatest of all operas.
No, I don't know why. It's impossible to say why
a god is divine.... I got as close as I could to Mo-
zart, who is so witty, so spiritual, so religious.

This project was the result of a meeting in 1964
between Gunther Rennert, a producer from Mu-
nich, Rudolf Bing, director of the Metropolitan
Opera, and the artist. Chagall threw himself into
this delicate and difficult undertaking with his
usual ardor. During three years he composed no
less than thirteen great curtains (54'×33'), twenty-
six smaller canvases and almost one hundred and
twenty-one costumes and masks. After having
studied the staging and untiringly nourished him-
self on that music, Chagall gave his sets and models
to the theatrical workshops who would execute
them.

Chagall's anxiety was such that he came to New
York a month before the scheduled date of the first
performance. He then discovered that the sets,
costumes and masks were nothing more than start-
ing points and that he had to rethink them and
take them up again. Feverishly, he painted an im-
mense homage to Mozart for the opening curtain.
To give more density to his costumes, he changed
the shapes, redid the colors and used different
materials in order to accentuate the textures. He
let his imagination go, gave himself up to bursts
of inventiveness and pushed the expression of form
to the limit. He sought out the superimpositions
and transparencies that would be best adapted to
the vicissitudes of the action, the lighting that
would convey the work's unreal atmosphere, and
the successive iridescences that would metamor-
phose the forms. However, all his effects definitely
did not transform the original work and should
rather be thought of as a pursuit of density. His
love of Mozart's music impelled him to discover
a specific tonality that would imbue the work and
become consubstantial with it.

For many, the monumental is expressed through
the imperatives of geometry, but Chagall has a dif-
ferent idea. For him, it represents the history of
the long development of his inner world. Great
audacity was required to renounce precision and
trust color alone, trust its power and intensity, to
attain fluidity. Yet that is precisely the measure
of Chagall's undertaking and what he accomplish-
ed. It enabled him to obtain that dazzling fusion
of sounds, forms and colors so often sought by
other means and so rarely achieved.

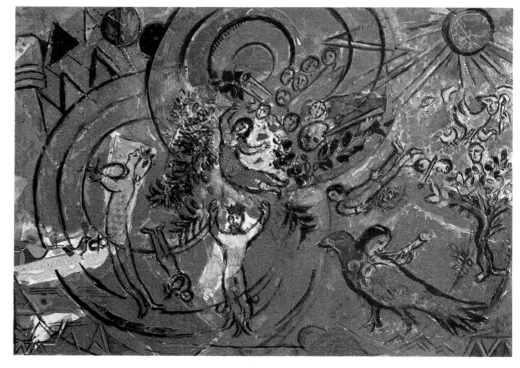

The Magic Flute.
Sketch for set of finale, Act II,
Scene 2. 1966.
Gouache on paper. 20½x28″.
Private collection.

La Flûte enchantée. 1966.
Maquette au décor *Finale* Acte II, Scène II.
Gouache sur papier 52x71 cm.
Collection privée.

The Magic Flute.
Finale scene at
the Metropolitan
Opera, New York.

Scène "Finale" au
Metropolitan Opera à New York.

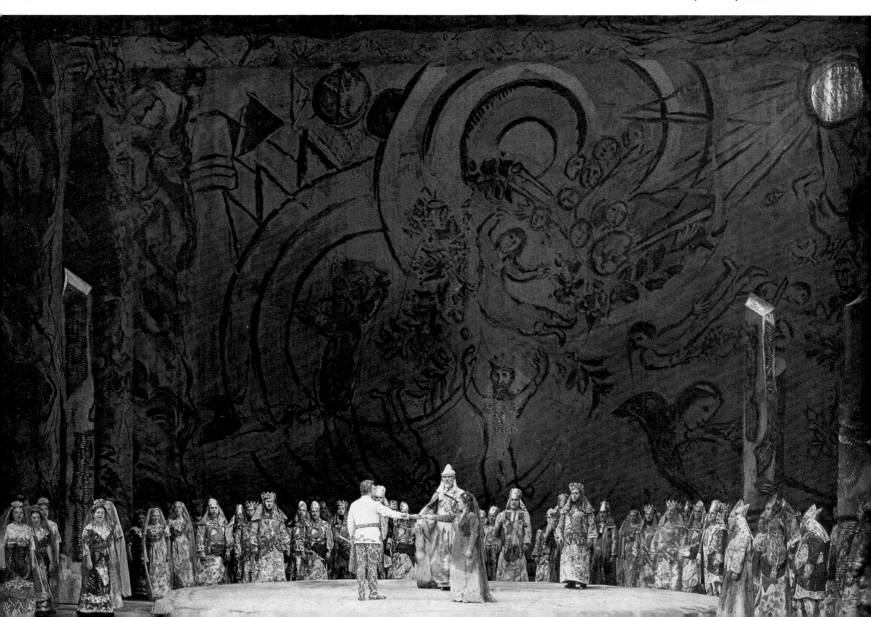

THE SOURCES OF MUSIC.

1. Orpheus and King David. 2. Beethoven. 3. Fidelio. 4. Bach and Sacred Music. 5. Romeo and Juliet. 6. Wagner (Tristan and Isolde). 7. The Angel Mozart. 8. The Magic Flute. 9. Homage to Verdi. 10. The Tree of Life. 11-12. New York.

LES SOURCES DE LA MUSIQUE

1. Orphée et le roi David. 2. Beethoven. 3. Fidelio. 4. Bach et la musique sacrée. 5. Romeo et Juliette. 6. Wagner (Tristan et Iseut). 7. L'ange Mozart. 8. La flûte enchantée. 9. Hommage à Verdi. 10. L'arbre de la vie. 11-12. New York.

The Sources of Music.
30x36'.
Drawings for the paintings
at the Metropolitan Opera
House, New York.

Les sources de la musique.
9,144x11 m.
Esquisse pour le tableau au
Metropolitan Opera House, New York.

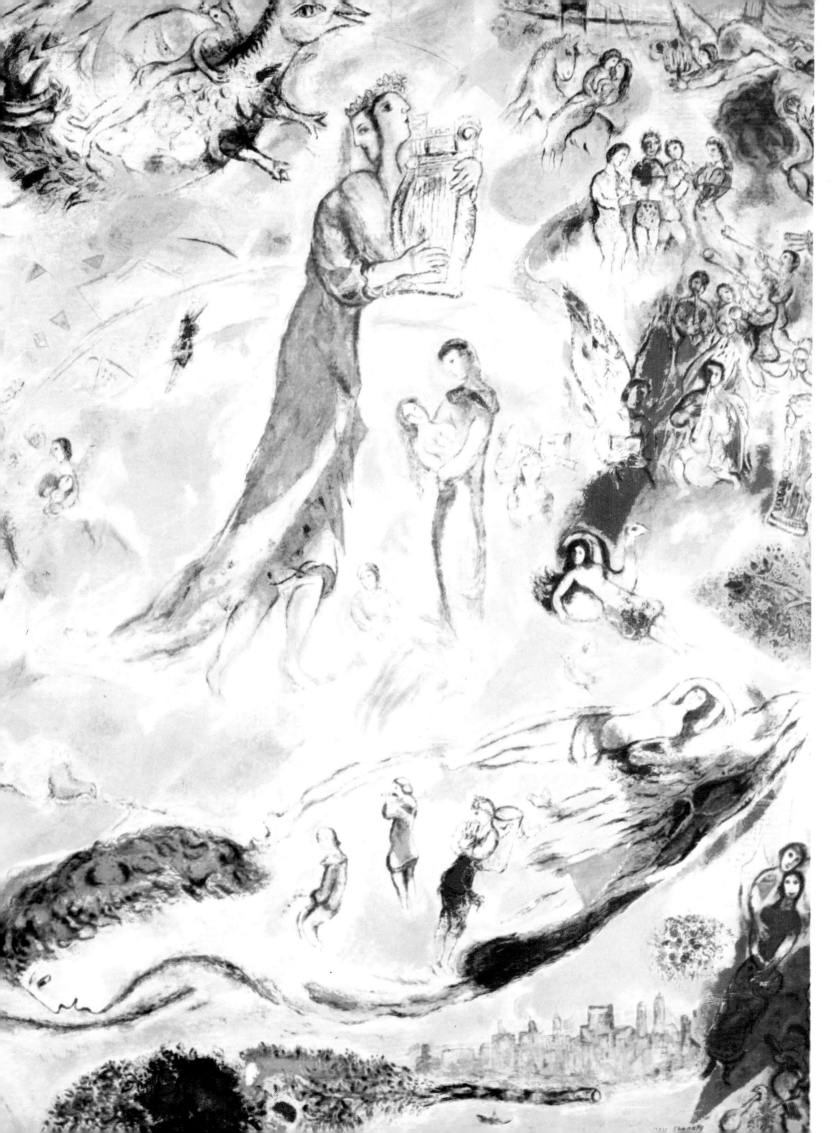

THE TRIUMPH OF MUSIC

1. The Song of the Peoples. 2. The Musician. 3. The Singers. 4. The Ballet. 5. Homage To American Music. 6. The Firebird. 7. Homage To French Music. 8. To Rudi Bing. 9. Russian Music. 10-11. Chagall and his Wife. 12-13. New York.

LE TRIOMPHE DE LA MUSIQUE

1. Le chant des peuples. 2. Le musicien. 3. Les chanteurs. 4. Le ballet. 5. Hommage à la musique américaine. 6. L'oiseau de feu. 7. Hommage à la musique française. 8. A Rudi Bing. 9. Musique Russe. 10-11. Chagall et sa femme. 12-13. New York.

The Triumph of Music.
Drawings for the paintings at the Metropolitan Opera House, New York.
30x36″.

Le triomphe de la musique.
Esquisse pour le tableau au Metropolitan Opera House, New York.
9,144x11 m.

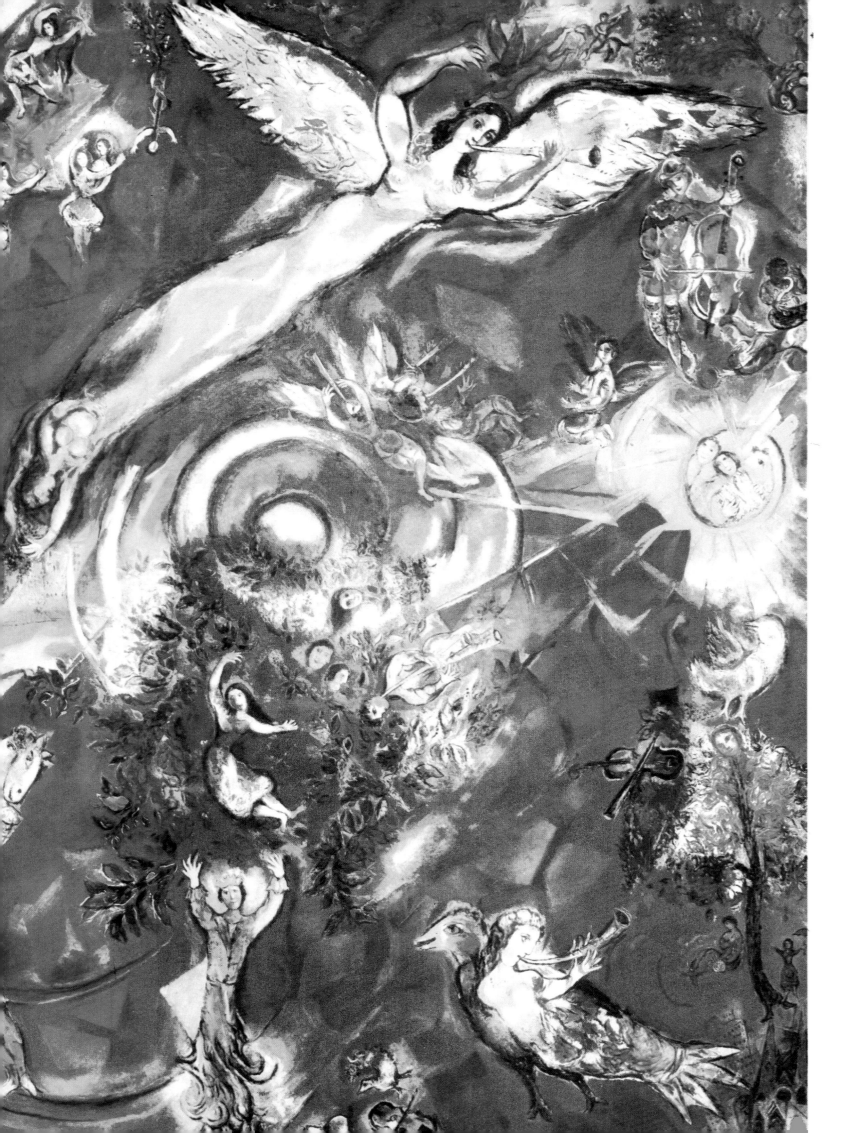

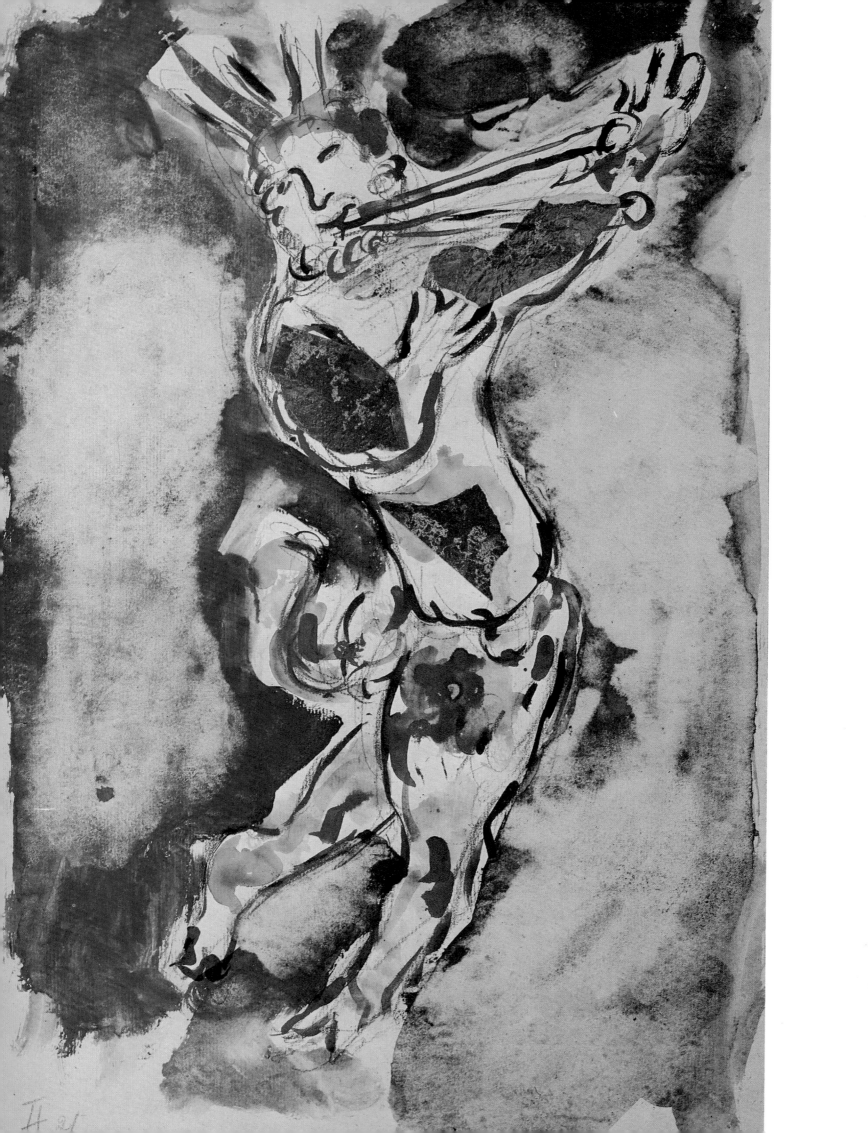

Sketch of costume for
Daphnis and Chloe. 1958.

Esquisse pour le costume de
Daphnis et Chloé. 1958.

cop. 1

Sketch of costumes for
Daphnis and Chloe. 1958.

Esquisse de costumes pour
Daphnis et Chloé. 1958.

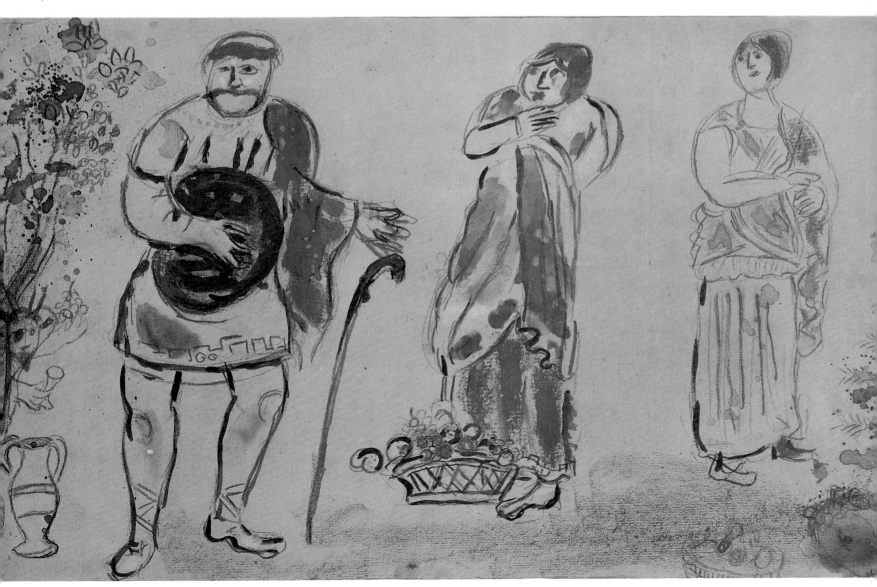

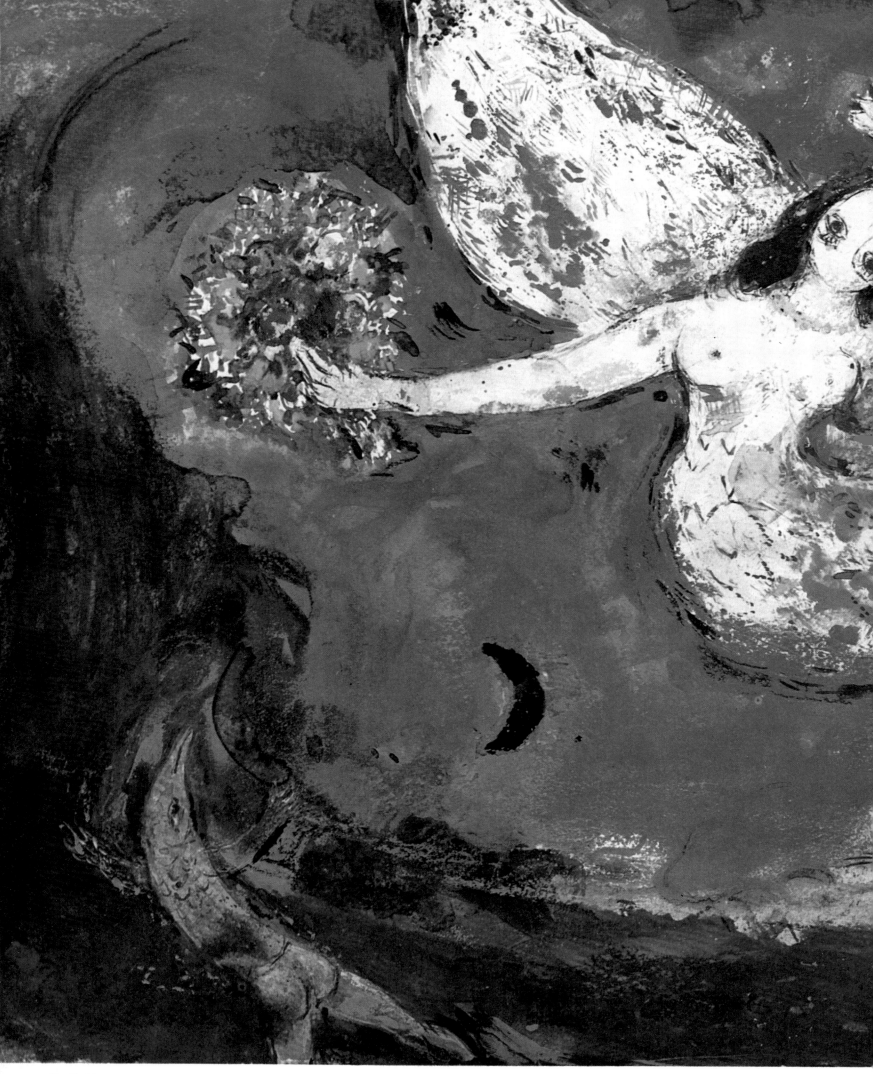

The Firebird. 1945. Opening Curtain.

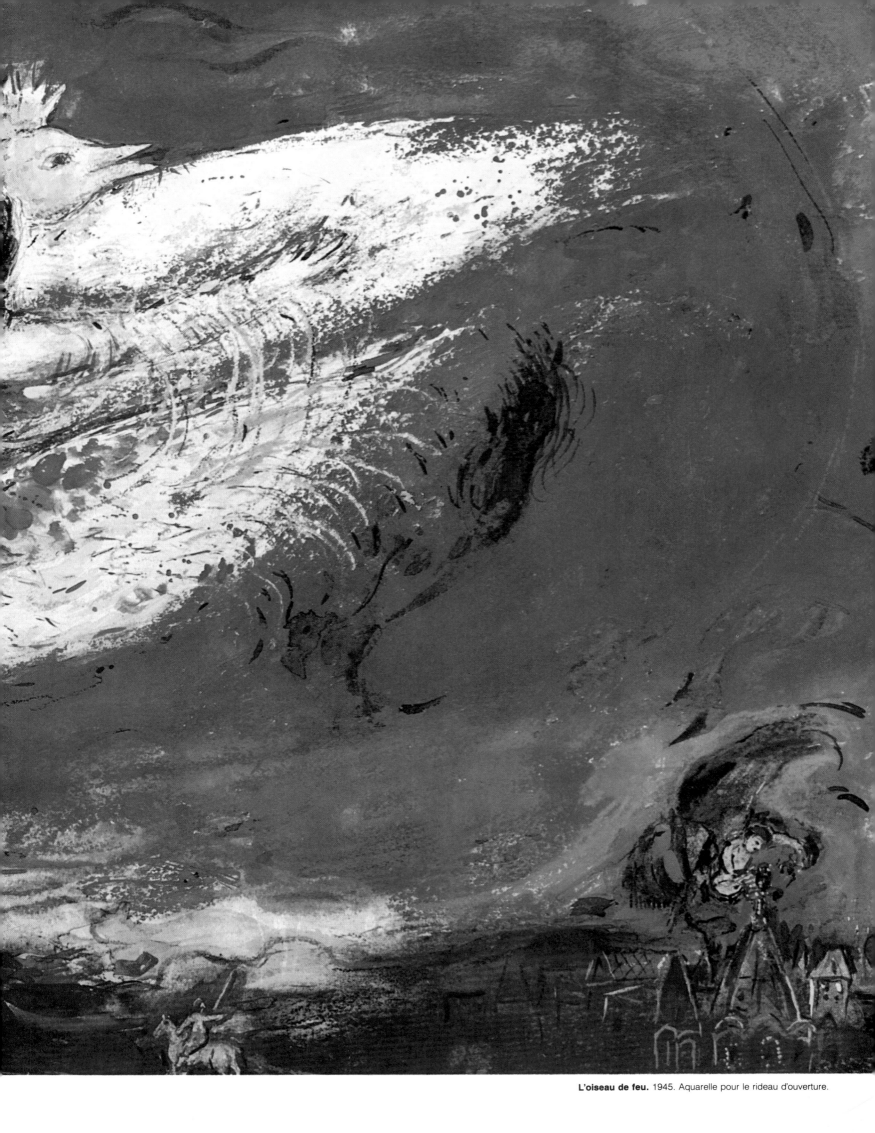

L'oiseau de feu. 1945. Aquarelle pour le rideau d'ouverture.

The Hunt.
1945. *The Firebird.*

La Chasse.
1945. *L'Oiseau de feu.*

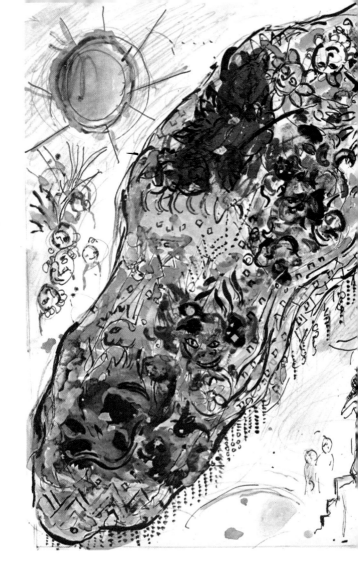

114

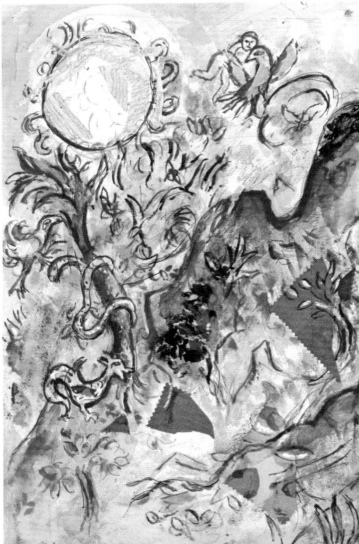

Curtain for Act I, Scenes 1 and 3.
The Magic Flute.

Rideau du premier acte. Scènes 1 et 3.
La Flûte enchantée.

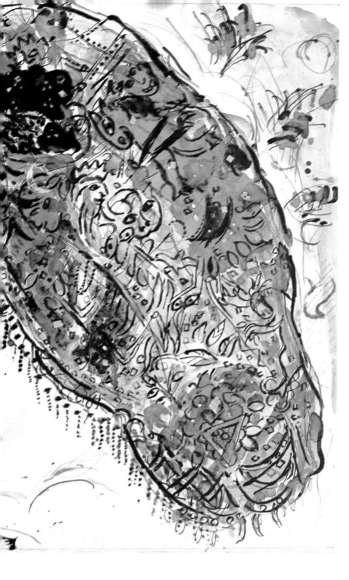

Curtain for Act I, Scene 2.
Queen of the Night.
The Magic Flute.

Rideau du premier acte. Scène 2.
La reine de la nuit.
La Flûte enchantée.

The Fruit Bearer.
The Firebird.

Le Suivant aux fruits.
L'oiseau de feu.

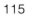

The Prince.
1942. *Aleko.*

Le Prince.
1942. *Aleko.*

Aleko. 1942.
Water color for the fourth curtain:
St. Petersburg: Fantasy.
15x22⅜″.

Aleko. 1942.
Aquarelle pour le quatrième rideau:
une fantaisie de Saint-
Pétersbroug. 38,25x57 cm.

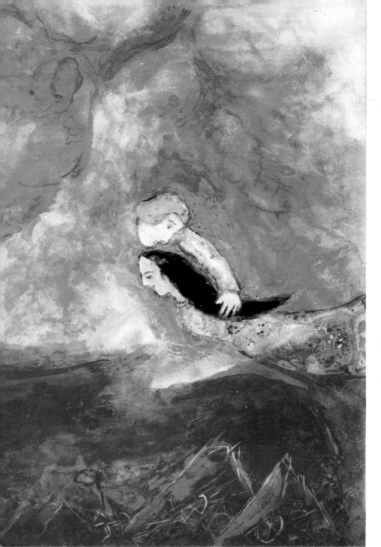

Aleko.
1942. Water color for the first curtain:
Aleko and Zemphira by moonlight.
15 x22⅜″.

Aleko.
1942. Aquarelle pour le premier rideau:
Aleko et Zemphira au clair de lune.
38,25x57 cm.

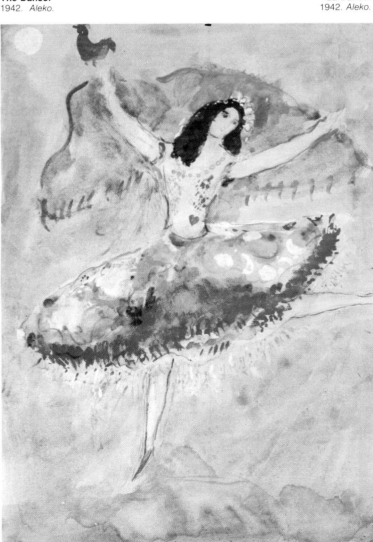

The Dance. **La Danse.**
1942. *Aleko.* 1942. *Aleko.*

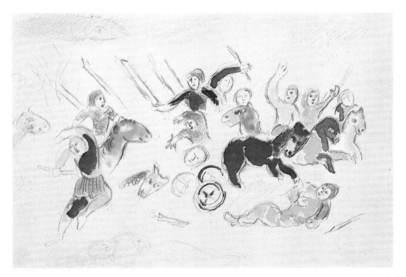

Daphnis and Chloe.
1958. *The Robbers.*

Daphnis et Chloé.
1958. *Les Brigands.*

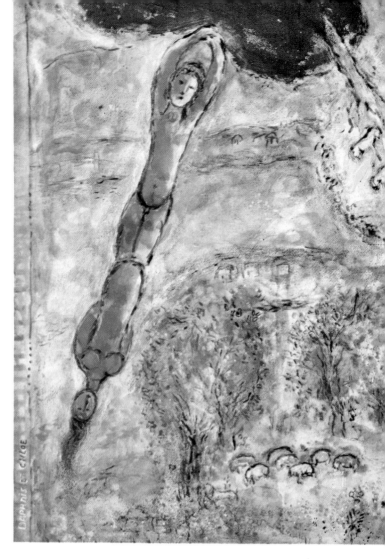

Daphnis and Chloe. 1958.
Water color for the final curtain.

Daphnis et Chloé. 1958.
Aquarelle pour le dernier rideau.

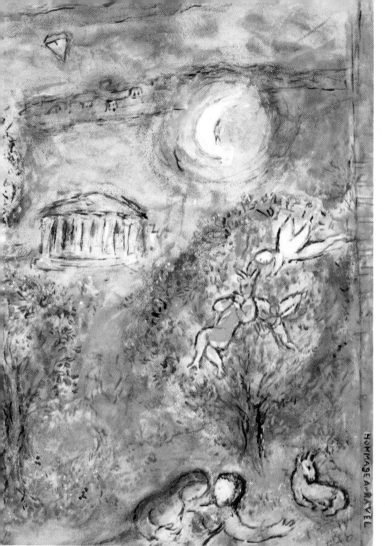

Daphnis and Chloe.
1958. Water color for the opening curtain.
Homage to Ravel. 22¾x30⅝".

Daphnis et Chloé. 1958.
Aquarelle pour le rideau d'ouverture.
Hommage à Ravel. 58x78 cm.

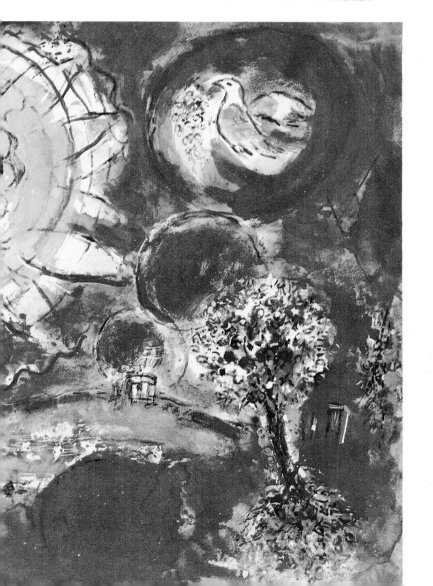

Daphnis and Chloe.
1958. Preparation for the feast.

Daphnis et Chloé.
1958. Préparation du festin.

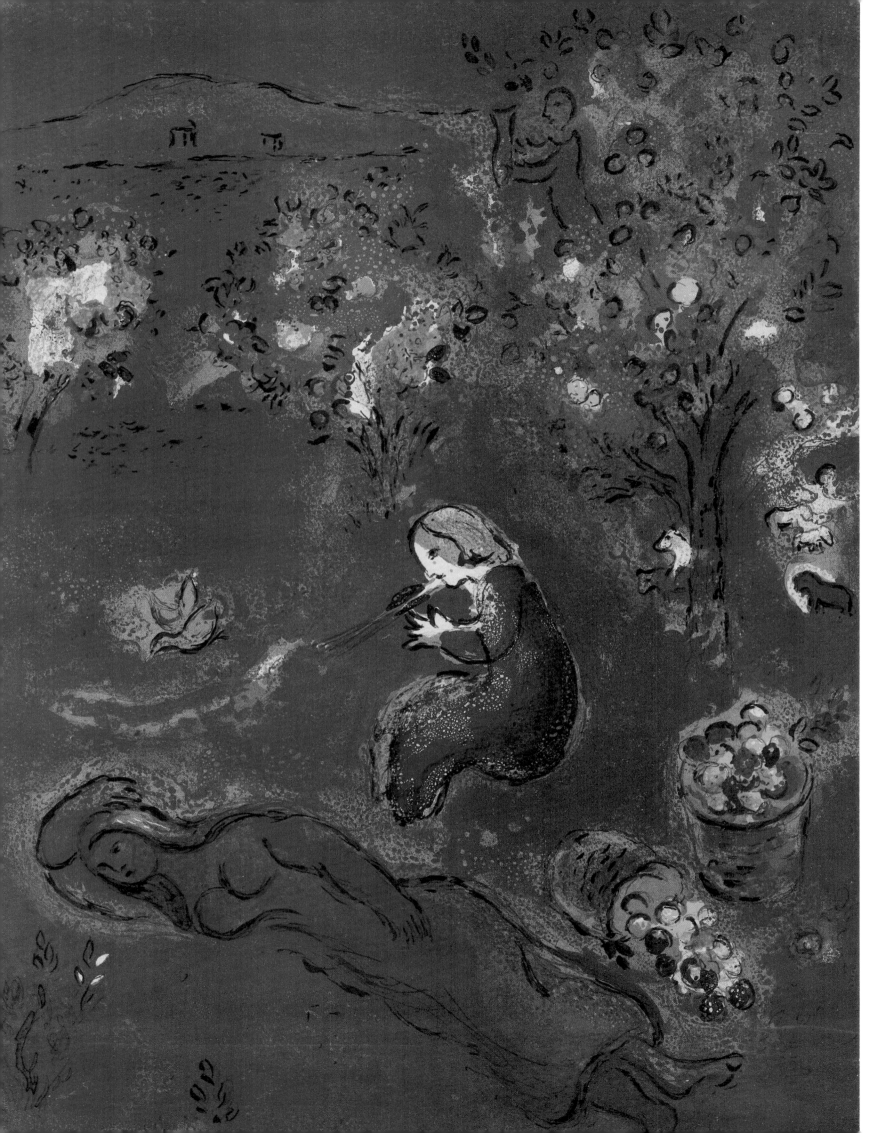

chagall as engraver

Summer at Noon.
Original lithograph for *"Daphnis and Chloe"*
by Longus. 16½x12⅜". Paris: Ed. Verve, 1961.

by robert marteau

Chagall arrived in Paris in 1910 and responded at once to the impact that it made on him. His personality was beginning to affirm itself even before the journey out of Russia: paintings such as *The Dead Man* or *The Burial*, painted in 1908 and 1909, are sufficient evidence of it. Now he was aware that above all he must preserve this nascent personality. He responded decisively, apparently foreseeing the whole direction in which the work that was to come must develop. "I had the impression that we were still just wandering around on the surface of matter, that we were still afraid of plunging into the chaos, of breaking up and trampling on the habitual surface of things... Down with naturalism, impressionism and realistic cubism... Welcome to the frenzy in us! A great bath of expiation. A fundamental revolution, not just a superficial one".

He left Paris in 1914, and so parted from his friends Cendrars and Apollinaire, and went back to Vitebsk, the town where he was born. He was to come back to France only in 1923, after the war years and the revolution were over. He stopped in Berlin on the way, where he had left some canvases with Paul Cassirer, the art publisher. The stay in Germany had a decisive influence, for it was there that he began to learn engraving in all its techniques, in Struck's atelier: drypoint, eau-forte, wood engraving and lithography. Franz Meyer states in his book *Marc Chagall, l'œuvre gravé:* "He owed his interest in graphic expression to the initial stimulus that Cassirer and Feilchenfeldt gave him. But even more", he adds, "to his stay in Germany, the classic home of engraving, where the Expressionists had quite recently engraved their most powerful works, using the techniques of wood engraving and eau-forte".

Chagall had the manuscript of *Ma Vie* with him, which had been written in Russia, and he began to illustrate it for Cassirer. Translation difficulties prevented the text from being published in German. But he finished the plates, some of which took up themes that he had already used in his paintings. The majority welled up from the intensely vivid memories collected in *Ma Vie:* plate 2, for example, which tells the episode of his grandfather retreating to the roof of the house for a bit of peace and quiet while he ate some carrots. This comic story reveals Chagall's predilection for the precise little events, extraordinary but entirely anodine, which imperceptibly dislocate the serious, customary, orderly world. We see him conniving with the unexpected, observing what happens with a child's perpetual surprise at the world about him. We also see how, working in what for him was still a new technique, he at once used it to acquire a greater freedom: he put aside the rigor of the metal plate for more spontaneity, for what was *painted from life.* Everything is hanging, in suspense,

Marc Chagall with Vollard, his daughter, Ida, and his wife, Bella, in Paris. 1930.

House in Vitebsk (Peskovatik).
Plate for the series *"My Life."*
1922. Copper engraving. 7½x9⅞".

The Wedding.
Copper engraving for the series "My Life."

Birth.
Plate for the series "My Life."

askew, expectant, searching, shaky, in process of appearing, of flowering. What is as it is now was not like this a second ago, and will be something else again in an instant.

The predilection for ascension that we notice in this anecdote was to be a constant in Chagall's temperament. It was affirmed with *The promenade,* where the fiancée glides sky-high over the roofs of the town, held by her fiancé's hand. His prismatic suit is in memory of cubism. A symbol of ascension that is present in many other paintings is the ladder, which we find again in *The Lovers at the Fence.* In *The House in Vitebsk* a whole team in harness has taken to the air, so that the landscape may assume the reality proper to memory. Memory merely seizes on some point that the senses have registered, in order to come flying towards us borne up on emotion. Chagall constantly invents the signs for this, and so charges the world with an illuminating poetic intensity: what is external can only really be seen as it truly is by inner vibrations. In this way, when Chagall engraves *At the Easel,* he doesn't hesitate about transcribing the subjective truth of the upheaval worked in someone who looks closely at the world and is *transported* by what he sees—or by passion. Such a man is uprooted from the earth, he walks on air. We see the same thing in his *The Lovers by the River* or again in *Above the City,* a black and white lithograph of 1922-23. This was one of the first he made, together with *The Man with Sideburns.*

When Chagall came back to Paris in 1923 he got to know Vollard, and undertook the illustration of Gogol's *Dead Souls* for him. Whereas in *My Life* drypoint was the dominating process, Chagall was now to use eau-forte as his major graphic technique.

Did Chagall himself suggest *Dead Souls* to Vollard? It wouldn't surprise us, especially when we remember that Dostoievski declared that every Russian was in debt to Gogol, just as one might say of every Spaniard that he owes something to Cervantes. In any case Chagall was to go on making pictures of the Russia of his childhood and adolescence, for the most part. The acuity of his vision strikes us immediately: there is nothing bookish about it. Life is seized in the very process, in all its daily aspects. Fantasy was to be the very essence of his art. In *Arrival of Tchitchikov, The Traktir, The Town* Chagall is still close to the style of *My Life,* only more richly voluble, so to speak. He is freer in expression, in verve, even in the composition itself, which gives the effect of being utterly unpremeditated. Objects and people are placed with a casualness that excludes any deliberate setting of the scene.

Two ways, it seems to us, soon began to attract him: *the pictorial way* and *the linear way,* we could call them. The former seeks what is melting or blended, the nuance, the passage of light and

color through the gradation of blacks. The latter works towards elegance of line, in its suppleness, its refinement, and its concern to give life to the white. So far from being diverging, these two ways are mutually supporting, either by contrast and opposition, or by uniting so totally together that we are held really fascinated. *The Old Park of Pliouchkine* is a case in point. The whole block abounds in detail, without its being in the least worked over and made heavy in execution. For it never ceases to take wing, to be exuberant, a filigree, with a shifting sky stirred up above the horizontal, ruinous, heavy hut that is itself pulled right towards the bottom of the picture. Elsewhere, tenderly humorous, and with a light, refined line, he depicts the young country girl with her big feet and rough outward appearance, showing the way to a hairy and bearded coachman. He also exaggerates Madame Korobotchka, "one of those good women forever declaring—head on one side—how poor they are, but who nevertheless gradually fill up the canvas bags hidden away in their cupboard drawers". The contrast between the old shrew's bloated face and huge, grasping hands (one of which has been still further thickened with aquatint) and the drawn ornament that gives a light touch to her dress and the quilt is remarkable. And all is grace and sensitive whorls in the architecture and landscape of *The traktir's House*. It adds to the comedy of the characters, those solemn puppets in a theater which they remain oblivious. The pictorial way is doubtless at its peak in *Tchitchikov on His Bed*. It could all be in color, so vibrant are the black lines—now free, now coagulated together, and at times distorted as though by childish laughter welling up at the sight of Tchitchikov straining to hoist his great naked buttocks up onto the bed.

An entire human comedy unfolds before our eyes. In *The Painters* the painters are painting a room white and the people and objects in it are having a high old time. This clearly terrifies the owner who, as host, is about to do the honors for his guests. In *The Witnesses*, each one, gesticulating, and given life by the fine, open line, is seized in movement and the heat of action; in *The Fleeing Naked Man* the tax assessor Drobjachkine, threatened by the peasants brandishing their implements, goes back to the fields and the cows and along with his clothes abandons house, bed, and the wife who lies in it; or in *The Toothache*, where the violence of the line makes us realize the rage and pain that the hero Tchitchikov is suffering.

I would like to note that Chagall always avoids caricature and satire. He prefers a tender, earthy poetry, full of vitality. Observation is what feeds this verve, always. Nothing is set, nothing fixed: people and objects take life under the graver without our expecting it to happen, and their *geste* follows its course under our gaze amid the

The Dining Room.
Plate for the series *"My Life"*. 1922.
Copper engraving, 8½x10⅞".

123

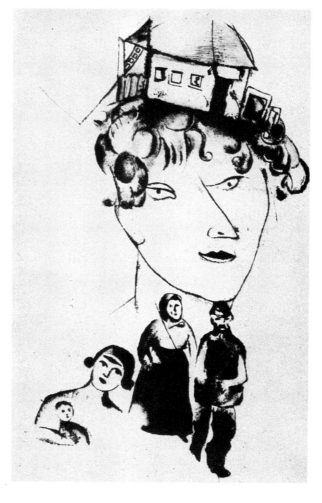

Family Self-Portrait.
Plate for the series *"My Life."*
1922. Copper engraving, 10⅞x8½".

Grandmother.
Plate for the series *"My Life."* 1922.
Copper engraving, 8¼x6¼".

The Grandfathers.
Plate for the series *"My Life."* 1922.
Copper engraving, 11x10⅞".

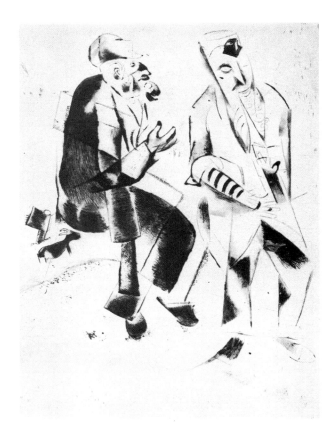

tribulations, joys and jokes that each new day brings. We always feel how greatly life delights him, but Chagall adds a dimension to the fleeting manifestations of life that he seizes, and this extra dimension puts the work far above any mere realism limited to particular situations.

In 1927 he undertook to illustrate the *Fables of La Fontaine*, again for Vollard. He was turning over *The Circus* in his mind at this same period, and there exist a few plates for it dating from this time. But the work was to be carried out in lithography after the Second World War, and it was published by Tériade in 1967. *The woman Circus Rider* dates from 1929: she is graved as if with the point of a thorn on springtime's skin, and she barely touches the back of the fabulous dream-horse. You could believe that her slender body will be bent at any moment by a breath of wind. Her hair and the horse's mane have the same wavy ringlets. Her arms are over her head in the form of the handle of a basket, as willowy as what they imitate. But Chagall was working on the *Fables* in a completely different spirit, as he elaborated the bestiary with its inextricable mixture of humanity. The point I am making is most readily understood by reference to Franz Meyer's text *(Marc Chagall, l'œuvre gravé)*, introducing the way Chagall approaches La Fontaine's world: "To begin with, Chagall thought in terms of color plates, worked on copper from his gouaches. But it turned out to be too difficult a piece of craftsmanship to transpose the originals, because of their rich coloring. So he had to give

up the idea of color, and he became a black and white engraver again to make the set. Yet the color that was in the gouaches is all there in the black and white of the eau-forte. The result comes from bringing several techniques together: first he engraves, then he covers the engraved parts with a touching-up varnish and so gets very marked painting effects. The needle draws leaves and thickets in their finest ramifications, conveys the complexity of feathering or of supple fur, and manages by lines and hatching to give the richest gradation from white to black, obtained by profuse scoring and counter-scoring. In some instances Chagall also uses a brush with multiple points, and in this way is able to modulate the values up to intense black. On top of it all the brush introduces light, in flashes, in areas, in lacework, brilliantly white against the blacks and the gamut of grays. In some places the whites then have eau-forte lines engraved in them. Each plate is thus the result of many cumulative phases, during which the structure of dark and light is slowly elaborated. The process is comparable to the stages in which the color construction of a painting is worked out".

Often Chagall likes to stress what is mythical and universal in a fable, as in *The Lion in Love*, for example, which he links with *Beauty and the Beast*. Tragedy and terror heighten the theme, and it is intensified by the tight network of fine lacerations which sometimes hems the protagonists in and sometimes coagulates in patches or in thick rings. In *The Old Woman and the Two*

Servants he exalts the young unclad bodies, crushed with exhaustion, by a lunar whiteness, and their brilliance forces the old shrew back into the shadows. He has made the splendid cock all swollen with vanity, lost in admiration before the pearl of his own silliness.

Chagall takes one detail or another that has moved him and uses it as a base, and so his own poem interweaves with La Fontaine's and a whole world emerges, at the extreme limit of the division between animal and human. Each character appears on the stage in all his complexity: for example, that other cock *(The Rooster and the Fox)* perched up in the tree, his mistrust plain to see in every line, down to the very set of his legs. As for the lion in *The Lion Grown Old,* he has assumed a human face: an infinite sadness possesses him, yet we get no impression of bitterness, nor of resignation, only something enigmatic that relates him to the sphinx.

In 1931 Chagall went off to Egypt, Syria and Palestine. On his return he devoted himself almost entirely to the illustration of *The Bible.* He worked on it up to 1939. That was the year of his journey to Holland, on the eve of the catastrophe: in that light it takes on the aspect of a real pilgrimage to Rembrandt. He was far away from France until 1948 and took up his work on the Bible again only in 1952.

The Bible is unquestionably Chagall's masterpiece so far as engraving on copper is concerned, and no doubt it is the single greatest masterpiece of engraving of our age. It becomes plain that everything previous to the Bible found its fulfillment in the Old Testament pictures. The anecdotes and observation of *My Life,* the spontaneity and perspicacity of *Dead Souls,* the understanding and technical knowledge of *The Fables of La Fontaine:* these all come together in *The Bible,* and the flowering is complete. Looking at these 105 eau-fortes, you would think Chagall learned how to engrave in Berlin with the one intention of going back to the source of the Hebrew soul; you would think he had been building up his strength for years in order to respond to the Word of his people and bring his contribution to the Book. Elsewhere he could show only facets of his spirit; here spirituality itself unfolds, the mighty breath of the poet-prophets. Fable takes on its real dimension, in the origin and creation of the world; to speak is to create; the word is lightning; the poem is made of stars, nights, days, dawn, water, woman; the man-shepherd receives the divine Word, comes down from the mountain,

On the Mother's Grave.
Plate for the series *"My Life."* 1922.
Copper engraving, 4¾x3½".

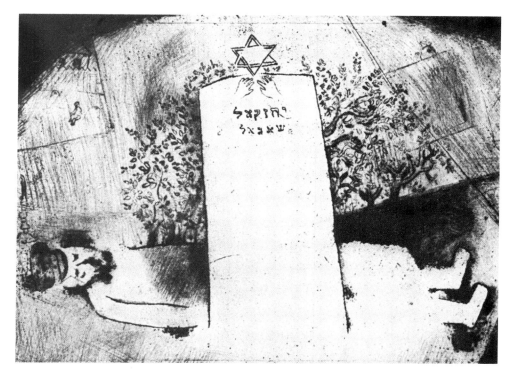

Father's Grave.
Plate for the series *"My Life."* 1922.
Copper engraving, 5¾x8⅛".

The Poultry Yard.
Illustration for *"Ames Mortes."*
Copper engraving, 8⅞x11⅜".

and transmits it. The living God reveals himself, the dove is the winged symbol from whom salvation is looked for; the angels, stilling their white wings, grow visible to Abraham's eyes, and the earth is present all around them just as they themselves are truly present without old Melchisadek the priest showing any sign of surprise; yes, they have taken on the reality which is now there in the hand that Abraham raises in front of his face, in *Abraham Mourning Sarah*. Then there is Joseph, full of music and sun like the shepherd Apollo, in the middle of his flock, a premonitory figure of the one who, like himself, is to be sold. The prophets are afraid at their vision, or afraid at the Word which they alone hear; God is the only witness of their solitude and suffering; the heavens open, Jerusalem perishes, and the living are clearly one with the dead, left standing upright only to weep. Chagall makes the great drama and the tribulation his own; and the tempest that shakes him is transmitted to the paper in its violence, its gravity, its amplitude: what is happening here and now, around this well, amid this flock, is at the epicenter of the great theater of the world.

We can really understand, then, that he truly did go to Holland as a pilgrim, to Rembrandt; he went to pay homage to the man who, like himself, had the gift of making the divine acts find access to the visible world. Complete mastery of technique leads the hand in this work to respond to every vibration of the soul. All is softly bound together. The eye searches the surface as though with hands, is enthralled, and cannot tear itself away.

From this moment on, as though he had the intimate conviction of having reached a summit in this art and in this technique, and that no wave could lift him higher and no river carry him further on, as the work began to be finished Chagall turned more than ever to color, and required of lithography that it should answer to another side of his painting. He had made 13 lithographs in New York for *Four Tales of a Thousand and One Nights*. He renewed the link with Paris again by making nine other lithographs published in 1954 in the review *Derrière le miroir* under the title *Paris*. In the same year he made his second visit to Greece and painted several gouaches. The plates for *Daphnis and Chloe* were to come out of these gouaches. The choice of the Greek text, full of fresh, sensual poetry, and his first visit to Greece, date from 1952.

Chagall always found it essential to walk over the ground of whatever country he had chosen for a work, and to see, feel, test the light and

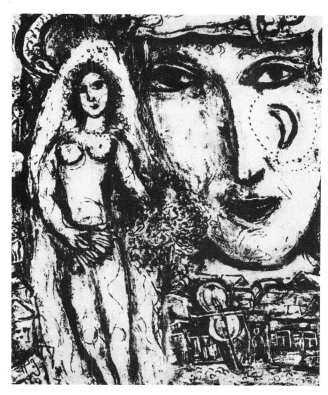

Lithograph for the **"Circus."**

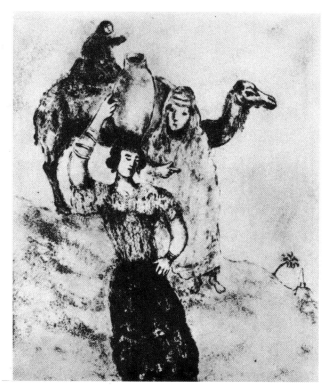

Engraving for the **Bible** (Ed. Verve).

Lithograph for the **Circus.**
(Tériade, Paris). 1967.

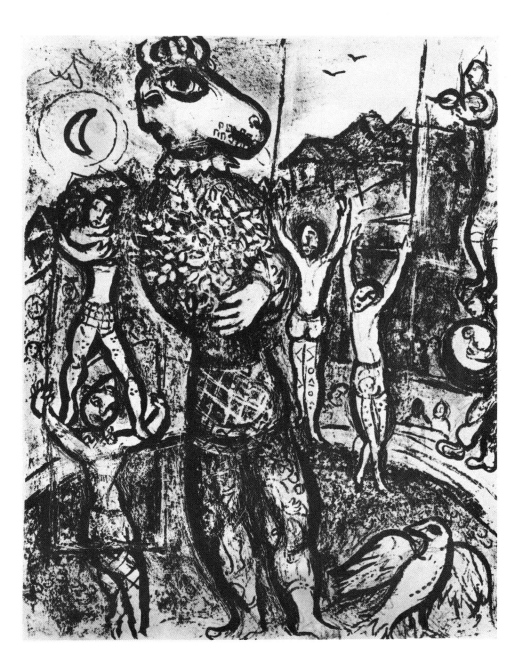

colours, and get to know the people. He did not undertake *The Bible* without visiting the land of his people, and he did not allow himself to decide on the colors for *Daphnis and Chloe* without first having had physical contact with the light and the sea and the land of Greece. True poet that he is, Chagall always works from what is concrete. That is where he found the life-giving joy that breaks through naturalistic appearances, causes forms to burst open like undreamed-of flowers, splashes color on the sky and the fields and in the fathomless depths of the sea, so that the soft sounds of grasses, rivers, trees and lambs commingle with the lovers.

A set of lithographs was published by Tériade in 1967 with the title *The Circus*. Chagall wrote the accompanying text-poem. In a sense it was an extension of *My Life*, which in 1922 was itself the point of departure for his engraved work.

This reminder comes quite naturally, for *The Circus* is not a work simply illustrating the circus in words and pictures. Perhaps above all else it is a secret testament, in which Chagall gives free play to the telling of his secrets. Again, it is a journal, or a fresco in which the human comedy is made to unfold and is denounced for what it is, or a mirror in whose greatly reduced space is reflected everything that becomes ex-

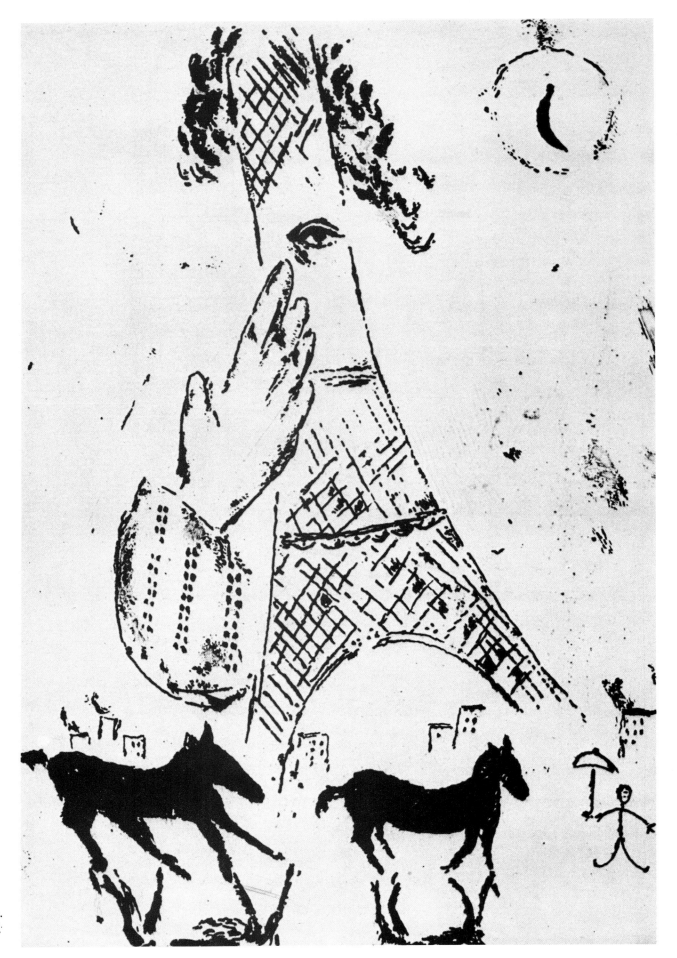

The Eiffel Tower.
1943. Copper engraving.
10¾x8"

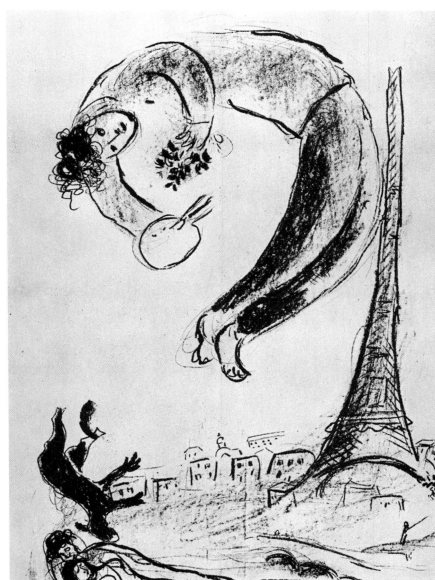

Painter in the Eiffel Tower.
1957. Lithograph in black and white.

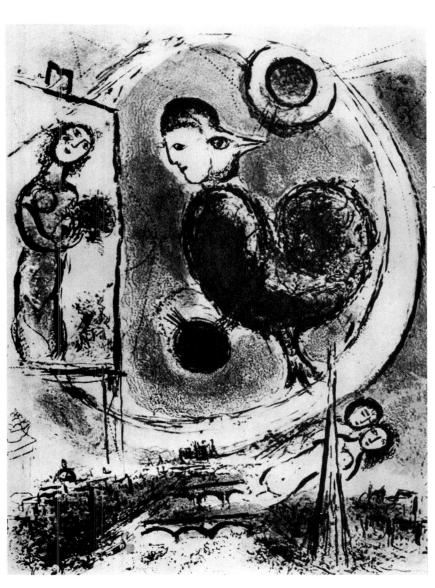

Rooster over Paris.
Original lithograph.

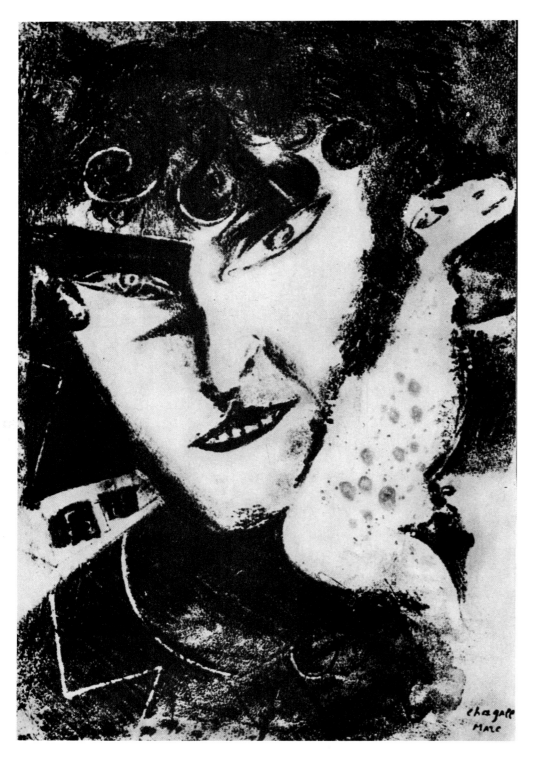

Self-portrait With a Goat.
Lithograph. 1922-23. 16⅛x10⅜″.
Berlin.

hausted or dissolved in day-to-day living. It is a way of saying that for Chagall the circle of the circus ring is magical only in so far as it encloses what is essential: each gesture and attitude being raised to the level of sign and symbol. For nothing is natural here, though all seems to be, thanks to an art and artifice based on the precise observation of instincts, habits and behavior. Is not the circus, by its very form, a replica of the universe, a world in which the impossible is still about to be annihilated at any moment? The girl on the trapeze goes from star to star; the horse and its rider make poetry spring from its source; men and animals begin to converse with each other again... Childhood marvels at a daylight that is almost the pristine light.

No, it is not a dream; only a reality slightly beyond the exchanges of every day. Chagall knows in a flash how to disclose this reality to us, by a surreptitious displacing of objects and people and a substituting of the true color for the expected color. In this way he creates relationships of enchantment, surprise and play, where what is grave banishes what is merely serious; passages and crossing places where comedy, drama, grace and humor are suddenly swallowed up; planets where what is imaginary is part of reality, not an effort to escape.

"It seems to me", says Chagall, "that I would have lacked something if, aside from color, I had not also busied myself at a moment of my life with engravings and lithographs.

From my earliest youth, when I first began to use a pencil, I searched for that something that could spread out like a great river pouring from the distant, beckoning shores.

When I held a lithographic stone or a copper plate, it seemed to me that I was touching a talisman. It seemed to me that I could put all my sorrows and my joys into them... everything that has crossed my life in the course of the years: births, deaths, marriages, flowers, animals, birds, poor working people, parents, lovers in the night, Biblical prophets, in the street, in the home, in the Temple and in the sky. And as I grew old, the tragedy of life within us and around us."

ROBERT MARTEAU

the "daphnis and chloe" of chagall

by charles sorlier

In order to indicate the prominent place that Chagall occupies in the history of lithography, we should first briefly review the history of this art.

Lithography was invented in 1796 by Alois Senefelder and is a method of engraving. For the artist, it consists of drawing on the surface of a fine-grained chalky stone (Munich stone) with ink and greasy lithographic crayons. After this, the stone is prepared with a nitric acid solution in such a way that it will pick up the ink only where it carries the image; a sheet of paper applied to this stone is run through a special hand press; the proof is thus printed by direct contact with the drawing. These prints, limited to a small number of copies, are then numbered and signed by the artist.

Today, a zinc sheet (zincography) is sometimes used instead of a stone, since it is both lighter and less fragile. The conception of the work and the results obtained would be identical in both cases.

As early as 1812 Charles Philibert de Lasteyrie du Saillant studied this technique, and in 1816 he founded the first lithographic printing shop, in Paris. Goya, one of the very first among the great masters of lithography, executed his four so-called Bordeaux plates on the theme of "The Bull-Fight" in France in 1825.

Nearly all the artists working around the 1830s were tempted by this new engraving method: Ingres, Delacroix, Géricault. But one name especially stands out in this field: Daumier; he eclipsed all the others and left us a considerable number of masterpieces, such as *La rue Transnonain* and *The Legislative Belly* (1834).

In 1837, Engelmann, a printer in Mulhouse, patented his technique for "Lithocolor printing or color lithography imitating painting." This method is identical to one-color lithography except that by the superimposition of plates inked with different colors the artist achieves a result that is without a doubt much closer to the painted work. But it was not until twenty years later that Jules Chéret understood the real meaning of this discovery and made the first polychrome lithographic poster *Orpheus in Hell* in 1858, preceding by sixteen years the first color print by a master: *The Punchinello* that Manet did in 1874. Save for a few plates by Renoir, Degas and Pissaro, this method was somewhat neglected by the Impressionists; it is true that print-lovers of the time were only interested by bad, eighteenth century style interpretative engravings, hand-colored and horribly mannerist. Neither *The Races* of Manet nor Redon's admirable plates caught the attention of the public.

Influenced by Chéret, Bonnard in his turn created his first color poster, *France-Champagne* (1889). Contrary to what is generally accepted as a fact, it was on Bonnard's suggestion that Lautrec became involved with lithographs. In *Le Bonnard que je propose* Thadée Natanson noted, "Little Lautrec made a lot of efforts to discover the author

of *France-Champagne*, and Bonnard took him by the hand and led him to Ancourt who shortly after printed the famous *Moulin-Rouge* (1891)." (This anecdote is confirmed by Bonnard himself in a letter dated January 7, 1923, addressed to Claude Roger Marx.)[1] Vuillard has also left us a substantial number of very beautiful color lithographs.

These three great artists mark the beginning of the contemporary print. Claude Roger-Marx has written regarding them, "Along with *Elles* by Toulouse-Lautrec and the *Landscapes* and *Interiors* by Vuillard, the series entitled *A Few Aspects of Parisian Life* (by Bonnard), which Vollard published in 1899, constitutes the most valuable and precise chamber music that has been orchestrated with four to six colored stones." With Chagall we leave the quartets and sextets behind to rise toward the symphony and the summits of *The Magic Flute*.

Certain purists have insisted for a long time that color lithography should employ a great economy of means. In their analysis they forget three important factors: in the first place, the influence of Japanese prints toward the end of the nineteenth century, with their refined tones and sparing use of color; secondly, the cost price of the printing—one proof in twenty colors being twenty times more expensive than a one-color proof—at a time when print-lovers were almost nonexistent. Finally, and perhaps most significantly, a lack of the necessary technical skill, which can only be

Lithograph in color for **"Daphnis and Chloe."**

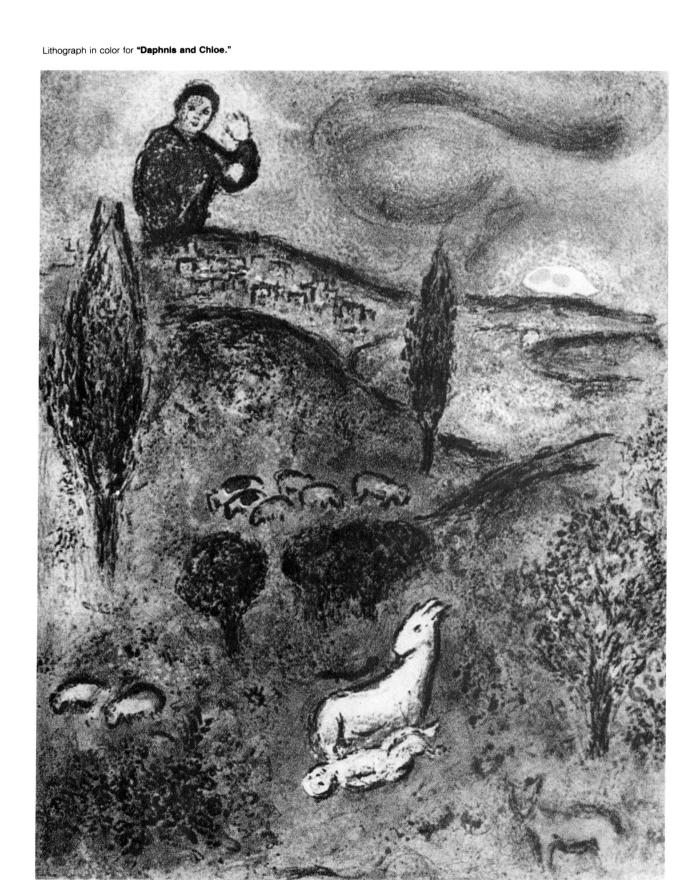

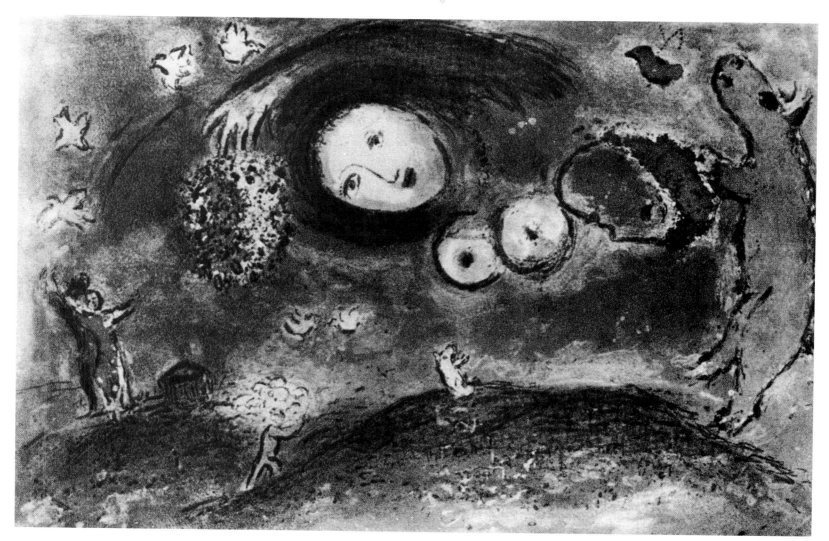

Lithograph in color for **"Daphnis and Chloe."**

acquired after long months of work in the workshops of specialized artisans.

With Chagall everything is different, for we are in the presence of the greatest painter-craftsman in the history of art. He executes ceramics, sculptures, mosaics, tapestries, stained-glass windows and graphics with equal assurance. But make no mistake, Chagall never improvised anything in any of these fields; his works are the fruit of long sessions spent in specialized workshops studying and trying to pierce the secrets of copper, stone, glass, enamel and marble.

Nor are Chagall's lithographs the result of a short-term effort. His first plates (thirty-five to be precise) date from his Berlin years (1922-1923) and were simply executed with lithographic crayon on transfer paper. In 1946, a refugee in America, Chagall accepted Jacques Schriffrin's proposal that he illustrate *The Thousand and One Nights*. The thirteen plates of this portfolio represent the beginning of his work in color lithography. All of these illustrations required from six to eight pulls apiece and were almost entirely done with crayon. Although the technique is still rather rudimentary, pure color has begun to be incorporated in the drawing in a stunning way. As his technical know-

ledge of lithography increased, Chagall was able to draw an enormous amount out of it.

When he returned to Paris, Chagall immediately started working with Fernand Mourlot, the printer who was largely responsible for the development of lithography after the war. From 1950 to 1952 Chagall came regularly to the old workshop on rue de Chabrol, and he came not as a famous master but as a young beginner. Untiringly, he studied, with Georges Sagourin, his pressman, every facet and possibility of the craft: working on zinc, stone and paper; using washes, brushes, scraping, etc.; making countless states of certain plates "to see how far one could go." Some of these test prints were printed in editions of several copies, but most were destroyed, as Chagall's purpose was not to produce but to learn how to make lithographs.

In 1952 Tériade, the publisher who had already published *Dead Souls*, *The Bible* and the *Fables of La Fontaine* (books which had been commissioned by Vollard), suggested that Chagall illustrate the pastoral poem *Daphnis and Chloe* by Longus; the artist was so interested in this project that he made two trips to Greece (one in 1952 and one in 1954) "in order to touch the earth behind the poem." The notes he brought back enabled him

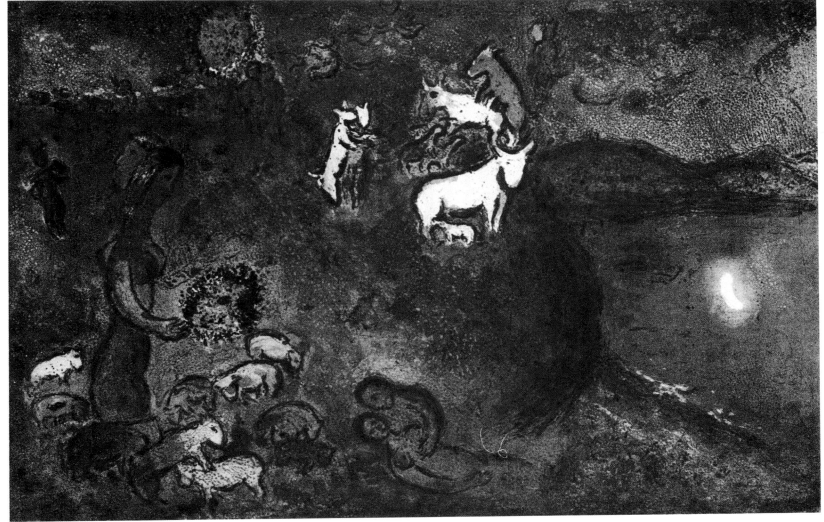

Daphnis and Chloe.

to make lovely gouaches that served as the starting point for the illustration of the work. Jacques Lassaigne has written:

Perhaps Chagall never felt such a direct shock, with the intellect playing so small a role, as that which he experienced in Greece. He thus certainly captured the spirit of Longus's pastoral poem, the feeling of youth and the innocence of a world without sin.

Daphnis and Chloe [2] consists of forty-two lithographs without text on the sheets, twenty-six in a $16^1/_2" \times 12^5/_8"$ format and sixteen in $16^1/_2" \times 25"$, or double-page, format. Each plate has between twenty and twenty-five colors, which shows the enormous work involved, since the artist had to work on about a thousand plates, not counting the numerous tests that did not wholly satisfy him.

The book is enchanting. In it, light is trapped in a stream of colors. No one prior to Chagall had attained such perfection, allying inimitable inspiration with a total mastery of a craft that had revealed all its secrets to him.

A study of this work from the first to the last page is a long journey toward perfection. The first plate, *The Bird Hunt*, stays within a range of cold tones dominated by blues, greens and violets; the technique indicates absolute mastery, but we can see that Chagall is still at the beginning of his adventure; the major notes of the symphony to come have not yet been struck. In the other illustrations the color suddenly starts to scintillate, stream and explode, embellishing the dream; Chagall the Visionary once again becomes the Thief of Fire.

Another one of the fundamental qualities of this work is the painter's humility before and understanding of Longus, the poet.

The poem ends this way:

Then, when it was night, they all led the bride and

The Lesson of Philetas.
Lithograph for *"Daphnis and Chloe."*
by Longus. 16½"x12⅜".
Paris: Ed. Verve, 1961.

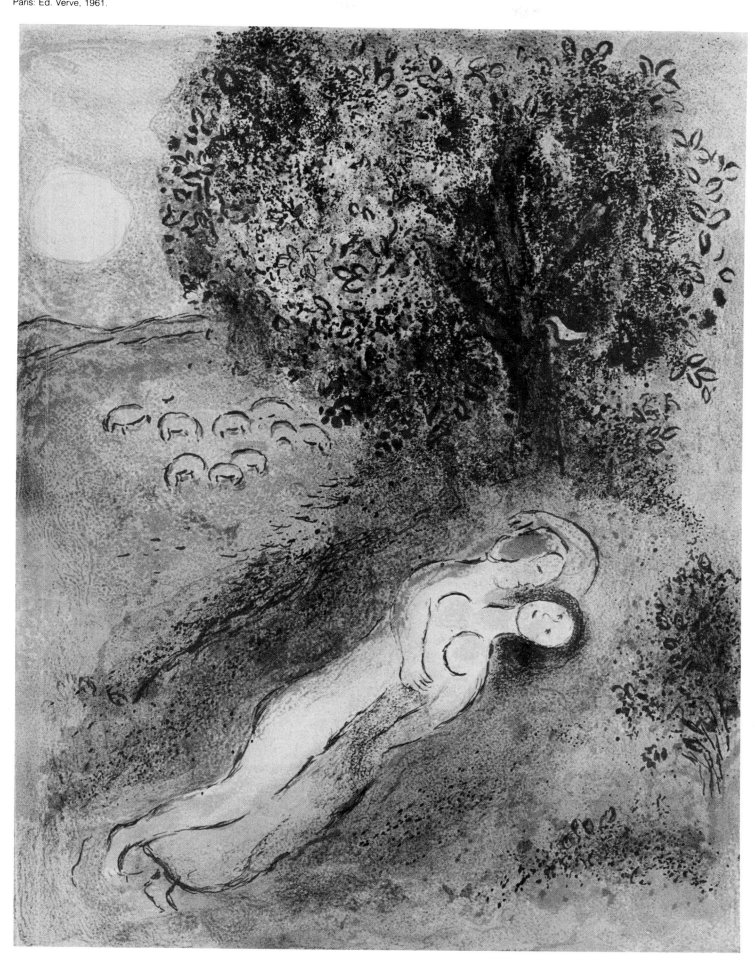

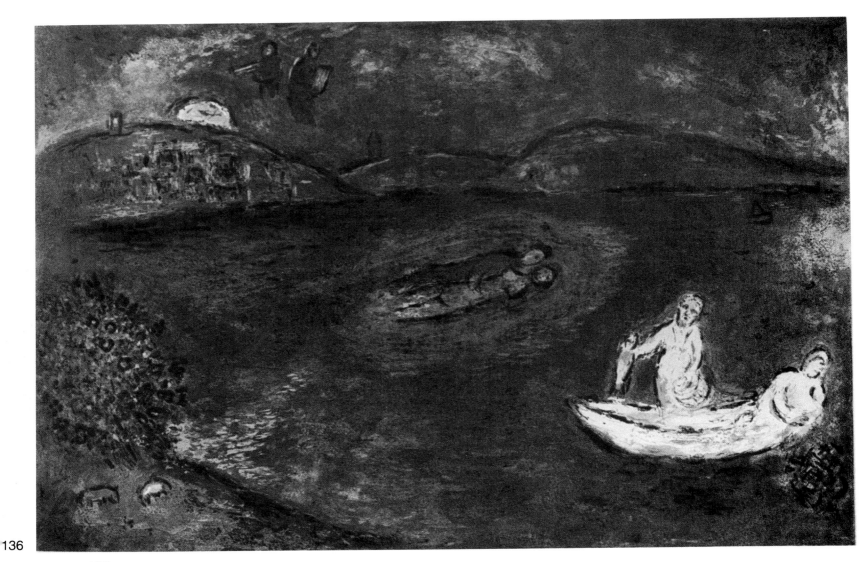

136

Daphnis and Chloe.

bridegroom to their chamber, some playing upon whistles and hautboys, some upon the oblique pipes, some holding great torches. And when they came near to the door, they started to sing, and sang, with the grating harsh voices of rustics, nothing like the Hymenaeus, but as if they had been singing at their labor with mattock and hoe. But Daphnis and Chloe lying together began to embrace and kiss, sleeping no more than the birds of the night. And Daphnis now profited by Lycaenium's lesson; and Chloe then first knew that those things that were done in the wood were only the sweet sports of children.

Hymenaeus, the last plate of the work (and, in effect, the last worked on) scrupulously follows this description, but the creative talent of Chagall is so great that he remains entirely himself while serving the poet perfectly.

No illustration in *Daphnis and Chloe* should or can be detached from the whole. Chagall is simultaneously painter-engraver-illustrator. This success is one of the monuments of publishing and will remain unequalled for a long time to come. Chagall can be proud of the "little apprentice" lithographer he was at the beginning and who found the following thought of Michelangelo so applicable to himself: "'Where are you going in this weather and with that white beard?' 'I'm going to school to see if there's still something for me to learn.'"

[1] *Bonnard, Lithographer*, by Claude Roger-Marx (Monte-Carlo: Editions du Livre, 1952).

[2] *Daphnis and Chloe*, a pastoral poem by Longus, translated by Amyot and revised and completed by Paul-Louis Courier; illustrated by Marc Chagall (Paris: Editions Verve, 1961). The work consists of two boxed $16^{1}/_{2}'' \times 12^{5}/_{8}''$ volumes. The edition was limited to 250 copies on Arches paper, numbered 1 to 250, and 20 *hors commerce* copies, numbered I to XX; all these copies were signed by the artist. In addition, 50 signed and numbered suites with wide margins were printed and reserved for the artist and the publisher.

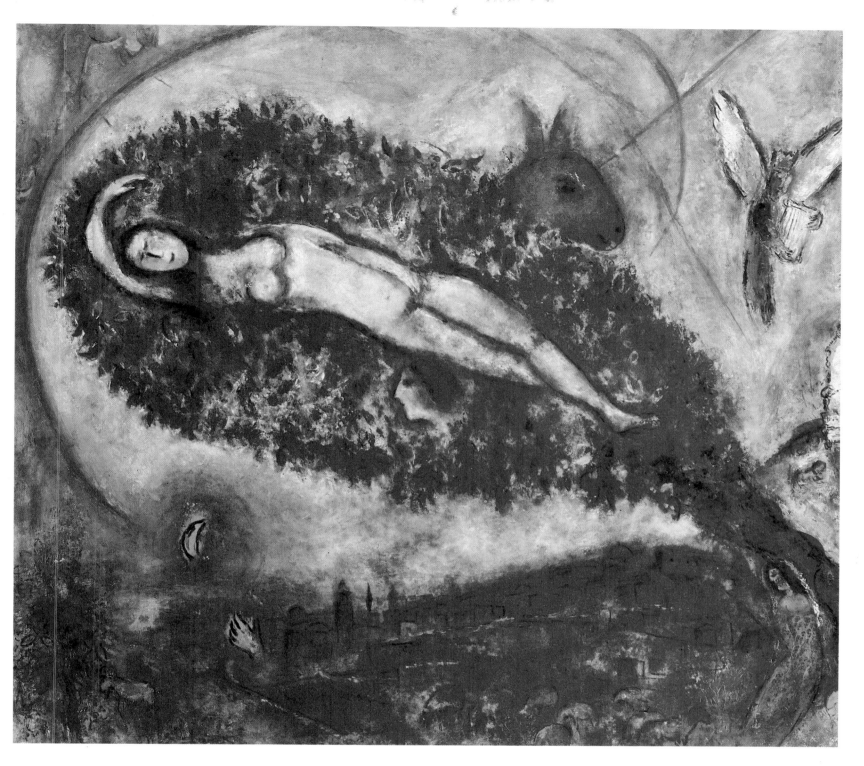

The Song of Songs.
Painting. 1957.
55⅛x60⅝".

Le Cantique des Cantiques.
Peinture. 1957.
140x164 cm.

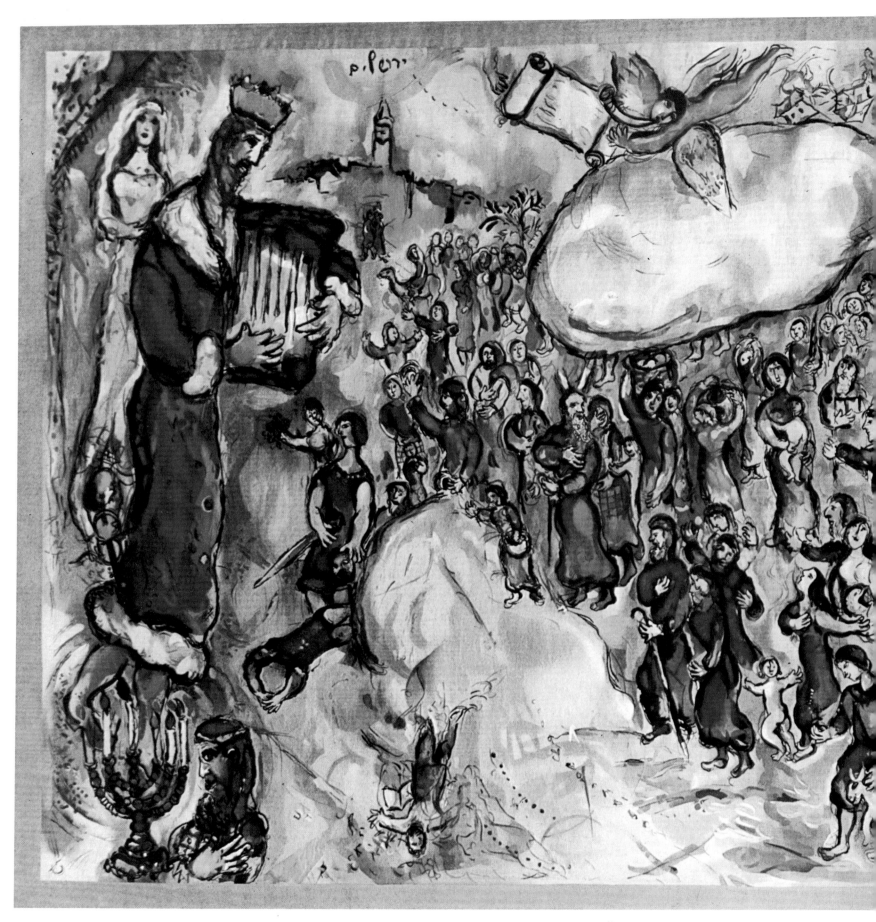

The Exodus.
1964. Tapestry.
15'6⅔"x29'5⅔".
Knesset, Jerusalem.

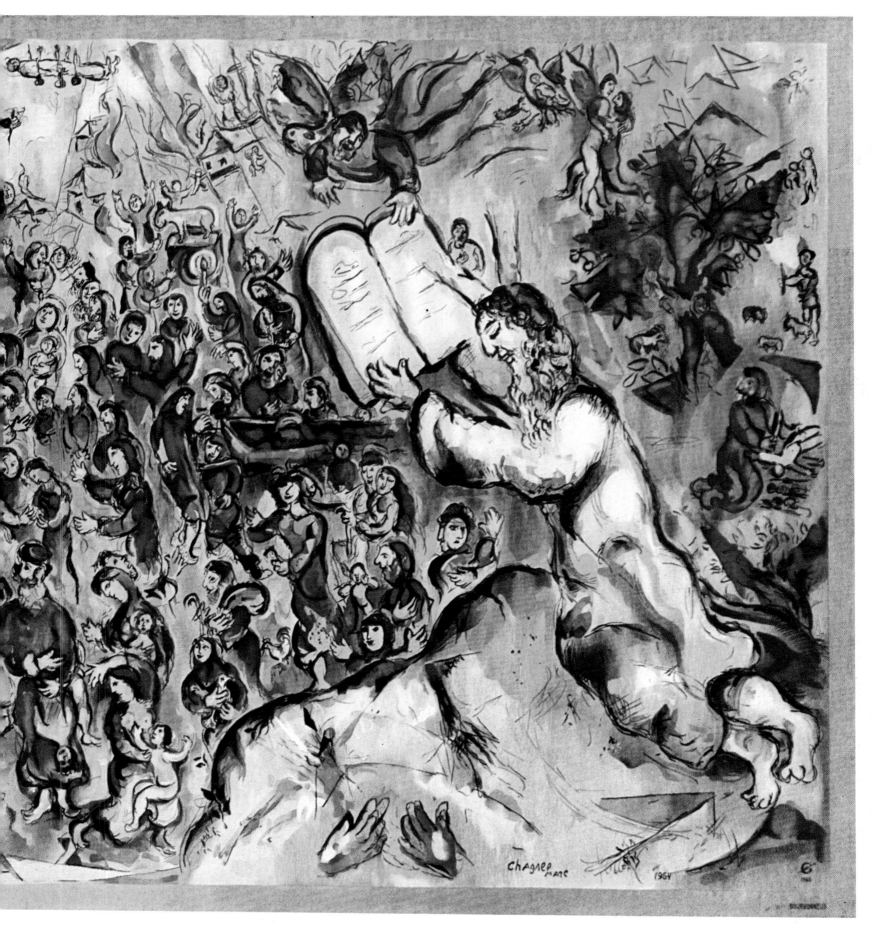

L'Exode.
1964. Tapisserie.
4,75x9 m.
Knesseth, Jérusalem.

King David Entering Jerusalem.
Detail of the *Entry Into Jerusalem.*
Cartoon. Gouache. 1964.

Le roi David entrant Jérusalem.
Détail de l'*entrée à Jérusalem.*
Esquisse. Gouache. 1964.

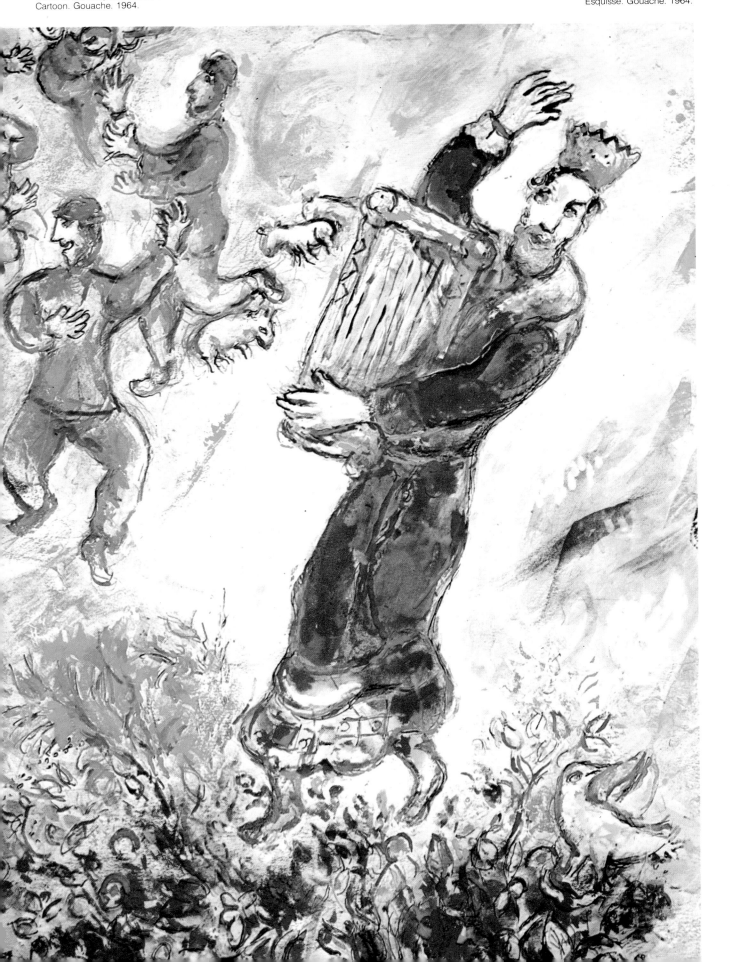

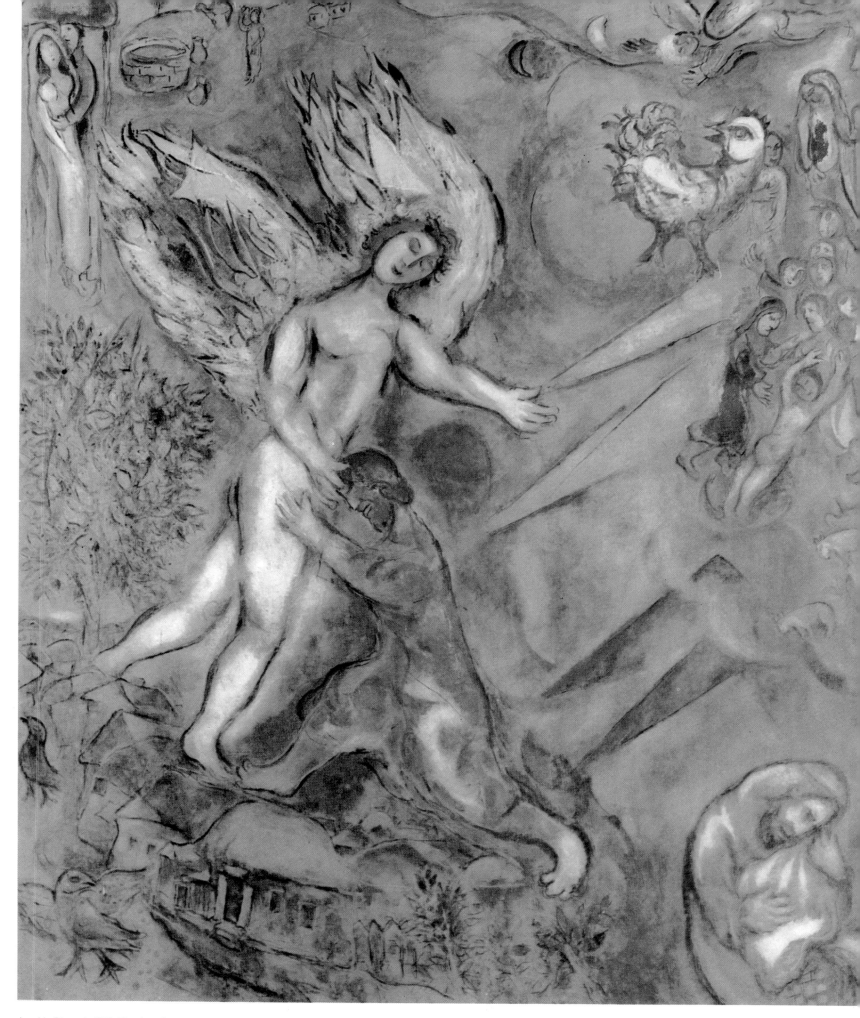

Jacob's Struggle With The Angel.
Painting. 94³⁄₈x81¹⁄₈".

Le combat de Jacob avec l'ange.
Painting. 250x206 cm.

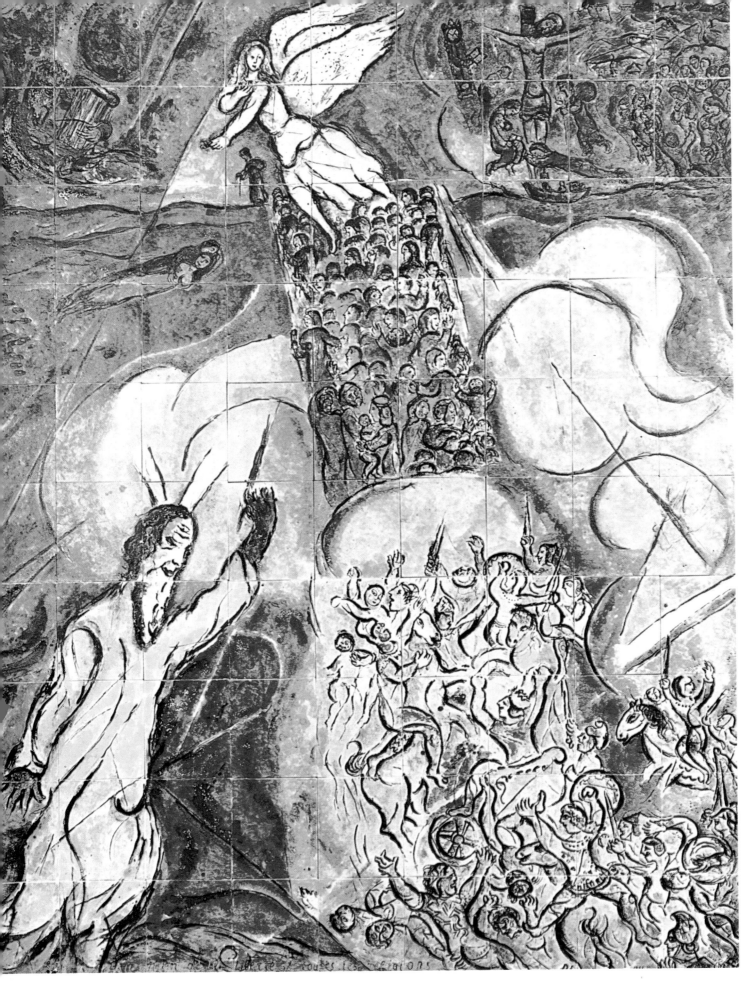

The Crossing of the Red Sea.
1956. Mural ceramic with 90 tiles.
10′x7′6¼″. Church at the Plateau d'Assy.

La Traversée de la Mer Rouge.
1956. Céramique murale en 90 carreaux.
3,07x2,31 m. Eglise Notre-Dame de Toute Grâce, Plateau d'Assy.

Moses Facing The Burning Bush.
Oil on canvas. 76¾x83⅜″.
Biblical Message, Nice.

Moïse devant le Buisson ardent.
Huile sur toile. 195x312 cm.
Message Biblique, Nice. 143

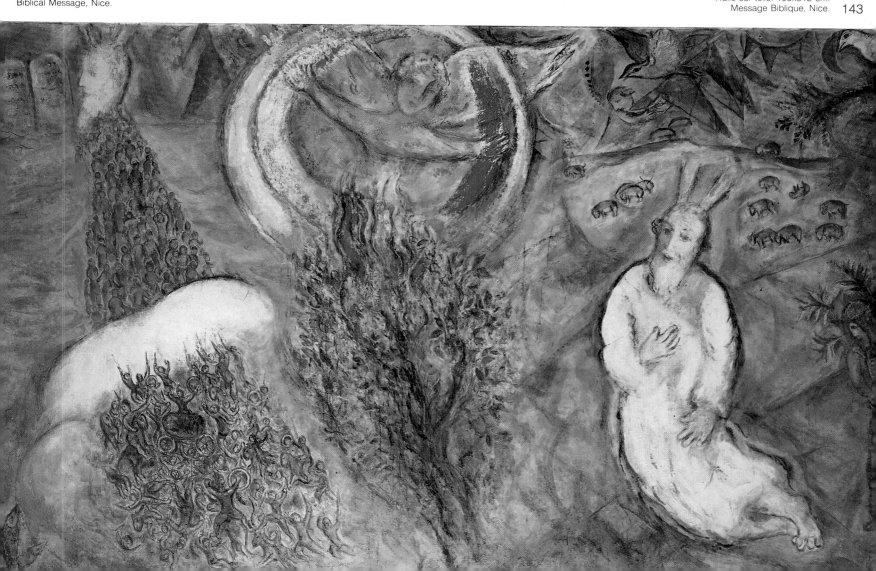

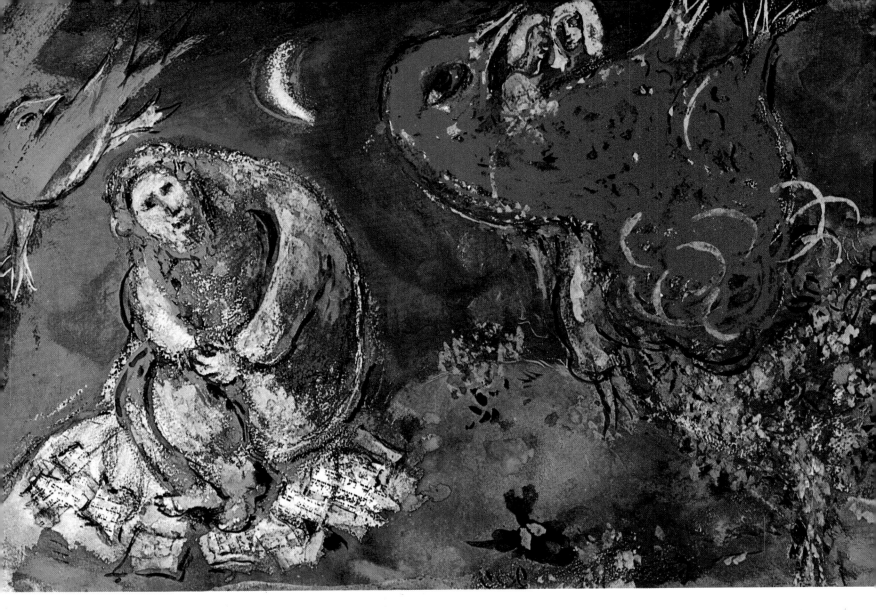

The Prophet Jeremiah.
Study of the tapestry for the
Helfaer Community, Milwaukee (USA).
76¼ sq. ft.

Le prophète Jérémie (maquette).
1973. Tapisserie pour la Helfaer Community
Milwaukee, Wisconsin. 23,15 m².

Let My People Go!
Lithograph from the story of the *Exodus*.
1966. Leon Amiel Publisher.

Libérez mes peuples!
Lithographie de l'Histoire de *l'Exode*.
1966. Leon Amiel Editeur.

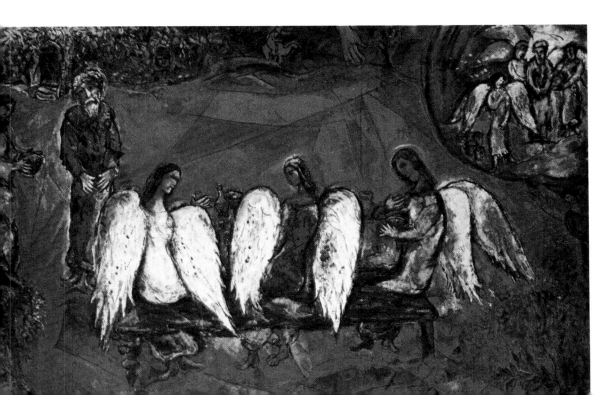

Abraham and the Three Angels.
1958-60. Oil canvas. 74⅜x115″.
Musée National Message Biblique Marc Chagall,
Nice.

Abraham et les trois anges.
1958-60. Huile sur toile. 190x192 cm.
Musée National Message Biblique Marc Chagall,
Nice.

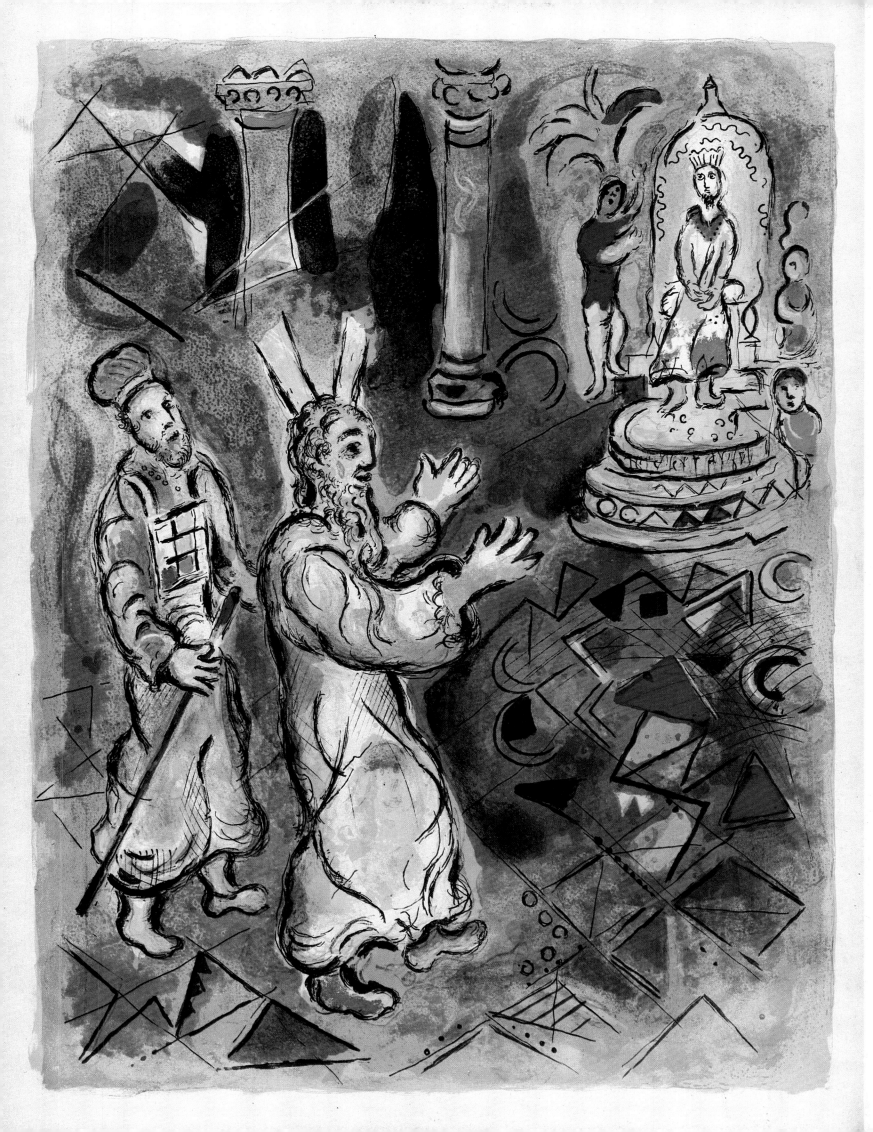

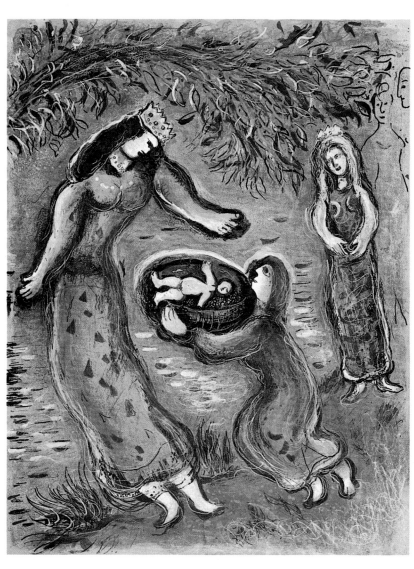

The Crossing of the Red Sea.
Lithograph from the story of the *Exodus*.
1966. Leon Amiel Publisher.

La traversée de la mer rouge.
Lithographie de l'Histoire de *l'Exode*.
1966. Leon Amiel Editeur.

Overleaf left.
Aaron.
Lithograph from the story of the *Exodus*.
1966. Leon Amiel Publisher.

Aaron.
Lithographie de l'Histoire de *l'Exode*.
1966. Leon Amiel Editeur.

Overleaf right.
Bezalel.
Lithograph from the story of the *Exodus*.
1966. Leon Amiel Publisher.

Bezalel.
Lithographie de l'Histoire de *l'Exode*.
1966. Leon Amiel Editeur.

Moses discovered by Pharaoh's daughter.
Lithograph from the story of the *Exodus*.
1966. Leon Amiel Publisher.

La découverte de Moïse.
Lithographie de l'Histoire de *l'Exode*.
1966. Leon Amiel Editeur.

Moses and the Burning Bush.
Lithograph from the story of the *Exodus*.
1966. Leon Amiel Publisher.

Moïse devant le Buisson ardent.
Lithographie de *l'Histoire de l'Exode*.
1966. Leon Amiel Editeur.

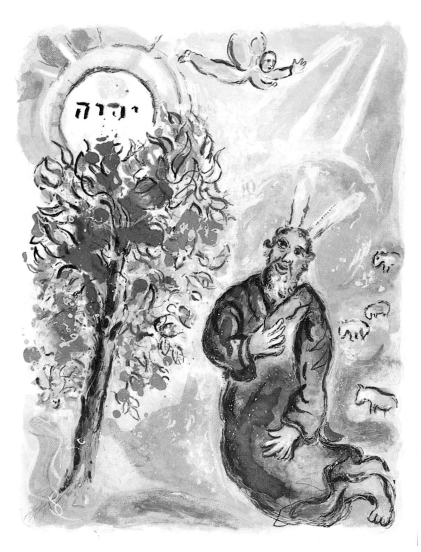

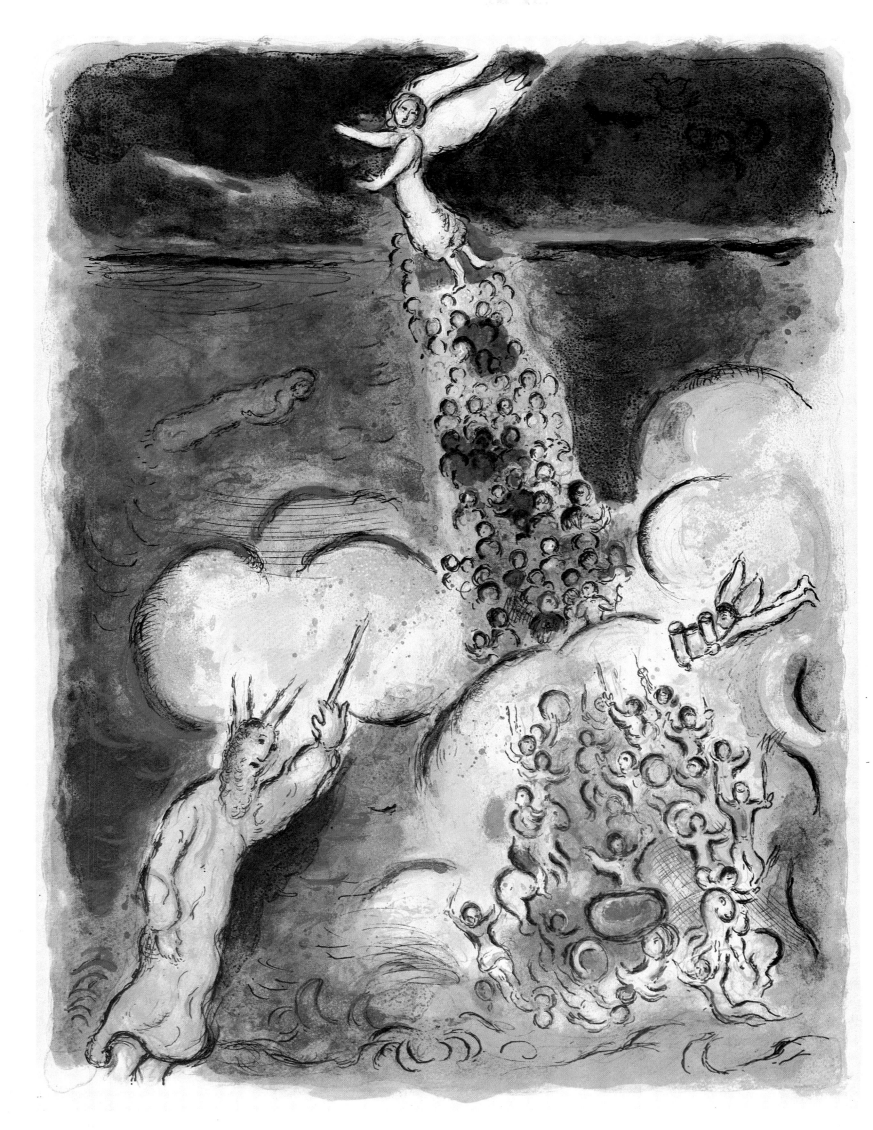

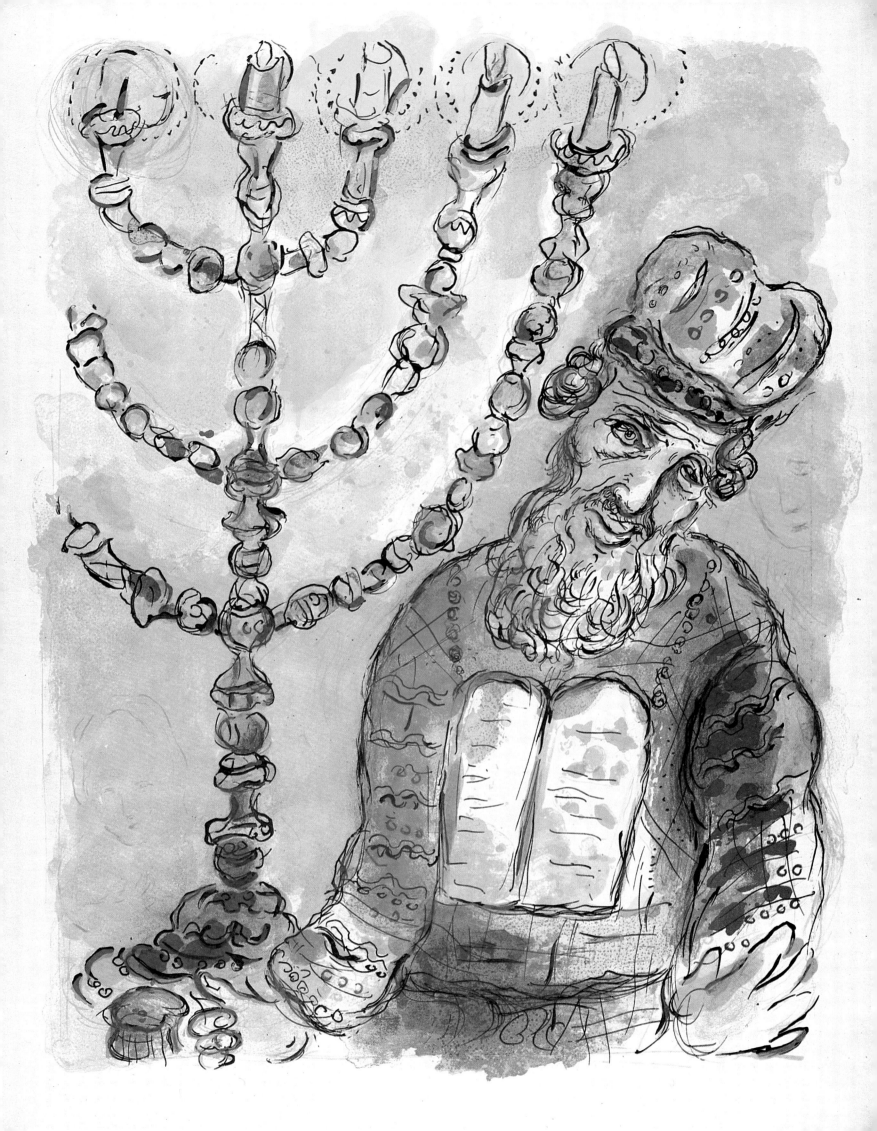

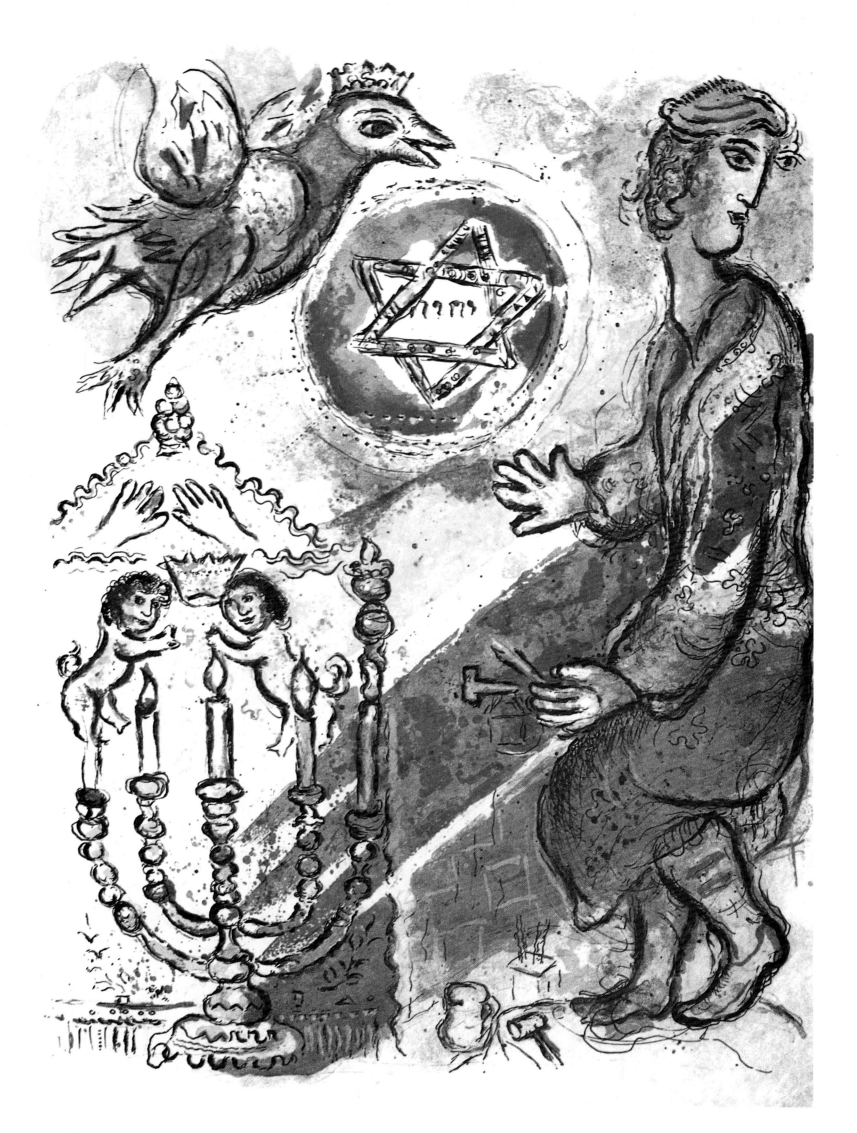

Ceramic.

Faience.

Ceramic. **Faience.**

monuments of a return to the land of the prophets

by guy weelen

And it shall come to pass in the last days,
That the mountain of the LORD'S house
Shall be established in the top of the mountains,
And shall be exalted above the hills;
And all nations shall flow unto it.
And many people shall go and say,
Come ye, and let us go up to the mountain of the
 LORD,
To the house of the God of Jacob;
And he will teach us of his ways,
And we will walk in his paths.

Isaiah, II: 2-3

"Isaiah's Prophecy." Tapestry.
Executed at the Gobelins Works, Paris,
by M. E. Melot and assistants.
15'7"x17'6". 1964-67.

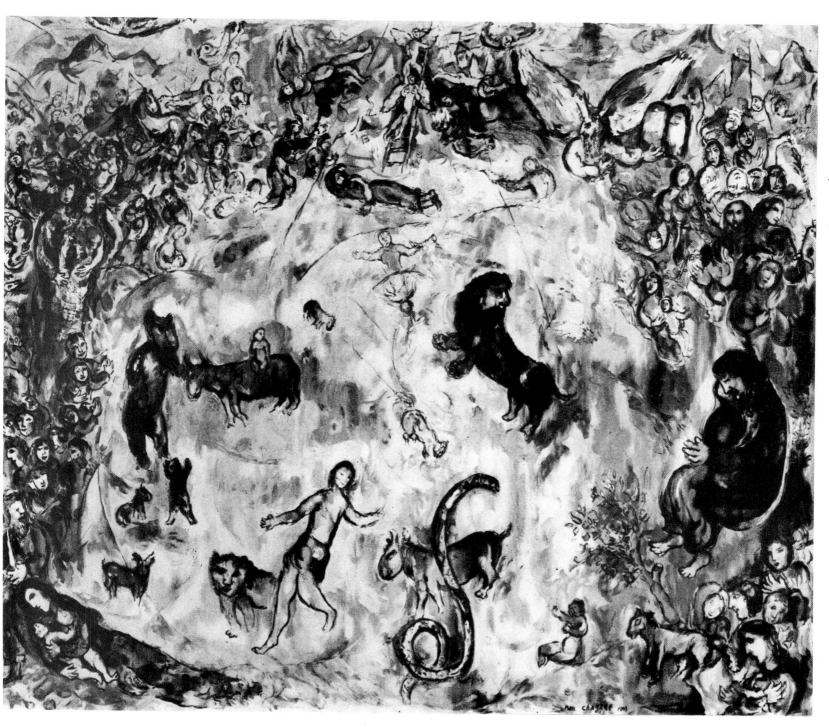

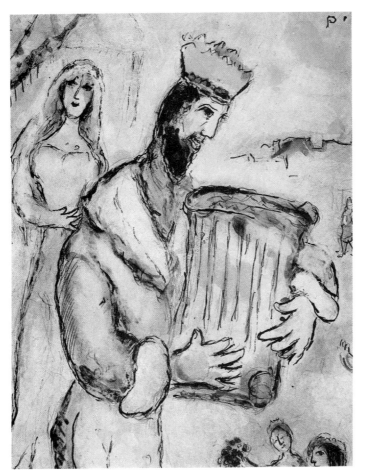

King David Playing His Lyre.
Exodus cartoon (detail).
Gouache 1964.

Impulsive, spontaneous, light-handed, quick-spirited painters do exist, but Marc Chagall is not one of them. A long meditation and often an inner unavowed drama always precede his work. Shut up within himself, overcome by doubts, he tries for a breakthrough, and, in order to go on any further, he must suddenly perceive a reality, but without disdaining or abandoning recourse to divination. As he himself admits, he recognizes this reality that is needed to trigger his painterly impulses by a sort of vibration, a sort of pigmentation of matter similar to the hoarfrost on the fields.

In 1965 the Gobelins studio began work on three large tapestries by Marc Chagall intended for the Israeli Knesset. The term "Knesset" is generally translated as "Parliament," but insofar as Israel is concerned, I would prefer to translate it as "the seat of government." To my mind, and as I see the State of Israel, the term "the seat of government" conveys more accurately the historic will power of this people to exist, as well as the general behavior of this nation.

This group of tapestries as well as the mosaic floor which, for mythological and metaphysical reasons, only Marc Chagall could have undertaken, express his faith and admiration before the extraordinary phenomenon of the resurrection of Israel.

The tapestries constitute a vast triptych. *The Exodus* (15'6²/₃"×29'5²/₃") forms the central panel. The panel on the right is *The Prophecy of Isaiah*

154

The Entrance to Jerusalem.
1964. Tapestry. 15'6²/₃"x17'7⁵/₈".
Knesset, Jerusalem.

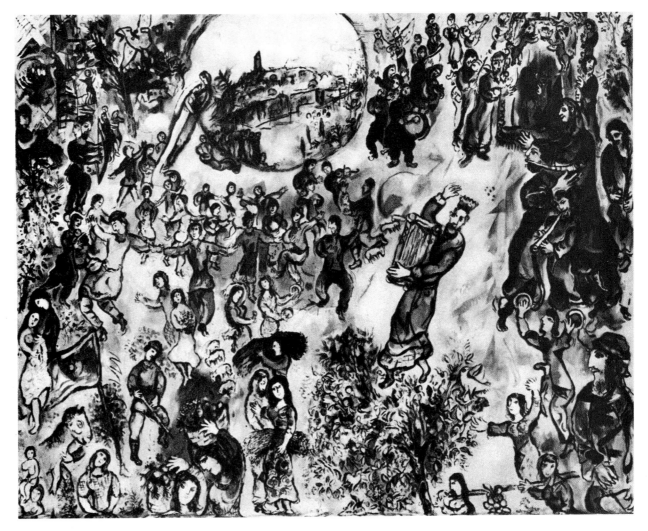

$(15'6\,^2/_3''\times17'7\,^5/_8'')$, and on the left *The Entrance to Jerusalem* $(15'6\,^2/_3''\times17'7\,^5/_8'')$.

Taking into account the historical reality, the artist sought to unfold in this enormous woven fresco a large-scale organization of color and light, of radiance and rhythm where the revery of his spirit could express itself freely, but without doubt he also wanted to portray in abbreviated form the destiny of the Jewish people.

The most striking thing about these great sketches executed by a hand carried away and enchanted by the magic it gives birth to is that all three are celebrations of energy.

It is easy, with respect to Marc Chagall, to employ the words "dream" and "revery," and they have not been used sparingly. But all too often dream and revery are considered to be opposed to action, and this seems to me to be an hierarchy of thought that is definitely outmoded. What we still refer to today as "dream" is so intimately connected with everyday reality that it provides a single, real image of man. How irritating to always hear dreams referred to as something mild, pleasant and ambiguous, and to have the images they secrete considered as the simple babblings of a man split in two. For Marc Chagall, energy and "dream" are one; they are the expression of the totality of man, and for this reason energy is not the opposite of the dream but its complement. Each instant bears the mark of engagement and decision, and it was for this reason that he chose

his themes. *The Prophecy of Isaiah* is the triumph, the everlastingness of Jerusalem. *The Exodus* is, at one and the same time, ordeal, rupture and agony. *The Entrance to Jerusalem* is the resurrection of the earth recaptured, the jubilation of homecoming!

Every great work is open to a great variety of possible interpretations and conceals multiple treasures; its ambiguity is the result of its complexity. Ambiguity has always seemed a virtue to me, and even a cardinal one; it is a reservoir of mystery and grandeur because, as nothing is fixed, everything can be, can happen. In its essence it is dynamism and the dynamic source of poetry.

The fantastic events that Chagall has tried to convey in wool are fleeting moments in history that have fundamentally affected man. Illuminating his destiny, they evoke the essential human truths. An ample gesture must stand behind such a design; a deep harmony must reign between the inspiration and its formulation.

Aware of the imperatives of his choice, Chagall established an overall compositional design; it is based on an enormous V supported by two strong points (Moses and David) that are connected by two large circles. In *The Prophecy of Isaiah* the compositional elements are distributed around a vast arena in whose center symbolic animals move. In *The Entrance to Jerusalem* the men advance in compact masses, whereas in *The Exodus* they traverse the surface in two intersecting diagonals.

Marc Chagall and André Malraux in 1961 at the opening of the exhibition of the Jerusalem stained-glass windows at the Musée des Arts Décoratifs in Paris.

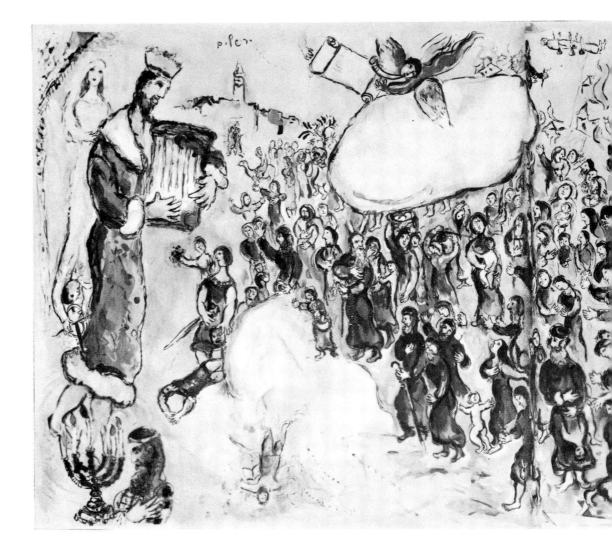

"Exodus" Tapestry.
Executed at the Gobelins Works,
Paris, by Mme. Bourbonneaux and
assistants. 15'7"x29'8". 1964.

Internal dynamic bonds unite these three compositions and bring out a sense of tension which, rather than being broken, is continued by the two large figures: David playing the harp and Moses revealing the Tables of the Law to the people. Like caryatids, these two figures bear the weight of the architecture and their colorful vigor accentuates and controls the dynamic effect of the masses. Without hindering the eye's movement across the undulating lines and the bright motes of color, they reinforce the active vigor of the composition.

Once again, Chagall, master of his art, has instinctively embodied his plastic ideas. He detests using evidence, detests believing in the necessity of precision. He knows it and has doubts on this subject: "I'm not sufficiently precise, so-called precise," he has written. And he adds, not without irony: "But words are not precise!" Something else is involved, which he wants to attain, and he declares, "Divine fluidity, now that's truly precise: the fluidity of Monet, of Mallarmé."

In effect, to specify is to arrest, encircle, isolate, to find an affirmation only at the very end of the trajectory. This attitude is contrary to the very

spirit of Chagall, for whom all things are interlinked and continually passing from one into the other, like communicating vessels. Hence, the comet in its lightning descent flaps wings like the cock perched on the roof, the bird pecks at the hours counted out by the old clock, and the streets of Vitebsk run through Paris as well as Jerusalem. In connection with this there is no need to evoke the fantastic: it is better explained in Chagall's own words: "I am against terms like 'fantasy' and 'symbolism.' Our whole inner world is real, perhaps even more real than the visible world."

Imagination is thus the key to the Chagallian conception of the world. Light, deceitful fantasy and imagination—which Baudelaire rightly considered to be "the queen of the faculties"—are two completely different things. Chagall's imaginary universe has its own coherence and internal logic which create a system of relationships and associations. Form and content combine in his work and produce new revelations. The V composition he chose with large open branches ending in circles is an attempt to unify, to fuse the various elements and forces; here, opposites, instead of being exalted, are abolished in the interest of the total com-

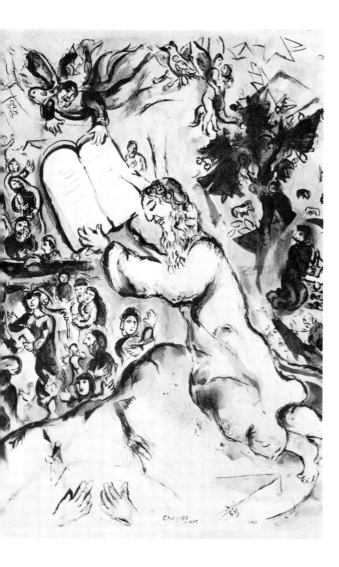

position. Moreover, Chagall is free, and to communicate his feelings he knows how to modify and diversify his means without being subject to any of them.

Jean Grenier has written pertinently: "A scattered appearance represents a succession of things in reality. Although events succeed each other in time, they cannot be shown that way on a spatial plane... Chagall brings together on his canvas events that one would experience in life step by step."

In effect, he does not let himself be burdened by the idea of time any more than he lets himself be caught in the constantly set trap of spatial description. He reinvents both according to his own feelings, but he naturally transgresses physical, rational unity, which can easily be both represented and measured. This is why he explores, with exemplary ease and using every means available, the realms of the supernatural. In the long run, Chagall appears to be a pertinent logician.

The concept of a mosaic floor posed a new problem. To start with, we should note that the flooring can be one of the most beautiful architectural elements of a building; think of the floors of the cathedral in Siena, the small church of Torcel-

lo, San Marco and Santa Sophia. A mosaic floor is a sort of carpet spread out under the feet of emperors and kings; it goes very well with the haughty gait of a master striding from the brightness of a large open door toward a sanctuary; it provides delicate ornamentation for women's baths and for patios where family members come together and around which social life is organized. Its humble postion below feet perhaps accounts for its being scorned or neglected, and yet all grandeur, all feeling for pomp and ceremony, extols it. Precisely because something in us rejects the lowly paving-stone, it is honored by those who want to set up a ritual and impress the traveler. But the organization of such stones into designs and figures should never act as an obstacle to the person who walks across them. His eye must not be encumbered and his step must not be hindered.

Considerations of this kind were probably behind Chagall's making a very special decision. Rather than stretching a geometrically shaped garden under the feet of the visitor, he preferred to embed the elements in a mass of stones from the Negeb that were of slightly different hues of the same color. As a result the huge State Reception Hall of the Knesset of Israel is sprinkled with unexpected mosaic forms. Furthermore, the floor can be visualized as having another, poetic aspect: couldn't what is involved here be a collection of broken and rearranged archaeological elements bearing the traces and wounds of time, the avatars of a long struggle, of battles throughout the centuries? It seems also that in establishing the coloration Chagall recalled the Greek and Roman mosaics he had had a chance to see during his travels, as well as those he saw in Israel (at Heptapegon and Tabgha, Beit-Guvrin, Shavey Zion and Beit-Alpha) from the fifth and sixth centuries.

It was tempting to use the Eilat stone from the Negeb, which has such lovely coloring. But since it was a matter of mosaics, some tiles had to be imported from Italy. Mr. and Mrs. Milano, assisted by Messrs. Guardini and Leoni, took charge of transposing Chagall's sketches into mosaics, carrying out the task with the skill of unusually sensitive craftsmen who are aware of the many different possibilities of their craft. The hues range from grey-blue to pale yellowish to burnt Sienna, punctuated by bursts of white. Transposing sketches into mosaics is always a very delicate business. The vague, imprecise nature of the sketch, which gives it all its charm, must nonetheless be captured and very often formulated. All the know-how of an alert, sensitive craftsman is necessary to establish the transitions that a small, simple square that is either too dark or too bright can break. And yet even more than elsewhere, the drawing must be present without being too heavily accentuated. The craftsmen seem to have resolved these problems very well.

The Wailing Wall.
Detail. Mosaic. Knesset, Jerusalem.

Mythic, sacred themes are not suitable for mosaic floors, which are better served by free or geometric ornamentation, as many artists realize. But we know that Chagall, if he uses geometry deliberately, does not really want to indulge in it. He encloses within forms that tend to be elliptical images that belong to the everyday world. However, the commonplace in Chagall, as we have learned, is full of complexity, and consequently we discover many unusual aspects in it: trees weighed down with fruit; overflowing baskets of produce that recall the time when Palestine was an orchard and the animals of nomadic tribes grazed on the rich grass; baskets of fish like those which the fishermen of long ago used to haul in plentifully on the shore, just as they still do today; branches of flowers; scattered grain; a bird caught in a trap, which an anxious hand comes to free; goats cropping the fragrant herbs on the hillsides; mysterious signs; checkerboards with their ends cut off; stars shining in the feathers of a partridge. These simple rustic and bucolic scenes illustrate the work of the pioneers who retimbered the hills, made the abandoned terrain green again and with enormous effort were able to repeople these lands that for centuries had been worn away by the blazing intensity of the sun. Even the use of Eilat stone is symbolic. Once calcined, split and unused, today it is hewn, shaped and assembled under the feet of the visitor, where it unfolds like a prairie ripe with possibilities and future wealth, charged with the history of men.

Finally, resuming the theme of a 1932 picture, *The Wailing Wall*, today in the Tel Aviv Museum, Chagall also created a large mosaic panel for the northern wall of the huge Reception Room of the Knesset. He took advantage of the considerable distance imposed by the architecture, and the wall-panel can be seen at the opening to a staircase where it underlines the perspectives of the stones of the temple and accentuates the effect of flight. The center of the composition consists of a flamboyant seven-branched candelabra above which an angel is poised. On the left is a comet with a long wavy tail; it is contrasted on the right with a human garland that originates in the center of a group of figures in prayer.

There are no superfluous details, but there are four or five essential figurations charged with obvious symbolism, with heavy echoes and deep meanings. In its simplicity of form and color, by the particularly intense scintillation of small juxtaposed cubes, this wall has the calm character of certainty. Isn't it, in a way, Chagall's response to the question that could be the caption for his picture *The Gates of the Cemetery* of 1917? "Wordless. Everything hides in me, is convulsed and hovers like your memory. The paleness and thinness of your hands, your dried out skeletons tighten my throat. Whom to pray?"

the song of songs

by san lazzaro

On bequeathing to posterity his "Biblical Message", did Marc Chagall choose? Of course, one can never forget the secular artist, the painter of the "Aleko" curtains, of "The Firebird", of "Daphnis and Cloe" and a hundred other masterpieces, the same works to which, after the Museum of Zurich, the Maeght Foundation in Saint-Paul (France) and the Museum of Toulouse are going to pay homage. It is true that even on finding inspiration in music and love, the artist remains in the "sacred" which Mircea Eliade has defined so well. However, the Biblical world is the "sacred" captured at its source: it flows directly from the Book of Prophets.

Marc Chagall's Biblical world was rediscovered by the men of my generation in their adolescence by leafing through the artistic and literary magazines of that time. We recaptured the reality of it in Chagall's work for he had been until then, for the children we were, a pure abstraction like the Earthly Paradise and the Tree of Good and Evil. It is the reality of this sacred but imaginary world that our teachers and parents, unaware of it themselves, would have wished us to be unaware of, too. A world in which the poor, too, like the Greek hero, the slave on the Egyptian bas-relief or the rich adolescents of the Florentine aristocracy or bourgeoisie, had a right not only to charity but also to their share of poetry; whatever "poetry" means today.

This race, whose inexorable destiny was forged by Moses and his brother Aaron, what would it have become if it had not been taken out of the still welcoming Egypt where it was already worshipping Pharaoh's gods? It's simple: there would not have been any Prophets and poet kings, no Bible and, thus, no Christ, the end result for us of the crossing of the Red Sea and the Sinai Desert: that Christ child to whom Chagall paid homage in 1912 in the famous painting, belonging to the Museum of Modern Art of New York, whose plastic qualities equal those of Picasso's *Guernica* which is considered one of the masterpieces of that great Spanish painter. I don't know what emotions urged Chagall to paint this picture at a time when the children of Israel still considered Christ as the symbol of the long period of persecution endured through the centuries and whose existence obliged them to remain outlaws, to live in the expectation of returning to Israel.

This Christ is a child, just as in the arms of some Portuguese Virgins, the Christ child is the bearded Christ he was later to be, wearing a crown of thorns and not that ridiculous royal crown in which the Son of God is generally rigged out. It seems to me that in order to understand the sense of Marc Chagall's Biblical message (which more recently has voluntarily interwoven the Old and New Testaments by painting the stained-glass windows in Jerusalem as well of those for the cathedral of Metz), one must go

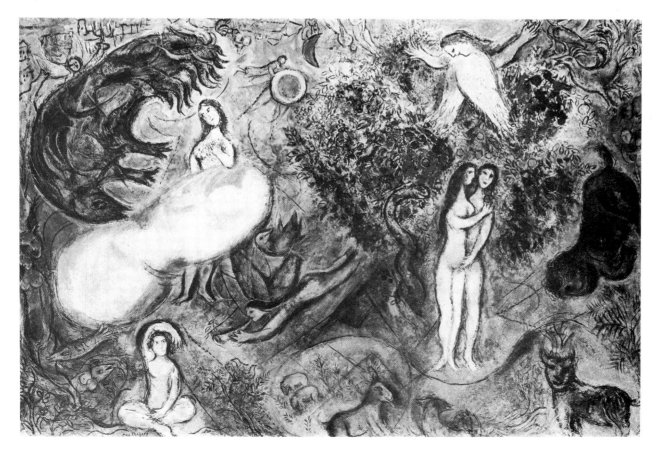

Paradise. 1956-58.
Oil on canvas, 72⅞x113".
Musée National Message Biblique
Marc Chagall, Nice.

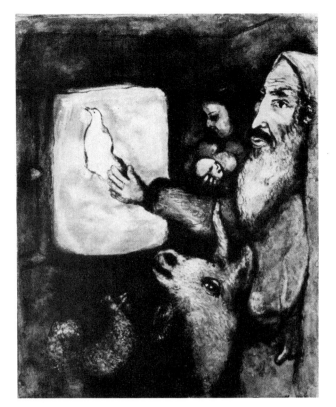

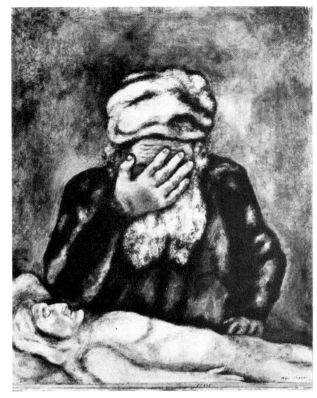

Noah Releasing the Dove.
1931. Oil and gouache. 25"x18⅞".
Biblical Message.

Abraham Mourning Sarah.
1931. Gouache. 24⅝"x19½".
Biblical Message, Nice.

The Song of Songs. Painting.
58½"x67¾".

back to this first example of reconciliation, to which cubism lent its traits.

Why did Marc Chagall paint that picture? I like to think that it was out of love for that image of man, in whom, he too, loving his neighbor as himself, recognized himself, and who had been, like him, before becoming a symbol, a child who astonished adults by his knowledge and intelligence. It was not, however, a personal gesture dictated by his own conscience, since the millenary world from which he sprang and which saw in him its first great painter, did not disapprove of him, did not veil its face like Abraham over Sara's corpse, did not reject him like a renegade from the community. That world understood, approved and admired its painter.

I have just seen in the basement of the Musée National d'Art Moderne in Paris the seventeen paintings to be exhibited in the Louvre in a few weeks. Like many people, I read Eugène Ionesco's article this morning on *the ignoble scoundrels:* "A race is in danger of being destroyed. A race that is not asking for the place of others but only a small place to live in this world... A race that has more right to live than any other because it has been the most slandered, persecuted, tortured... The moderation of the reactions of the world's moral conscience fills me with indignation. It has always been so..."

Around 1930, wishing to illustrate the Bible for the publisher Ambroise Vollard, for whom he had already created extraordinary engravings for *Dead Souls* and for La Fontaine's *Fables*, Marc Chagall, accompanied by his wife and his daughter Ida, went to Jerusalem, discovering the land of their ancestors and the sky that opened to submerge the world, with the exception of the wise Noah, his sons and the animals, but also to make the celestial manna, like honey from a hive, fall on the heroes of the great Exodus. This return to Hebraic sources by a native of provincial Russia was obviously an important stage in the artist's life and evolution. However, its importance is entirely different from, for example, Delacroix's trip to the Orient. For Chagall, the pilgrimage to Palestine was not a revelation but a confirmation, for Palestine, its history, its legend has always dwelled in his heart (where he was also to discover Greece). In his childhood home, in his Vitebsk, he had spoken of and dreamed of the Holy History. Abraham's hand, covering his face beside Sara's mortal remains, was his father's hand; the Prophets were no less familiar to him than the friends of his family, and the animals of the Ark had been his first and only toys. Thus, it was not a reflection of a world gone forever that he discovered in Palestine, but its sky, its light—that light in which the children of Israel purified themselves, like an offering to the Eternal.

Even before setting foot on the land of the Hebrews, Chagall was already considered, and with reason, a great colorist. It was on his return, when we saw the gouaches that he brought back to France, that we discovered that his colors before the trip, in spite of the pleasure they gave us, were still objective, impersonal. He had lacked that sacred fire that he discovered in Palestine, his "chemistry"—that mysterious word that the artist was later to use—subjective, inimitable. Chagall certainly realized the new power of his colors but, modestly, continued to believe that one cannot demand more of a painter's palette than to hold its own with the color of his garden or the bouquets of roses placed by Madame Chagall each day on the living room tables. I agreed with him until the day when, the contrast being too evident, I dared to tell him that he had been misleading me, that "his" red had a luminosity, a gentle fury, a "chemistry" that did not exist in nature's red, and that I really could not put them on the same level. "I'm sorry," he said, looking at me with astonishment and blushing like a child.

That light of Palestine undoubtedly palpitated and sang in his heart like no other light ever had before, but it is in his artistic inner depths that he found the one, the unique that will assure his fame during the centuries to come. It is not a vegetal explosion, it is not possessed of that joy that the artist, in his modesty and in his love of nature, believed he could give it, but the fluidity, the sparkle, the fire of mineral, the purity of precious gems or molten metal. Without speaking of mystic colors, even without the artist's knowledge, that "chemistry" has been modified, has, in a manner of speaking, become inflamed and purified. Since his first trip to Palestine, it illuminates his canvases like a stained-glass window. And we recapture in front of these seventeen paintings of the "Donation" the same enchantment we felt a few years ago before the twelve stained-glass windows of the Synagogue of Jerusalem: it is the Song of Songs in color.

However, the supreme test for a colorist is black and white and monochrome. Only Matisse knew how to "suggest", like Chagall, the magic of color in his drawings, in certain gouaches and a few paintings without actually using it.

Is this "Biblical Message", thus, a message of poetry? Undoubtedly: just as of Solomon's glorious reign there exists only one beautiful poem of love, the history of Israel—and Christ, too, belongs to the history of Israel—like the bloody tragedy of the Atridae, is nothing more than song where the dramatic rhythm rings with nostalgia in the heart of this great painter and great poet, Marc Chagall, that Mozart of painting. But it is, above all, a message of faith. We tremble these days, dear Ionesco, at the idea that this poetry, this faith may become mere history again, and your indignation at the moderation of our reactions fills our consciences with shame.

Of all the great painters of our time, Chagall alone has not felt the very ephemeral call of actuality. Braque himself at the end of his life felt obliged to sacrifice quality to quantity and covered his canvases with a thick paste that his brush tilled like a plow. Picasso has occasionally let color flow from his brush like a *tachiste* painter. Chagall, rather than reply to the call of the new "isms", on growing older (an incorrect term, for his youthfulness of spirit and his physical resistance are amazing), seems to be drawn by that of his great elders: it is his manner of growing older without shame that shows his Oriental origins. Like a Chinese sage he is able to love youth—and even with a certain coquetry—

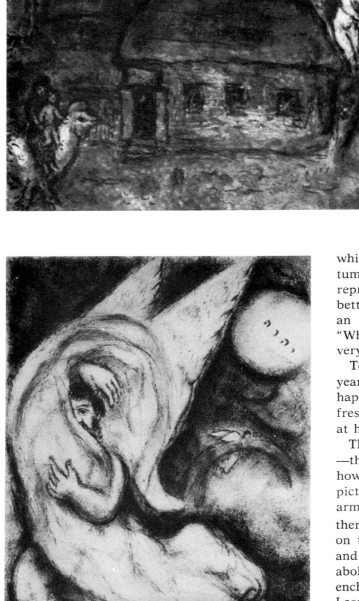

Jacob's Ladder. 1973.
Oil on canvas. 28¾x36¼".
Private collection.

**God's Forgiveness
Prophesied to Jerusalem.**
Illustration for the Bible.
Ed. Verve. (Paris, 1956).

while keeping his poetry sheltered from the tumult. I told him one day that Jean-Paul Sartre reproached Titian (whom he called Vecellio, the better to emphasize his scorn) for not having been an "involved" painter. "What?" replied Chagall. "Why, he was "involved" in his painting to the very last drop of his blood."

To the very last drop of his blood: for sixty years Chagall has been "involved", with steady happiness, in his painting, and with a vigor, a freshness, a youthfulness that very few artists, at his age, have experienced.

The painter of Jerusalem's stained-glass windows —that rare proof of today's genius—taught us how important it is to limit each element of a picture by enclosing it in its contour, as if in armor, the better to insert it in the composition, thereby strengthening its unity. In his paintings, on the other hand, all frontiers between heaven and earth, between man and the cosmos, are abolished. Chagall gives way, in his turn, to enchantment. One thinks of the famous lines by Leopardi: "*E il naufragar m'è dolce in questo mare.*" But it would be rash to think that the painter has said everything and given all he has to give. I am convinced, to the contrary, that we can confidently expect a new stage in his evolu-

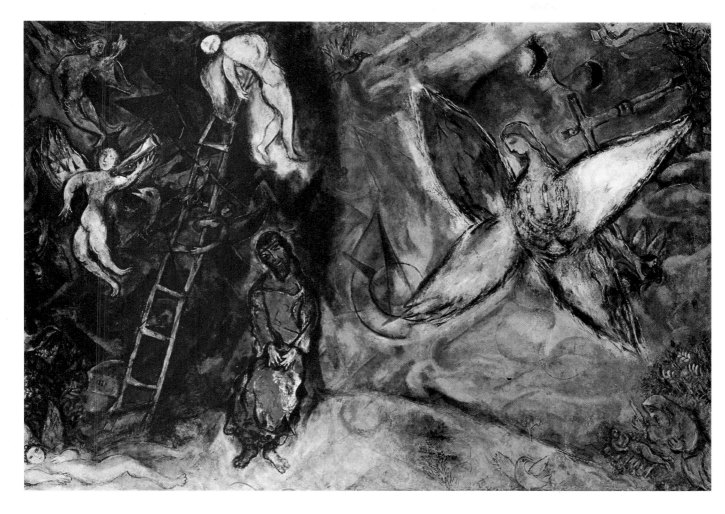

Jacob's Dream.
1958-1960 Oil on canvas.
Message Biblique
Marc Chagall, Nice.

tion which will constitute a happy synthesis of his work.

Will blood flow in Jerusalem? Someone told me this morning that, by way of precaution, the stained-glass windows are being removed, only one of which—the "window" of the Gad tribe—recalls the horrors of war. Chagall has never sung like Jeremiah: "Prepare ye the buckler and shield, and draw near to battle. Harness the horses, and get up, ye horsemen." Over his work only the banner of love is unfurled: love for man and love for painting. In a period when both are brutally shaken, under a thousand pretexts, the artist recaptures in that love "the sacred present in the world"—according to the expression employed by Mircea Eliade in her excellent article. "Thus, he takes his place," she adds "among the human beings who have rediscovered happiness,"—a happiness of which the Western élite have almost lost the sense. For a painter, happiness is, above all, the joy of painting.

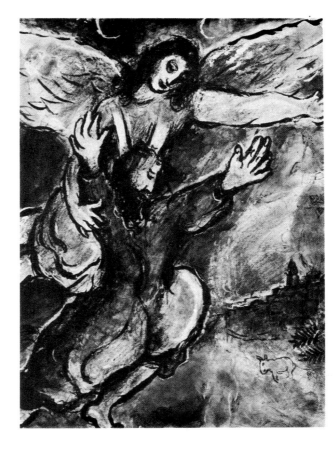

Moses in Sight of the Promised Land.
Study for the volume
"The Story of the Exodus."
1965. Gouache. 18⅞x13¾".
Collection of the artist.

164

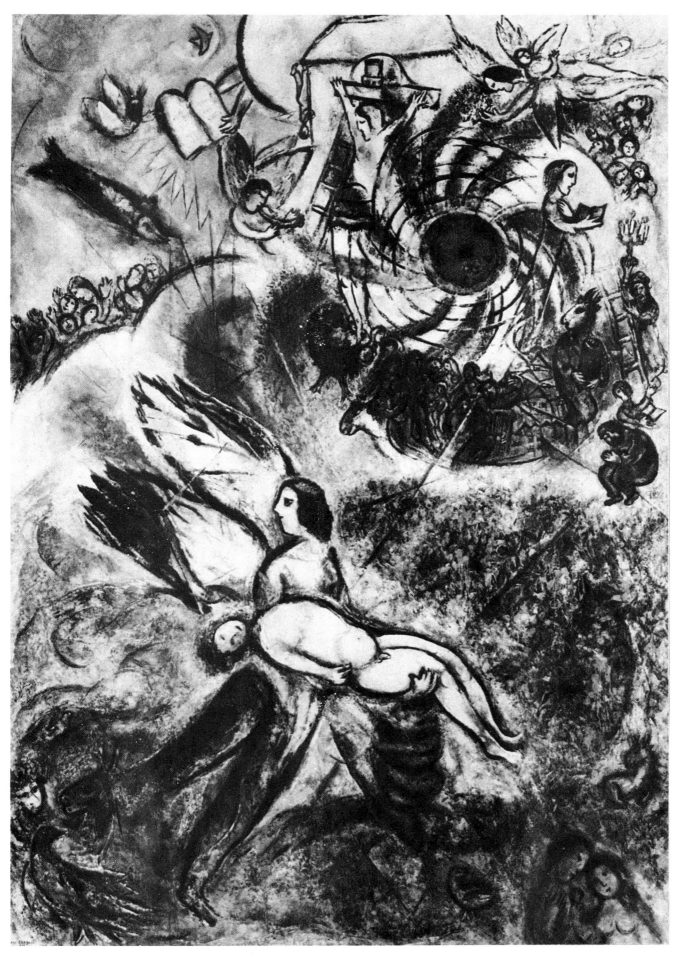

The Creation of Man.
Painting. 1956-58.
118⅛x76¾".

eternity recaptured

by andré verdet

On Friday morning, January 12, 1973, Marc Chagall was at the work-site on the Cimiez hill in Nice where the Biblical Message Foundation was in the process of being built. He visited the various rooms that, since his gift was dedicated in July, 1973, have received his works. He spent a particularly long time in the music and conference room in front of the three stained-glass windows constituting *The Creation of the World* and on the patio in front of the large mosaic, whose image will be reflected in the water of one of the pools. The stained-glass windows and the mosaic had been completed. Their setting is an integral part of the architectural scheme, which was carefully planned and took into consideration their long-range destiny and the spiritual light that emanates from them.

In an article published in the December, 1971 issue of *XX siècle* (No. 37), the material, moral and artistic characteristics of the building specially designed for the *Biblical Message* were discussed in detail, providing a preview of the now-completed building.

Chagall and his grandson at the opening of the exhibition of his Biblical Message at the Louvre.

Marc Chagall in front of the Biblical Message in Nice, France.

165

It seems germane to recall here that in the mind of the great Chagall this project can in no way be likened to a "museum," as one usually conceives of such an edifice today. Rather, it is a "sensitive, spiritual place" open to winged meditation and subtle revery, "a place," Marc Chagall would say, "where a certain presence imposes respect."

The Biblical Message building allies structural rigor, aesthetic function and high material quality. It has a clarity and a resoluteness of harmonious lines. The diversity of its lines makes for peaceful interplay between the rectangular spaces and the more inventive lozenge-shaped ones. The rooms inside are adapted to the terraces, pools and shaded gardens outside.

The stone, extracted from the neighboring mountains, reflects the bright sun and has a hard, clean look; it constitutes the principal element of the masonry, streamlining it in a way. Other metallic materials — alloys of aluminum and silicon — are used in conjunction with the noble stone.

Artificial light is combined with natural light in such a way that the lighting from all directions is optically unified in a tranquil flow, a peaceful radiance. The problem insofar as the inside galleries were concerned was how to temper the great, voracious luminosity of Provençal sky. This light is extremely intense because of the reflections of the sun on the sea a short distance beyond the spacious terrace that is on a level equal with the gallery-foyer of the Biblical Message. The precise problem was how to respect, to the letter, the safety regulations imposed by the Directorate of the National Museums and ensure the preservation of the works, the danger being that overexposure to light would fade the paper, ink, gouaches, etc.

I would also like to point out the use of tinted glass for the glass walls in certain parts of the building; this was done to prevent people's eyes from being dazzled by the very brilliant sun when looking out at the gardens.

The constant concern that guided André Hermant, the architect, was to serve to the best of his ability the cosmogonic thought of Marc Chagall, his lofty inspiration, the plain song of the pure legend. The studies for, and the execution of the work on the superb site provided by the city of Nice were carried out over a period of a few years under the joint supervision of the Directorate of the Museums of France and the officials of Nice. The painter of the *Biblical Message* made his first donation to France in July, 1966. The Louvre Museum (Mollien Gallery), for a memorable exhibition in 1967, accepted the large paintings done after 1955 as well as several important gouaches and watercolors dating from 1930 and 1931. The exhibition enabled the public to understand with what fervor, awareness and insight Marc Chagall had prepared the development of the majestic pictures whose rich lyricism towers above and crowns all the studies he did for so many long years. The second donation, like the first, was made by Marc Chagall and his wife Vava.

Moses Receiving the Tablets of the Law.
1958-60. Oil on canvas, 93¾″x9⅛″.
Musée National Message Biblique, Marc Chagall, Nice.

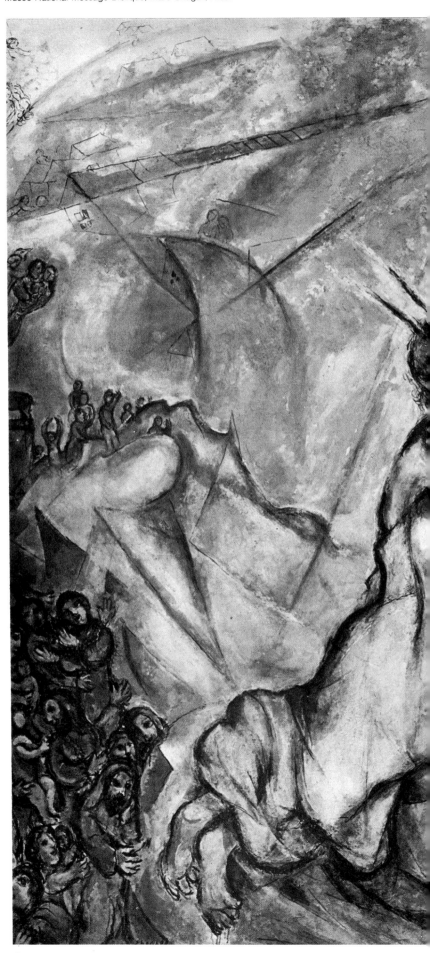

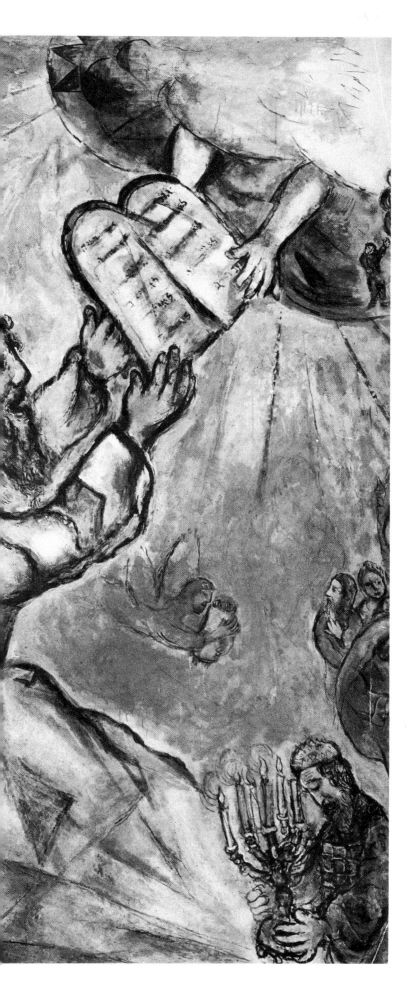

The true spiritual starting point of the *Message* goes far back in time, no doubt to Marc Chagall's stay in Palestine from February to April, 1931. Ambroise Vollard had commissioned him to do some etchings for a Bible. The artist had just illustrated Gogol and La Fontaine. He departed for Palestine because, as he said, "I wasn't seeing the Bible, I was dreaming it." Contact with the landscape of the Holy Land, with that sort of luminous and fluid streaming of the legendary centuries, gave him both a revelatory shock and the dazzling confirmation of the meaning of his preceding works related to biblical motifs. Here, under the lovely Palestinian sky, he discovered the poetic and at the same time the spiritual element of those works in which nostalgia for the fabled land soared toward mystical regions.

He had seen the trace and heard the echo in his past works.... And here he was face to face with a land in which history continued to live and be incarnated, from a distance certainly but still present through its myths, among the most ancient of human civilization.

When Chagall returned to Paris from Palestine, he painted for himself a series of gouaches which today form part of the *Biblical Message* in Nice. In the same burst of inspiration, he set to work on the etchings intended for Vollard. From 1931 until Vollard's death before the war, more than sixty plates were made. But it was not until 1952, after Chagall had come back from his exile in the United States where he had fled from Nazism, that the painter resumed this work; completed in 1956, it was taken over and published by Tériade in 1957.

When Marc was a child in Vitebsk, his birthplace, the reading of the sacred book had rung in his ears like the sound of golden music. Throughout his adolescence it provided him with a sort of poetic sustenance with the flavor of a charm whose essence was expressed by the philter of time and past centuries—that same flavor and essence that we can find in many pictures by Chagall. Not only the Old but the New Testament inspired him when his talents as a painter began to be affirmed. In 1910 he painted a *Holy Family* and drew a *Christ on the Cross*. A gouache of 1911 depicted the figures of Cain and Abel. His affection for the Bible grew as can be seen by, among others, three *Golgothas* (1911 and 1913), *Susannah Bathing*, and two *Resurrections of Lazarus* (1912 and 1913). For the next fifteen years, until 1930, when Chagall met Ambroise Vollard, his inspiration moved away from the sacred book.

Then the biblical theme came back powerfully with pictures that we can classify among the most charged with lyricism and drama in all of Chagall's painted work. Thus we have *Solitude* (1933) with its intense emotional force, *Angel with Red Wings* (1936), *Fall of the Angel* (1937), etc. Later on, the mystical inspiration shifts from the Old to the New Testament, and there are an abundance of Christs: *White Crucifixion* (1938), *The Painter and Christ*

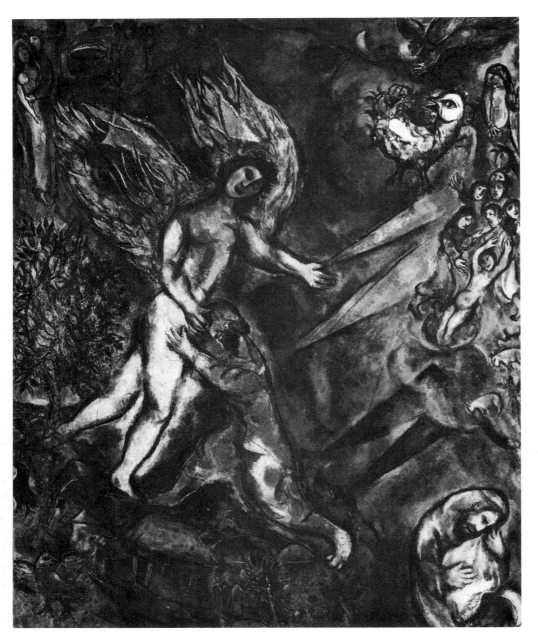

Jacob Wrestling with the Angel.
1958-60. Oil on canvas,
98x80¾".
Musée National Message Biblique
Marc Chagall, Nice.

(1938-1940), *Yellow Christ, Descent from the Cross, Persecution, Christ with Candles* and *Mexican Crucifixion,* (canvases executed between 1941 and 1944).

After the dramatic flowering that continued through 1951, the Old Testament once again became the focus of Chagall's inspiration; *Abraham and the Three Angels* marks the beginning of a series of large canvases: *David, The Crossing of the Red Sea, Moses Receiving the Tables of the Law, Moses Breaking the Tables of the Law.*

In 1955 the painter settled in Vence. Near his house there was a Way of the Cross with a large chapel flanked by a sacristy and smaller votive chapels strung out like so many stations of the cross. These buildings had been deconsecrated. The village officials thought it might be possible to have the chapels decorated by the painter. Chagall welcomed the idea. He planned to ,begin with the large chapel, which because of its size and structure best lent itself to his purposes.

For a long time the artist meditated before the white spaces. He measured each wall. Mentally, he prepared the installation of the canvases and their subjects. As he stood alone in the silence of the rooms, the images that rose in his imagination were gradually suffused with the enchanted fervor to which he has remained faithful ever since his young hand seized pencil and brush to try and set on canvas or paper that world of supernatural legends told to him from the Open Book, that world of mystery, wonder and terror encrusted like an immense sign from an immemorial time. The young Marc also found its echo and coloring in the smoke-blackened icons of old Russia.

In Vence, Marc Chagall plunged into the work, exalted by the project for the chapels of the Way of the Cross. Once the measurements and the locations in the large chapel had been determined, he began painting large canvases scaled to the architecture of the walls. He had decided to use Genesis, Exodus and the Song of Songs as motifs. Thus he painted for the back of the apse a *Creation of Man,* flanked on the right and the left by an *Earthly Paradise,* an *Adam and Eve Driven Out of Paradise,* a *Jacob's Dream,* and a *Jacob Wrestling with the Angel.* For the right transept Marc Chagall had visualized a *Sacrifice of Abraham* and a *Smiting the Rock,* and for the left transept a *Moses Receiving the Tables of the Law* and a *Noah's Ark.* For the nave a *Burning Bush, Abraham Entertaining the Three Angels* and *Covenant of the Lord with Noah.*

Starting in 1955, then, seventeen canvases were born in silent enthusiasm. But the Vence project couldn't be realized. The canvases created for the Vence project are among the works that can be contemplated on the Cimiez hill in Nice. Twelve of them fill the large Genesis and Exodus Room. The five others adorn the Room of Songs.

The seventeen paintings have been placed in rooms whose measurements, volume and style of architecture were designed to be in accord with that of the Vence chapel.

The other rooms hold an important collection of studies, gouaches, watercolors and copperplates, a perfect introduction to the large central compositions; regardless of whether one considers the latter to be pictorial or monumental, the additional presence of the former causes the Biblical Message Foundation to truly take on the air of a Spiritual Place. It is personalized and raised to the level of a cosmic symbol by the demiurgic genius of a visionary painter who was able to reinvent—so that today's crowds can better perceive its astonishing poetic content—the images of one of humanity's oldest sacred texts, a text considered to be one of the major and most probing parts of the Enigma: that original, incessant dialogue, now terrible, now appeasing, between God and his creatures.

The biblical stories are integrated in the historical process of the Afro-Mediterranean civilizations. They profoundly nourished Chagall, who has furnished us with a plastic version that is only related to his visionary art. He interprets, makes them his, while respecting the spirit, the law I might say, of the Scriptures. Having forgotten the pictorial tradition that was connected with them, rejected conventional iconography and the irritating anecdotal aspect, he imparts to them youth and freshness, charm and a new force and does so in such a way that contemporary man, touched in his heart and soul, becomes attentive to their ontological meaning, their moral resonance on the plane of the complexity of human destinies.

The Word is painted. Painted, it attains an epic grandeur, often verging on the sublime, but at the same time it remains familiar, grazed by fantasy and winged grace. Its severity is full of touching details and, like a stubborn and tenacious flower, a bit of dawn always pierces the heart of the tragic. The drama in it is accompanied by humor and candor. The appeasing starry idyll appears in a vast, prophetic, eternally blue night. What is described here is precisely the ineluctable confrontation between God and man (I was about to write between God and his gods and men, or between God and Nature raised in front of him).

The Creation consists of three stained-glass windows: *The Elements* is devoted to the first four days, *The Species* to the two following and *The Lord's Rest* to the seventh day. *The Elements* (15'3$^1/_2$"×13') is adorned with a vast, dominating ultramarine blue in the center of which oranges, rubies, pinks, greens and yellows spring up, blossom, flash or shimmer, grow lighter or deeper or

169

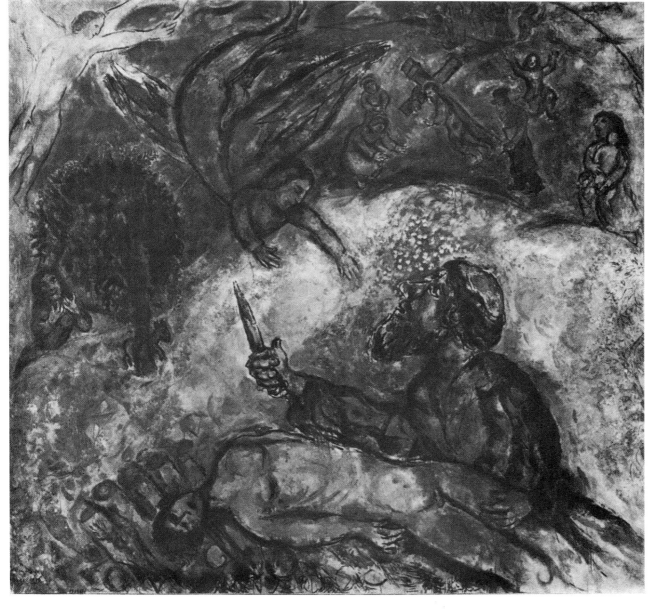

Abraham's Sacrifice.
Oil. 90x92".

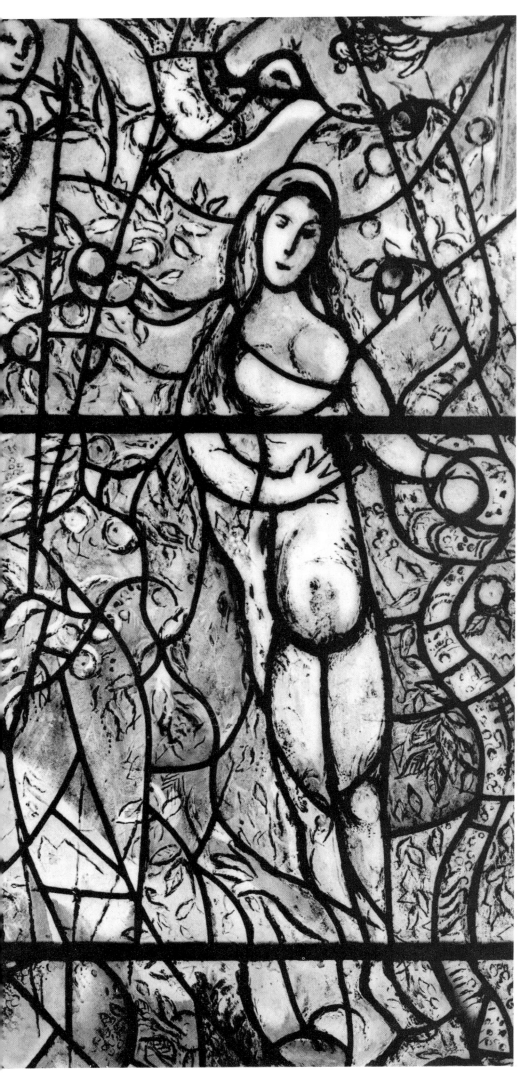

recede, depending on the time of day and the changing availability of light. At dusk a violet abyss little by little extends its solemn empire under a nocturnal velvet wherein a few astral forms still continue to flicker and burn out in the darkness of Genesis.

There is a dynamic conception behind this stained-glass window. The abstraction of the forms thrust into space and clothed with a creative light hides a powerful concentration of forces, forces drawn out of chaos, orchestrated, integrated into an already cosmic rhythm. Structural lines, struggling against each other, establish points of tension, relations between movement and speed: circles and diagonals in full trajectory, some fuse-shaped, some orbicular. We are confronted with the dynamism of the light and the celestial mechanisms: suns and planets.

Cobalt blue is dominant in the stained-glass window of *The Species* (15'3$\frac{1}{2}$"×8'9"), that of the Creation of Man, the Animals and the Plants. Here are Adam and Eve, the Serpent, the Goat and the Birds, the whole fauna familiar to Chagall, the creatures of his countless fables.

Triumphant angels cover the space of the third stained-glass window, that of the seventh day, *The Lord's Rest* (15'3$\frac{1}{2}$"×4'2$\frac{3}{8}$"). Here again the forms emerge from the controlled yet powerful dynamics; faceted prismatic forms, a little like stones mounted in space, with developing chromatic vibrations, are metamorphosed according to the position of the sun, changing with the morning, noon and early evening light. As in the two other stained-glass windows, we find the same lines of inner tension, feel the "electricity" that runs through them.

As usual Marc Chagall worked in the Simon workshop in Rheims in close collaboration with Charles Marq, the master glassmaker who always assists him and whose sensitivity, creative craftsmanship and intuitive gifts for transposing the work are highly appreciated by Chagall.

Standing before the stained-glass windows of Marc Chagall, we perceive the work for the first time: the light absorbing, dissolving the mechanical lead framework. The technical skill of Charles Marq was put at the service of the painter's inspiration, became one with it, as it were. Hence, when the jointly carried out work was complete, the effort was invisible in the face of the work it helped to create.

Marc Chagall supplied the master glassmaker with a model scaled to a tenth of the size of the final window. Charles Marq studied it for a long time, bent on discovering its "insides"—what was hidden and existed within it. He tried to capture its main intentions. Then he transposed the pictorial language of the model into the masses of basic colors and the leads.

One of the major triumphs of the master glassmaker consists in his ability to underline the principal movements of the composition by the placement of the leading. The initial lead framework is basically graphic, contributing to the expressiveness of the drawing and the color. The second is purely mechanical, contributing to the maintenance of the work's structural soundness and the physical strength of its armature. The master glassmaker must avoid monotony in the windows by breaking the lines; a systematic geo-

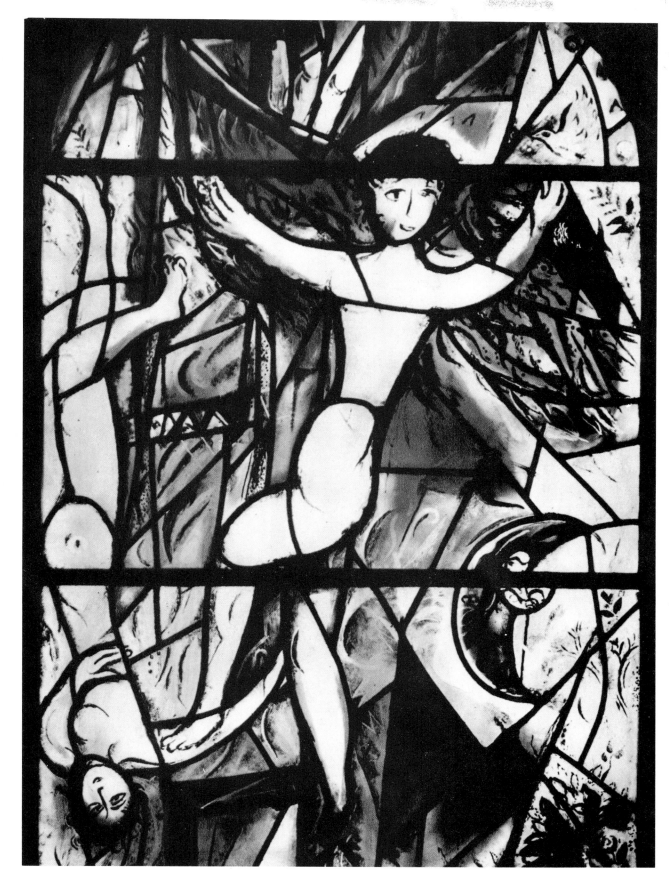

**Stained-glass window
for Metz Cathedral.**
Detail. 1959-60.

metrical checkered system would be fatal to the work.

The artist can, if he judges it necessary and after consulting with his assistant, rectify, add or substract certain lines from the leading of the first framework.

Marc Chagall's work consisted in painting directly on the surface of the colored glass, adding to the masses of basic color. In technical terms this is called "applying the grisaille." The structure of the composition is worked out after the principal forms and details have been decided upon. Such and such a design is emphasized by a harder or softer contour. The work requires constant vigilance, since the physical nature of a pane of glass and the specific use to which a stained-glass window is put necessitate following other rules than those that govern an oil painting. In the end Chagall had to integrate into his design, without any break, the various leadings required by the master glassmaker. In order to sensitize the background matter, in this case the colored glass, the artist employed scratchings, or what he calls "peckings." Soon the surface was sprinkled and tattooed with traces, imprints, figures similar to those in engravings found in ancient caves, poly-

Opposite page:
Eve and the Serpent.
Detail, 1964. Third lancet of the north transept window on the west side of the Metz Cathedral, France.

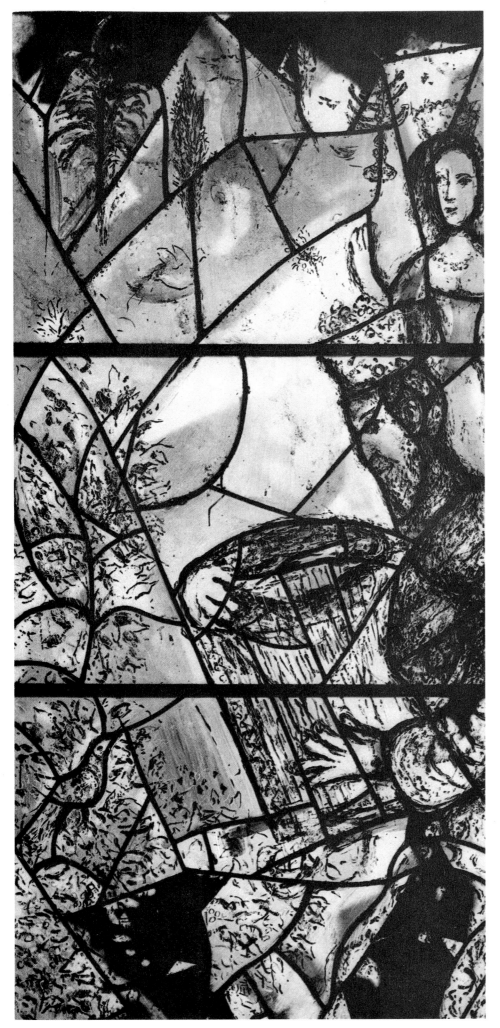

King David. 1969-70. Detail of the bottom of the window *"Heavenly Jerusalem,"* 30'2¾"x3'1¾". Fraumünster Church, Zurich.

morphic enigmas.... Eventually, these "peckings" are transformed into *signs*. When the stained-glass window is illumined, they are drowned in the triumphant light, in the sacred apotheosis of the colors. Nonetheless, they live in the incessant metamorphosis like imperceptible particles of swarming life, buried in the splendor, robust fossils of space and the air.

The monumental mosaic on the patio, *The Prophet Elijah*, rises on one of the side walls of the Foundation above a pool whose water will reach the level of a watermark on the mosaic which is one of the linear plastic elements of the work. Elijah, upright on his fiery horse-drawn chariot, in the shape of a prow, constitutes the central figure. He surges up like an apparition. A sort of astral line envelops, encircles him like an aureole, outlines his beige-colored form, reminding one of a planetary crust, a planet from which the words of the Prophet Elijah will soon thunder forth.

The space around Elijah and his chariot is filled with the symbols of human destiny which appear to move around him in a clockwise direction; we clearly feel the turning of the stars and the constellations, each of which is itself carried away by the revolving motion suggested by a subtly sketched circle. The duration of motion and the rhythm of time are thus fixed in space. The interpretation is miraculously fresh: an aerial vision that resembles the pictures in children's storybooks. The whole work sings like a pure poem of love. The figures seem to escape from a dazzling dream, to be made iridescent by a thin cloud that becomes more and more blurred, impalpable celestial smoke.

It is like a rich field sown with graduated hues and washed out colors, with bursts of flowers and subtle blossoms in pale colors. The forms bathe in pools of tenderness. They are often outlined by a supple, nervous line that accentuates the astral rhythm of the composition.

The discreetly emotional sensitivity of the matter, impregnated with memory, charged with meaning, is adapted to the medium of the stained-glass window or of the oil paintings: it resembles a fluid in which can be discerned the constantly enriched chemistry of Marc Chagall.

A barely perceptible spinning motion was imparted to the whole set of stones, glass marbles, etc. whose arrangement on a concrete wall ends up by forming a gigantic palette in which the general background greys are, I believe, the source of the chromatic iridescence of the composition, the basis of the accord between all the different tones.

The reds that dominate the upper right-hand section are those of the Sign of the Bull. They contrast with the other colors, initiate a dynamism, set the eye in motion and lead it to the right in order to bring it toward the blues and then into the rotation of the Zodiac, of which Elijah the Prophet seems the guide and master.

Lino Melano, the ceramist, one of the most sensitive specialists in Europe and who for many years has been assisting well-known artists, col-

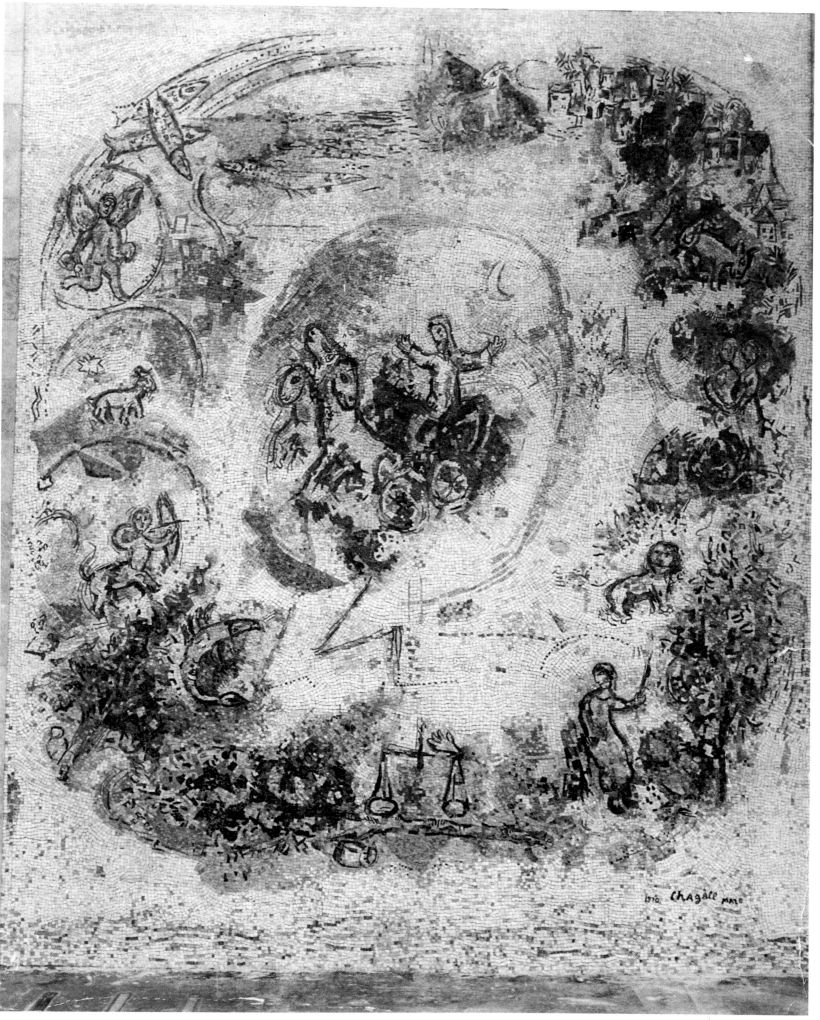

The Prophet Elijah.
1970. Mosaic. 23′6⅞″x20′11½″.
Biblical Message, Nice.

Chagall with Jon Mosoïste.

laborated with Chagall on this composition $(23'6^7/_8'' \times 20'11^1/_2'')$ and helped him to successfully produce a mosaic that I believe is one of the painter's most outstanding monumental works.

The two curators, Charles Marq and Pierre Provoyeur, are delighted when Marc Chagall pays them an occasional visit. Their conversation about the *Biblical Message* sometimes turns into a spiritual exchange as they walk through the beautiful rooms, still deserted and open to the wind, or under the numerous olive trees that make the gardens peaceful. The two curators know that the *Biblical Message*, of which they are the trustees and which they guard, will give to men in search of culture and knowledge not only a part of the innumerable and often enigmatic riches of the Scriptures, but will affirm the most meaningful presence, that of the painter-poet illumined within by the Obscure Word of the Origins and Destinies.

A haven for meditation offering the public a spiritual sense of grave joy and of the pathetic grandeur of existence, the *Biblical Message* will be endowed with four sculptures and a tapestry woven at the Gobelins, in addition to the paintings and mosaics.

Marc Chagall and his wife Vava, receiving André Verdet in their drawing-room.

when chagall hears the angels singing

by charles marq

Charles Marq and Chagall.

Technique is nothing other than the manner in which the artist uses his materials, and it is the finished work that shows his workmanship. There is no pre-established technique for work, and the first mosaics, the first frescoes, the first stained glass windows are no less perfect than those that came after. The painter does not make a separation between art and handicraft and all of our work with Marc Chagall is that mutual effort to invent at every instant, to never find oneself transposing.

Marc Chagall, similar perhaps in this respect to certain painters of the Renaissance at its apogee, has the gift of inspiring his collaborators. Far from asking them to adhere strictly to the model (a work perfect in itself and impossible to copy), he has a mysterious way of inciting others to relive his creation by means of another art. And the love that he demands has a force more powerful than the best intentions.

I remember our first conversations. Chagall had just been commissioned by Robert Renard to create the stained glass windows for the Metz cathedral. After the two small windows of Assy, this was quite another thing: a world of color and an immense space in the Gothic cathedral that he had to grasp and fill in. We spoke of the orientation of stained glass windows, of the way forms are reduced in a Gothic edifice, but above all, we talked of the light passing through the work, ready at any moment to make it explode with color, exalting the radiance of tones, transforming forms according to their transparency or their opacity, that sovereign power on which form and color depend. There was no question of technique, of lead, of the size of the glass... dead frameworks in which life itself would have wilted. Chagall was wrapped up in his vision, waiting for work to give it form.

A short time later, before the large models of the windows, I experienced the same feeling. How could I transmit that modulation, that luminous song of color? A thousand difficulties, even impossibilities, confronted me but I was conscious only of a deep desire to carry it out, of an ardor to give the painter's vision to the world.

In my studio I experimented with a scale of colors, seeking now in glass that suppleness, that continuity of light. Thus, I was gradually forced to make a complete scale of flashed glass that would permit a modulation within each piece of glass. By engraving with acid one obtains a shading off of value in the same tone right down to pure white, and this without the intermediary of the black lead setting. This light that is recaptured is, for me, the very life of the window

The Tribe of Naphtali. 1961. Stained-glass window. 11'1"x8'2½". Synagogue of the Hebrew University Hadassah Medical Center, Jerusalem. Twelve windows, all the same size, oriented in groups of three on the four cardinal points. 1960-61.

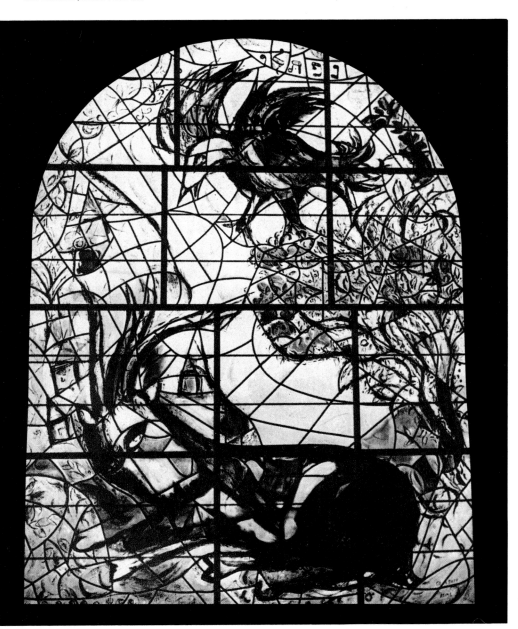

for it is the white that makes colors live, determines them, defines them, limiting the optic blending and playing, in every case, the role of a passing tone as black does by means of grisaille.

After showing the model—the painter's first proposition—Chagall then awaited my own proposition, made this time in glass and lead. When he says, "Now show me what you know how to do"... it is actually an appeal to your freedom, to that faith in our poor hands, capable, God willing, of transmitting to creation. He shows with humility that his genius is greater than he, so great that it can also inhabit others.

How I admire his manner of being outside of himself when he arrives at the studio. My work is there, a window that concerns him in every way but for which he is not responsible. With what force he enters into that dispersed, stammering, skeletal reality! "I'll take everything," he says, not lingering over criticisms but knowing that he can make his own all those forms, those colors although they are still foreign to him. He harmonizes the pieces of glass, examining, correcting, touching on only a few essentials but with astonishing precision. And perhaps his love for France is so deeply rooted in that spirit of clairvoyance that it carries him into unreality.

Now the window is ready to be "done". The glassmaker, like Adam's clay, has fashioned the glass, the masses, the possible forms, the weight of color required, but the window is there like a lifeless being awaiting that first breath of life.

Chagall then begins to work before our dazzled eyes.

He enters the studio with the punctuality of an artisan who knows that work alone allows one to accomplish something, sometimes also with the precision of those tight-rope walkers whom he loves and who float up there in gravity by the grace of an immense daily labor.

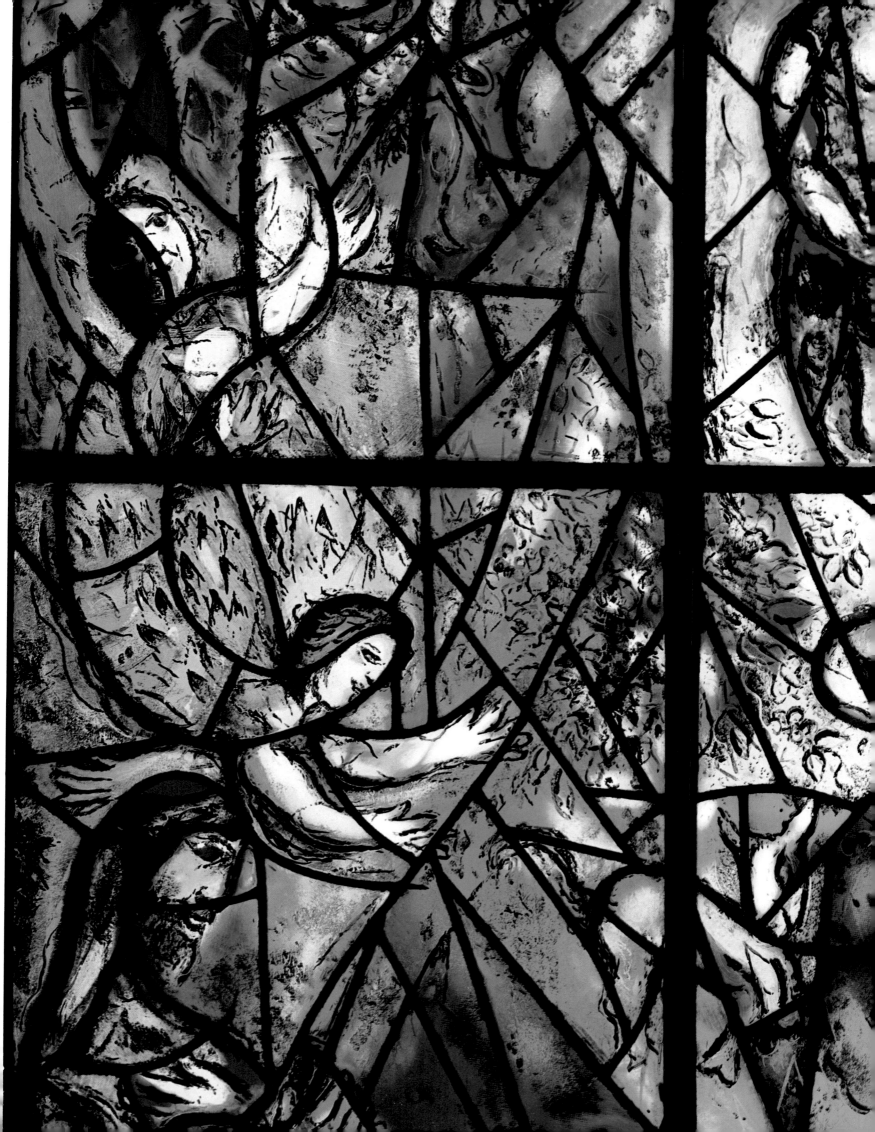

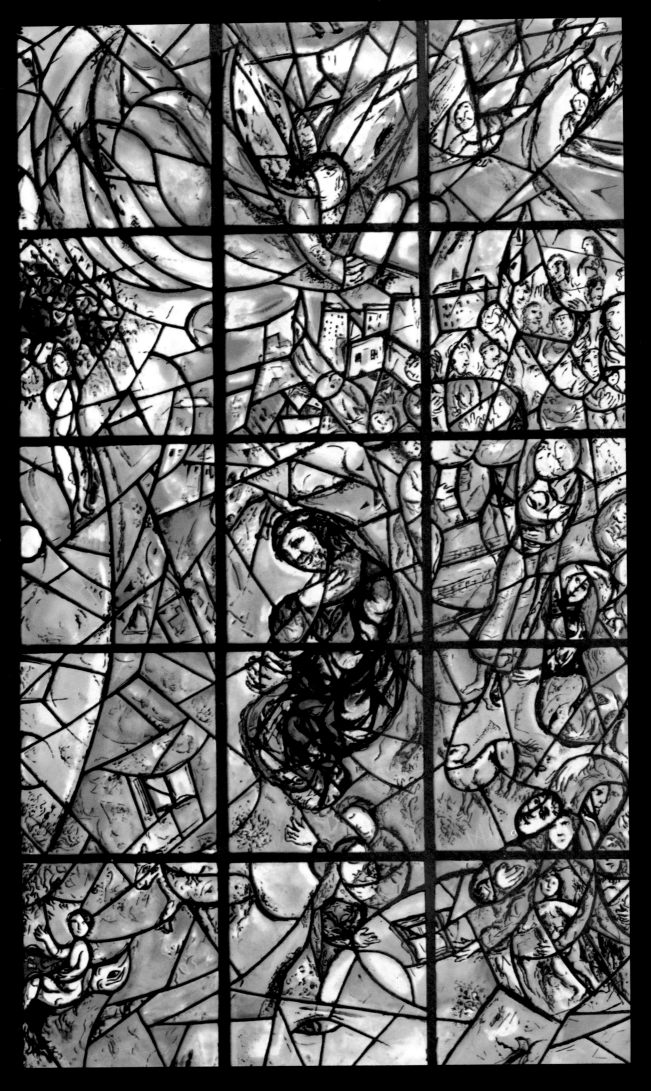

178

La Creation d'Eve.
Vitrail de Metz. Détail.

The Creation of Man.
Stained-glass window
for Metz Cathedral. Detail.

Stained-glass window
for Metz Cathedral. Detail.

Sacrifice d'Abraham. 1962
3,62x0,92 m. Signé en bas à gauche. Détail.

The Dream of Jacob. 1962.
Stained glass window for Metz Cathedral. Detail.

Le songe de Jacob. 196
3,62x0,92 m. Signé en bas à droite. Déta

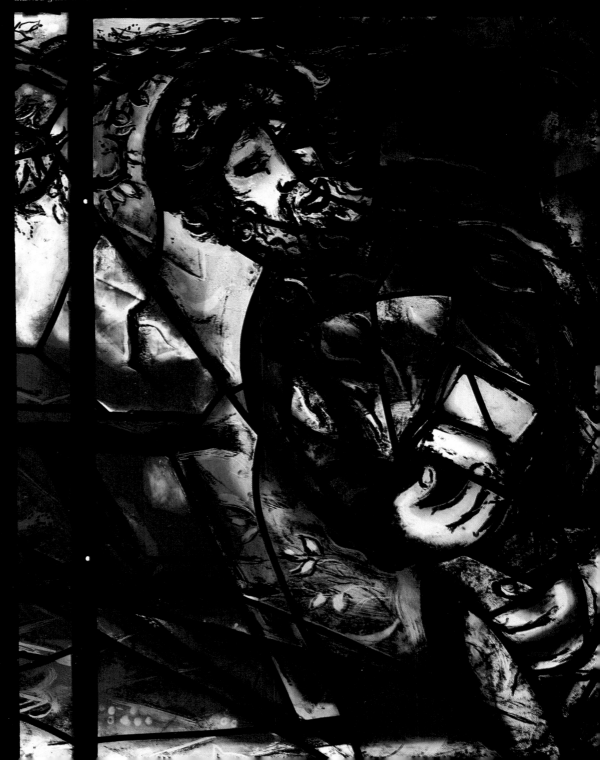

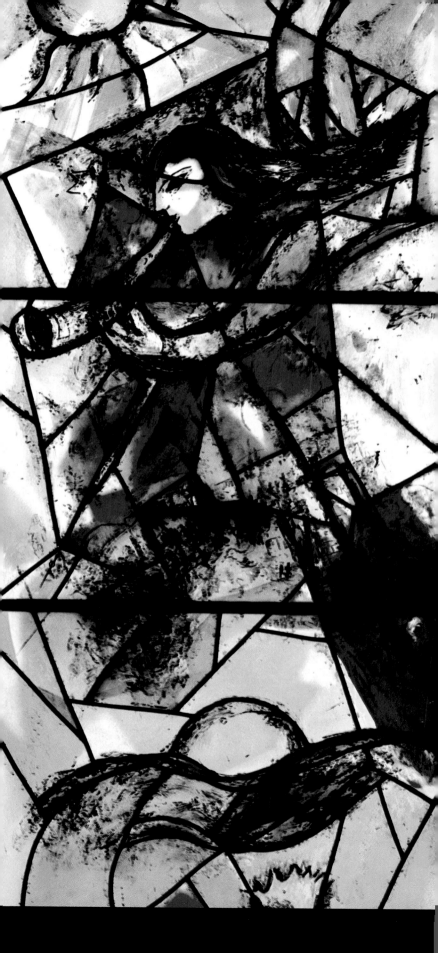

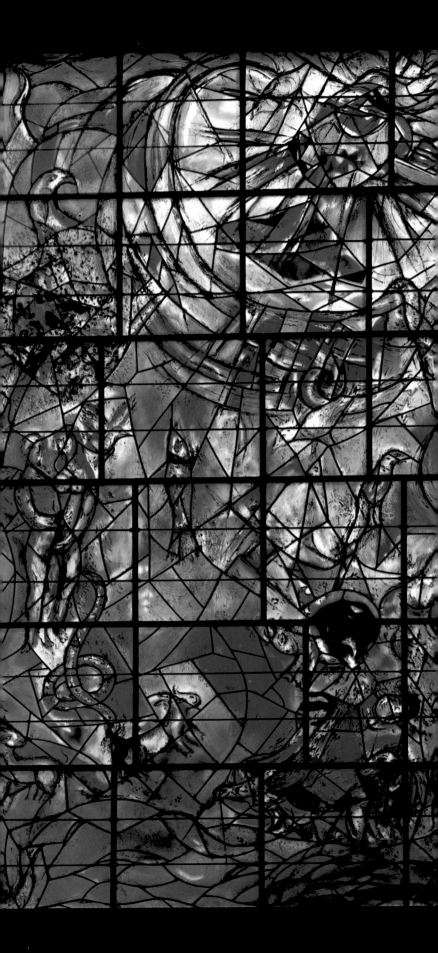

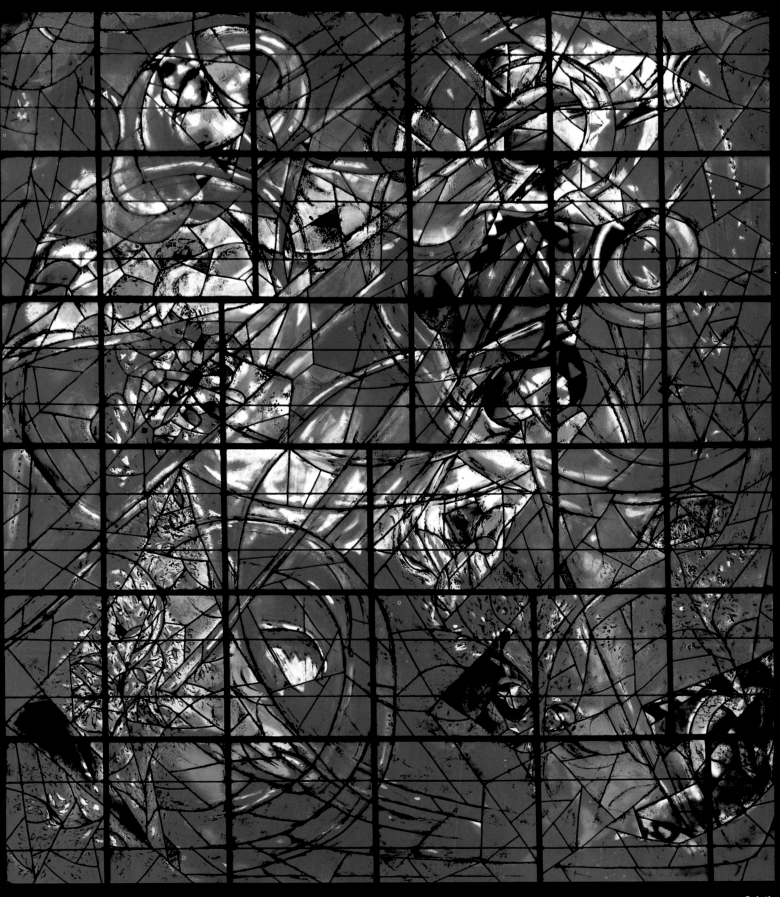

183

Creation.
Windows of the Biblical
Message, Nice. 1971-72.
Left: **The Species.** 4,67x2,67 m.
Right: **The Elements.** 4,67x3,98 m.

Création.
Vitraux du Message
Biblique de Nice. 1971-72.
A droite: **Les Eléments.** 4,67x3,98 m.
A gauche: **Les Espèces.** 4,67x2,67 m.

Judah.
Stained-glass window for
Synagogue in the Hadassah
Hospital, Jerusalem.

Juda.
Vitraux au synagogue de
l'Hôpital Hadassa, Jérusalem.

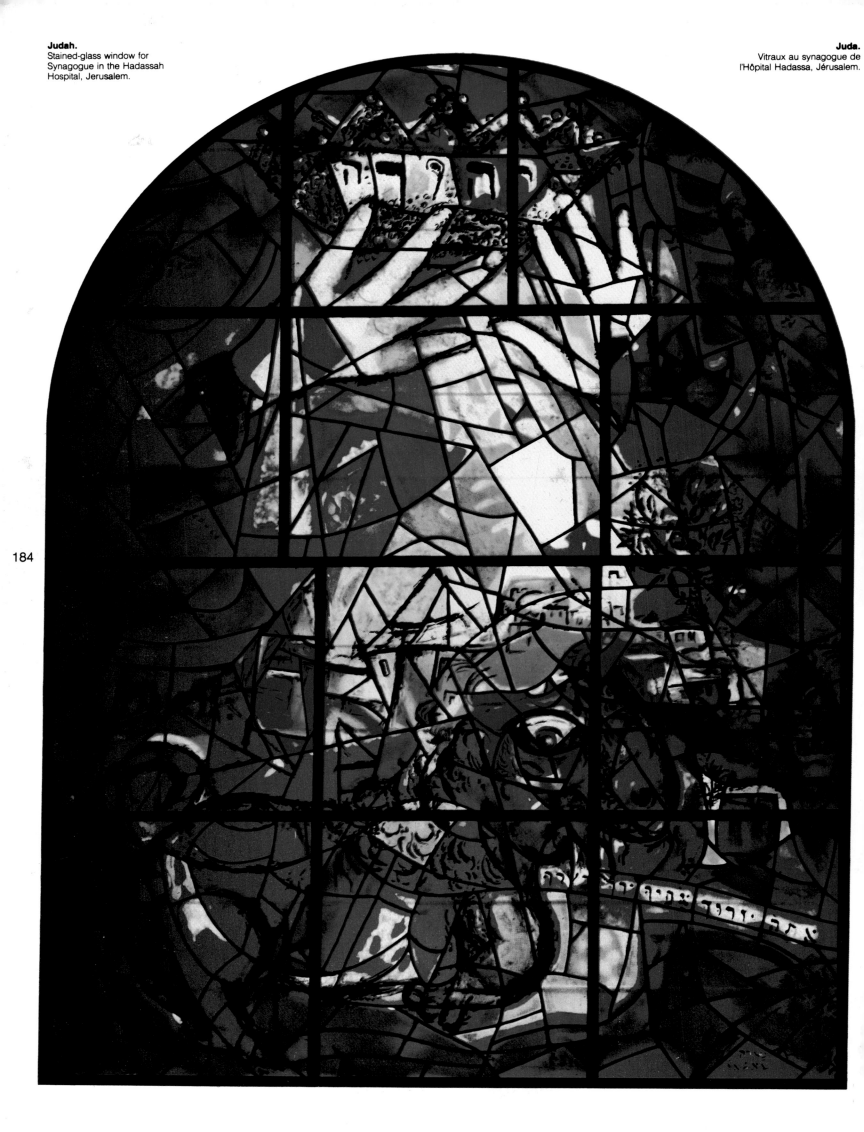

184

An artisan finding life by the contact with materials, as poets or "poor men" by a contact with flowers. A material which, he says, "is a talisman... to touch this talisman is a question of sentiment." Thought always says too much or too little and the intellect, for him, is left outside the door of the studio.

"In the soul there is a sort of intelligence, but in the intelligence there is not always a soul."

He paints. The grisaille, by the sole power of its value and of the line, permits him now to justify everything...

Form, that is his soul. In it there is neither an idea, nor a symbol, nor even reminiscence. I see a curve become, according to his inspiration, a plant, a flower, a face, an animal or a moon... or simply remain a curve.

An intensity of spirit that makes a new form spring forth. Infinite boundaries between order and disorder. He looks, moves away, rejects, begins again, going mysteriously towards a new image that he does not yet know.

The feeling he has about a subject dictates a line to him, a certain touch, and that touch enlightens him on his subject. The painting explains itself to the painter.

And in this ceaseless back and forth movement the window is born and gradually finds its form. There is no question of subject, technique, senti-

ment nor even sensitivity... only a mysterious relationship between light and eye, between grisaille and hand, between space and time... as if biological, as if molecular, becoming visible in rhythm, color and proportion. When the glass appears to have received its exact weight in grisaille, its proper quantity of life, the hand stops as if restrained by another hand. But any form that has not received all the painter's blood, dies, wilts, fades and disintegrates.

Chagall speaks of chemistry... No need to back away, this touch discloses the whole picture and this glass the whole window. Everything is there, everything is reassembled in every way in a living work. A touch born in a flash, produced by millions of years of accumulated forces or by a slow maturation of a gesture eternally repeated, an obscurely ripened deposit of effort. "Look at Rembrandt, look at Chardin, look at Monet—each has his own chemistry."

How, then, can one speak of technique when the "how to do" becomes the "how to be"? How can one speak of reason when I see the sublime fatigue of work destroy all determination to become only "color, light, liberty"?

Color... The impassioned weight of red, the infinite exchange of blue, the great repose of green, the dark mystery of violet, the implacable limit of yellow—here it is exalted in all the

plenitude of its richness—and Chagall likes that color. But his color is something else.

"Ah! This isn't mere coloring. No question of red or blue there. Find your color and you've won the battle." The grisaille is spread in sheets, in accents, ordering, orchestrating by value until the moment when that sonority of color-sensation is perceived.

Light... "You kill it or it kills you and that's not it." Light that passes directly through the work to be painted, that animates it and gives it life; but light that must be tamed, directed, imprisoned in glass, allowed to live where it belongs.

"Stained glass is not easy. You must take it as one catches a mouse: not in a cage but with the hand. There are no 'in-betweens', it is yes or no."

Chagall scrapes, washes, repaints, becomes angry.

"What a nightmare! One must struggle with the lead: struggle, struggle, and then perhaps we'll win out."

"Ah! I don't know how to draw... One doesn't need to know how to draw. A line, that the good Lord knows how to do perfectly. When it's X or Y, it's still a line, it is not God. And so I make little dots, pricks, like that, full of little things of no importance."

His hand races over the glass, placing spots, lines, tints, stamps and marks for a whole hour...

"Ah! I have forgotten everything. Where am I?"

Liberty... the eternally repeated instant, a childhood that is his source and his goal. A childhood from which he emerged whole, from which he still draws his strength. As a painter he is like a newborn child. His anxieties, his torments, his long life of work have turned his hair white but for him painting begins at the break of day.

"The sign of a masterpiece is its freshness."

The inspired freshness of a Mozart, of a Schubert, whom he adores and who revive him after long hours of work.

A Schubert quartet... "That is what Art must be. Ah! Schubert, he cried because he had no friends, no love, nothing but look at what he has done to the whole world. Listen to the way he cries. I love that... Ah! How he suffered!"

He goes on working, becomes moved and thinks out loud. "One must caress. Nothing is given for free. Even the love of a dog must be won with a lump of sugar."

A quintet by Mozart... "Where did he unearth that? Someone whispered it to him... sing it... sing it, and he sings, he listens to what the angels tell him... that gift is not given to everyone... he does anything he wants, whether here or there, and it's right, always right."

Chagall continues his creation; his work accompanies him, and in the dazzling light of the creation I cannot distinguish one from the other.

This poet's dream of an ever new and luminous subject is perhaps what forces him to leave his completed work so quickly in order to go out and find the street and life—and to await the birth of a new dream tomorrow.

CHARLES MARQ

86

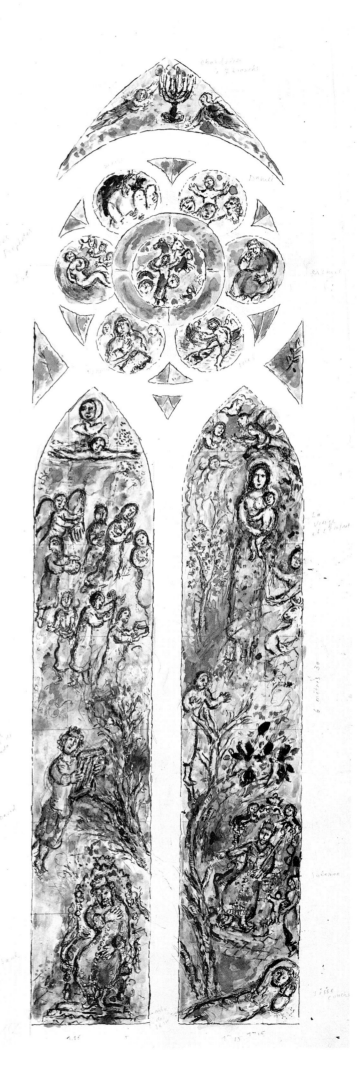

Left:
The Tree of Jesse.
Gouache. 38⅛x10⅝".

Center:
Abraham and Christ.
Gouache. 39x10¼".

Right:
The Kings of France.
Gouache. 39⅜x10⅝".

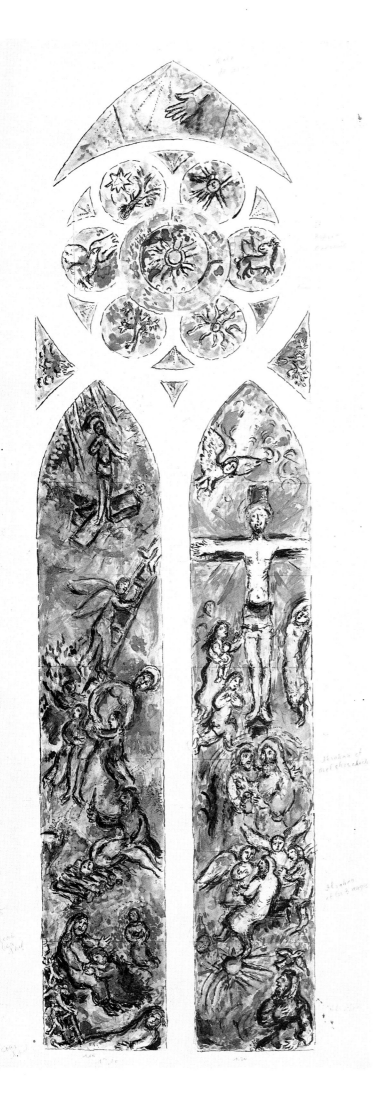

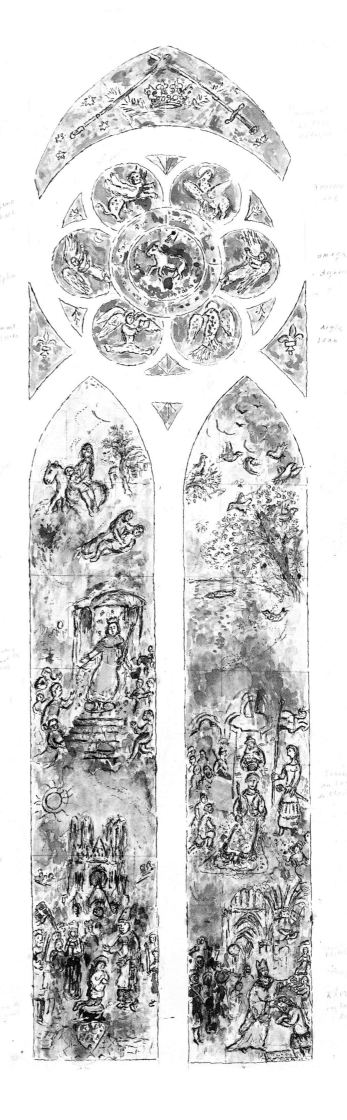

187

188

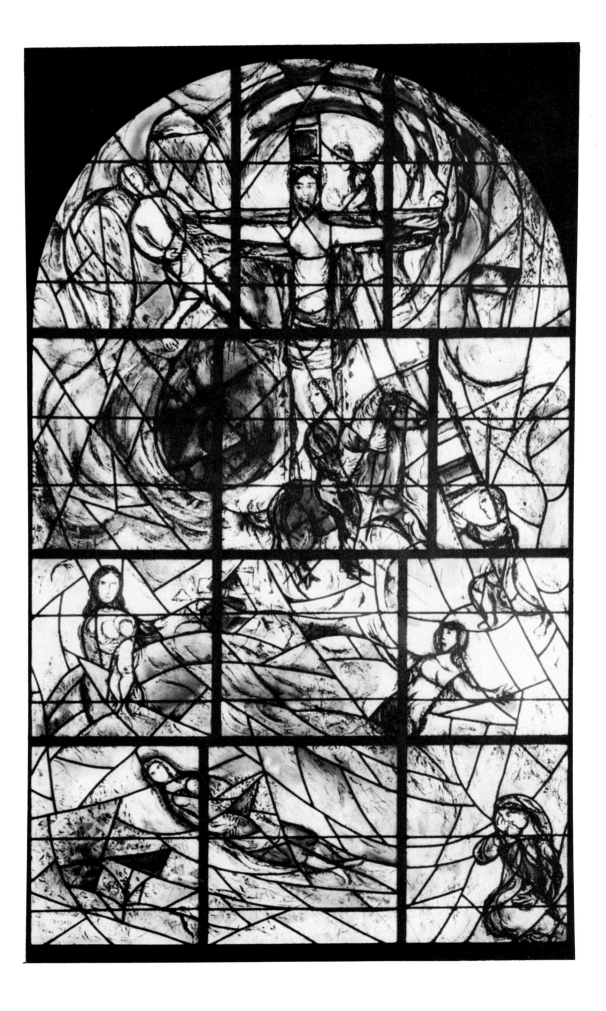

Stained-glass window of the chapel
at Tudeley, near London.

chagall's saint stephen's church in mainz

by wolfgang sauré

Saint Stephens Church in Mainz is one of the oldest religious structures in the Rhineland-Palatinate. Built in 990 during the time of Emperor Othon III, it was meant to honor Saint Stephen. Willegis, then archbishop of Mainz, later canonized after he became archbishop of the entire empire, undertook the task and ordered the construction of a basilica with two choirs which was characteristic of the type of construction during Othon's reign.

Saint Stephens basilica fell into ruin in the 13th century and was replaced by a gothic church between 1290 and 1338. The interior of the church was especially light, no doubt because the central and lateral nave as well as the transept were the same height; also, the church was located at the top of a hill. The slightest ray of sunshine brightened the town and shone through the 19 long windows of the church. It was perfect for a stained glass window. During the second world war, the church was seriously damaged when Mainz was bombed, but since then, it has been completely restored. When the time came to restore the large window of the eastern nave from which the altar was visible, the church authorities decided to call on Marc Chagall, known for his stained glass windows since 1957, and especially for the 12 panels he created for the Hadassah Synagogue in Jerusalem.

Chagall was not unknown in Germany. In 1914 in Berlin, he was introduced by the poet Apollinaire to the editor and owner of an art gallery, Herwarth Walden. Chagall was 25. Walden exhibited Chagall's works in June 1914 at the "Sturm Gallery" after which the artist became known in German Expressionist circles. Chagall came to the exhibition. Then he went off to Russia where to his great surprise he found himself when war broke out. He did not return to Berlin until 1922. Of course, he had acquired quite a reputation by that time. He wrote and illustrated an autobiography which was edited by Cassirer. At the beginning of 1923 Vollard asked him to illustrate Gogol's *Dead Souls*. Chagall then returned to Paris.

Since 1931 Chagall has illustrated many a biblical theme for Vollard. He made a special trip to Palestine and to Syria and in 1932 to Holland to study Rembrandt's work. He also spent quite a bit of time in Spain (1934) studying El Greco's paintings. His biblical offerings, however, are almost entirely inspired by childhood memories — the little Jewish boy from Eastern Europe is enveloped in the lyrical nostalgia of Chassidic piety.

The large stained glass window in Mainz is in a style that is somewhat religious, yet profanely and naively marked by Yiddish folklore. The characters of the Old Testament and the poetic figures of his imagination are simply sketched in such a way that the eventful aspect is visible as in a realistic picture. The multiple nuances of blue which take

on an enameled reflection emphasize the poetry which emanates from the window.

In the first panel, God appears to Abraham in the form of the three angels who invite him to sit down at the table — Genesis 18, 1-10. Above, Abraham breaks away from the angels who are going, like judges, towards Sodom and Gomorrha. The third panel represents the sacrifice of Isaac — Genesis 22, 1-3, 9-18 — above which is Jacob's dream serving as a transition to the tablets of the Law — Exodus 34, 27-32. The fourth panel to which is associated the fifth and last crowns the whole with the angel of peace and a candelabra (inspired by Psalm 85). The central pillar divides the window in two parts but Chagall's global conception of the work restores its homogeneity. The different scenes, superimposed, are not exactly separated from one another. There is the deep belief in the hidden presence of God and this comes forth in each scene and presides over the human condition while guaranteeing the harmony of the transitions. The result is an impression of simultaneity which evokes surrealist principles.

The theological content in the artistic creation is transposed as far as the legend, the poetry and the symbolism is concerned. Therefore, Saint Stephens stained glass window delivers a universal message of peace to men of any race and condition.

Talks started in the spring of 1973 about creating a stained-glass window for Saint Stephens Church in Mainz. In order for Chagall to get a precise idea of the spatial dimensions that would be required, German television channel ZDF (Zweites Deutsches Fernsehen) wrote a documentary on the Church and presented it to the artist. Chagall completed a model in March 1977.

The model consisted of five superimposed panels representing holy scenes from the Old Testament. However, the poetic and magical aspects surpass any exact reproduction of the theological facts and there are a number of parallel with the New Testament as well. The religious authorities of Mainz accepted Chagall's model and the Rhineland-Palatinate government took care of the financing.

The first task of Jacques Simon's atelier in Reims, where the contract was executed, was to transpose the model onto glass which meant that the model had to be enlarged from 1/10 to scale. The Reims atelier, by the way, has been making stained glass windows for the great French Cathedrals for hundreds of years. Among the personnel of the atelier are the couple Charles Marq and Brigitte Simon, their son, and quite a few highly skilled workers who are not only artists but craftsmen and technicians as well.

They prepared the colors as needed. Quite a few of "Chagall's tones" had already been obtained from previous works. Others, including a certain "blue on green" had to be created from scratch. Then Charles Marq drew the leaden frames which not only connect the different pieces of glass, but, depending upon the way they are prepared, also serve to bring out the deep intentions of the artist. In this respect, Charles Marq's knowledge of Chagall's work and personality was very beneficial.

While the frames were being made, they had to decide where and to what degree the glass had to be polished. The glass was first blown at the glass factory in Saint Just sur Loire. It was covered on one side with a white base, then glazed with several colors. The atelier in Reims then prepared some moulds and proceeded with the cutting. This was followed by a long polishing of the glass and the assembling operation which is similar to that of a mosaic. There was a temporary leaden frame, light enough so that Chagall could add a coat of *grisaille*, which was made with an iron oxide. Polishing the glass adds a certain translucence and the *grisaille* gives an opposite effect. The fusion of the two creates a very subtle transition from the darkest to the lightest shades. The two operations are complementary and assume an essential role for the reflection of light on a stained glass window.

Chagall always applies the *grisaille* himself so that he can make sure the window, as well as the whole project, bears the stamp of the artist. The temporary frame was then removed at the atelier Simon and the glass mosaic was heated in a kiln at a temperature between 600 and 650° so that the *grisaille* could blend with the glass.

Finally, the pieces of glass were assembled with a permanent leaden frame and then sent to Mainz and installed in Saint Stephens Church.

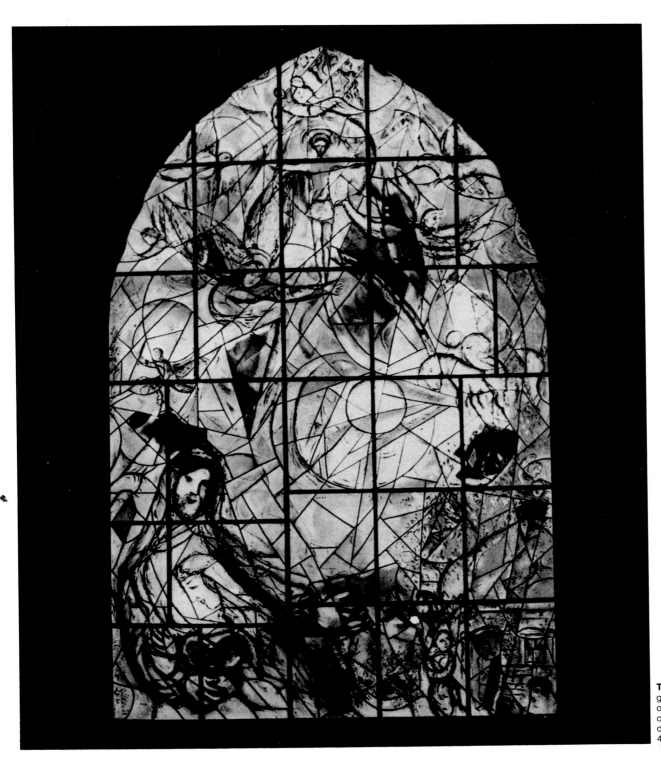

19

The Good Samaritan. 1964. Stained-glass window. 14′7⅔″x9′1¼″. Chapel of Pocantico Hills, New York. This chapel comprises eight other windows, all the same size: 4′10¼″x3′10½″.

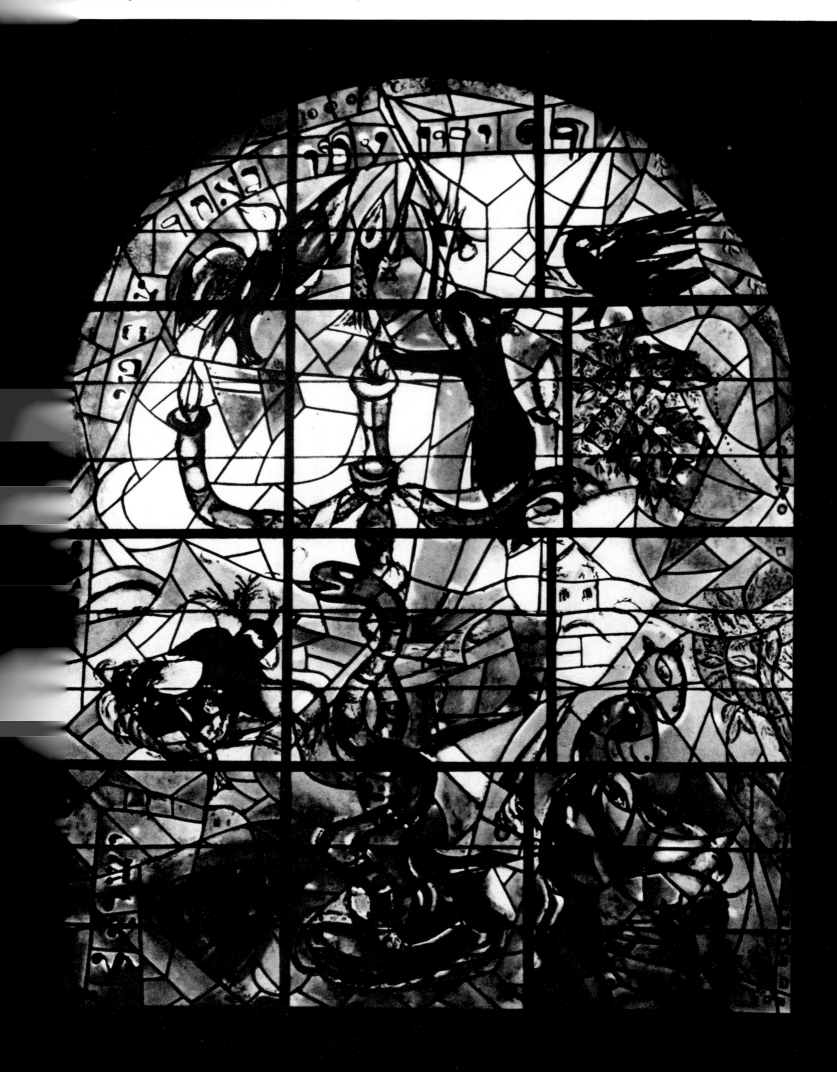